MONSTERS

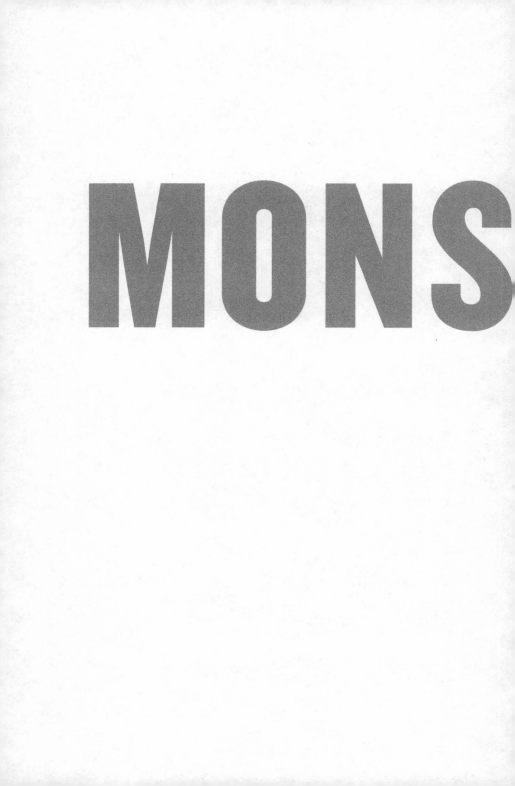

TERS

A FAN'S DILEMMA

CLAIRE DEDERER

 ALFRED A. KNOPF NEW YORK 2023

THIS IS A BORZOI BOOK
PUBLISHED BY ALFRED A. KNOPF

www.aaknopf.com

Knopf, Borzoi Books, and the colophon are
registered trademarks of Penguin Random House LLC.

Grateful acknowledgment is made to the following for permission
to reprint previously published material:

The Estate of Jenny Diski and Bloomsbury Publishing Plc: Excerpt from
In Gratitude by Jenny Diski, copyright © 2016 by Jenny Diski. Reprinted by
permission of the Estate of Jenny Diski and Bloomsbury Publishing Plc.

Hal Leonard LLC: Lyric excerpt from "Little Green," words and music by
Joni Mitchell. Copyright © 1971 by Crazy Crow Music, copyright renewed.
All rights administered by Reservoir Media Management, Inc. All rights reserved.
Reprinted by permission of Hal Leonard LLC.

Vintage Books: Excerpts from *Lolita* by Vladimir Nabokov, copyright © 1955 by
Vladimir Nabokov, copyright renewed 1983 by the Estate of Vladimir Nabokov.
Reprinted by permission of Vintage Books, an imprint of Knopf Doubleday
Publishing Group, a division of Penguin Random House LLC. All rights reserved.

Small portions of this originally appeared, in slightly different form,
as "What Do We Do with the Art of Monstrous Men?" in *The Paris Review*
(November 20, 2017), and as "Cutting Remarks" in *The Nation* (June 14, 2004).

Library of Congress Cataloging-in-Publication Data
Names: Dederer, Claire, [date] author.
Title: Monsters / Claire Dederer.
Description: First edition. | New York : Alfred A. Knopf, 2023. | "A Borzoi book." |
Includes bibliographical references.
Identifiers: LCCN 2022032926 (print) | LCCN 2022032927 (ebook) |
ISBN 9780525655114 (hardcover) | ISBN 9780525655121 (ebook)
Subjects: LCSH: Arts and morals. | Artists—Conduct of life.
Classification: LCC NX180.E8 D43 2023 (print) | LCC NX180.E8 (ebook) |
DDC 700.1/03—dc23/eng/20221026
LC record available at https://lccn.loc.gov/2022032926
LC ebook record available at https://lccn.loc.gov/2022032927

Jacket photograph by Gjon Mili / The LIFE Picture Collection / Shutterstock
Jacket design by Kelly Blair

Manufactured in the United States of America
First Edition

For Lou Barcott and Will Barcott, my best teachers

Who has not asked himself at some time or other:
am I a monster or is this what it means to be a person?
—CLARICE LISPECTOR

It is always tempting, of course, to impose one's view
rather than to undergo the submission required by
art—a submission, akin to that of generosity or love . . .
—SHIRLEY HAZZARD

CONTENTS

PROLOGUE: THE CHILD RAPIST 3

1 ROLL CALL 14

2 THE STAIN 40

3 THE FAN 51

4 THE CRITIC 61

5 THE GENIUS 81

6 THE ANTI-SEMITE, THE RACIST,
AND THE PROBLEM OF TIME 112

7 THE ANTI-MONSTER 134

8 THE SILENCERS AND THE SILENCED 151

9 AM I A MONSTER? 160

10 ABANDONING MOTHERS 175

11 LADY LAZARUS 210

12 DRUNKS 225

13 THE BELOVEDS 243

ACKNOWLEDGMENTS 259
NOTES 261

MONSTERS

THE CHILD RAPIST

ROMAN POLANSKI

It all began for me in the rainy spring of 2014, when I found myself locked in a lonely—okay, imaginary—battle with an appalling genius. I was researching Roman Polanski for a book I was writing and I found myself awed by his monstrousness. It was monumental, like the Grand Canyon, huge and void-like and slightly incomprehensible.

On March 10, 1977—I recite these details from memory—Roman Polanski brought Samantha Gailey to his friend Jack Nicholson's house in the Hollywood Hills. He urged her into the Jacuzzi, encouraged her to strip, gave her a Quaalude, followed her to where she sat on a couch, penetrated her, shifted his position, penetrated her anally, ejaculated. All of these details piled up, but I was left with a simple fact: anal rape of a thirteen-year-old.

And yet. Despite my knowledge of Polanski's crime, I was still able to consume his work. Eager to. Throughout the spring and summer of 2014, I watched the films, their beauty its own kind of monument, impervious to my knowledge of his crime. I wasn't supposed to love this work, or this man. He was the object

of boycotts and lawsuits and outrage. Even so, here I sat in my living room, watching *Repulsion, Rosemary's Baby, Chinatown*.

It's hard to imagine a scene of greater coziness and safety. My house sat in the middle of a field in the middle of the woods in the middle of an almost entirely crime-free island. The living room faced south and was flooded with light even on the gloomiest Pacific Northwest afternoon. The room was furnished haphazardly—frankly a bit shabbily—and filled with books and paintings. It was the kind of room that would be recognizable the world over as the living quarters of a culture worker, or at least a culture lover. It was a room that suggested—all those books—that human problems could be solved by the application of careful thought and considered ethics. It was a humanist room. I mean, if you were in a certain mood you could call it a room descended from the Enlightenment. That's a lot for a room to signify, especially when the bookshelves are from IKEA. But it was clear to see: in this room, everything could be cured by thinking.

That was my mental framework as I settled in to watch the films of Roman Polanski. Really, to solve the problem of Roman Polanski—the problem of loving someone who had done such a terrible thing. I wanted to be a virtuous consumer, a demonstrably good feminist, but at the same time I also wanted to be a citizen of the world of art, a person who was the opposite of a philistine. The question, the puzzle, for me was how I might behave correctly, confronted with these twin and seemingly contradictory imperatives. I felt pretty sure the problem was solvable. I just needed to think harder. I made it through the early films, starting with *Knife in the Water,* made when he was barely out of art school. I had first seen it as a college student

and felt terrified and confused by it—so pretty and so scary. It still felt that way. From there I went on to *The Tenant, Repulsion, Rosemary's Baby, Chinatown.* All films I had seen many times. I expected them to be radically altered by my deeper knowledge of Polanski's crimes, but that's not exactly what happened. The knowledge just sort of *hovered* there.

Drawn in by the great films from the 1960s and '70s, I watched the newer movies too. *The Ghost Writer,* a film that seemed to have gone unseen by everyone except film buffs: in it, Ewan McGregor ghostwrites the life story of tycoon Pierce Brosnan, and—get this—not all is as it seems. The film ought to be a formulaic thriller, but in Polanksi's hands it becomes something weirder and better. In fact, it opens with a shot that made me feel confused and dumb in the face of its very goodness. What made the shot so magnificent, so magisterial? It is, after all, a simple image: a lone car in the open mouth of the deck of a ferry. But it's filled with menace. Writing now, I can see the scene in my mind's eye and feel its furious, implacable beauty.

Somehow that Polanski moment—not the Los Angeles River of *Chinatown,* not the gleeful menacing "chocolate mouse" of *Rosemary's Baby,* not the image from *Repulsion* of Catherine Deneuve crawling down a hallway in her negligee—is what made me really *feel* his greatness. An unfamous moment, in an unfamous film, and still it thrilled me. Even Polanski's throwaway moments shine hard—pearls cast before his detractors.

My love of the films did not grow from any forgiveness of his crime. That forgiveness never happened, even though I understood the circumstances and the context: sex between grown men and teenage girls was normalized at the time, the subject matter of songs and films; Gailey has said she forgives him; Polanski

himself was a victim, his mother murdered at Auschwitz, his father held in concentration camps, his wife and unborn child murdered by the Manson Family. There's no denying the horror of Polanski's backstory—after all, two of the terrors of the twentieth century happened to *him, personally*. None of this swayed me toward forgiveness, though; it wasn't as if I weighed the issue and decided that, given these mitigating factors, the crime wasn't so bad after all. The fact was, I simply wanted to watch the films because they were great.

I told myself that Polanski was a genius and that was all there was to it, problem solved—but as I watched, I couldn't ignore something that seemed disturbingly akin to a twinge. More than a twinge, truth be told. My conscience was bothering me. The specter of Polanski's crime wouldn't leave the room.

I found I couldn't solve the problem of Roman Polanski by thinking. The poet William Empson said life involves maintaining oneself between contradictions that can't be solved by analysis. I found myself in the midst of one of those contradictions.

Polanski would be no problem for the viewer at all—just another example of how some men happen to be black holes—if the films were bad. But they're not.

There is no other contemporary figure who balances these two forces so equally: the absoluteness of the monstrosity and the absoluteness of the genius.

Polanski made *Chinatown*, often called one of the greatest films of all time.

Polanski drugged and anally raped thirteen-year-old Samantha Gailey.

There the facts sit, unreconcilable.

How would I maintain myself between these contradictions?

My comfy living room couch had become an uneasy chair. I didn't know what to do about Polanski; and I did feel, if somewhat obscurely, that something needed to be done. Or needed to be decided.

I hoped that there would be an expert who would tell me what to do. Some kind of philosopher who had puzzled it out before. I studied intellectual history in college but could think of no one who had addressed this head-on. One afternoon I fired off an email to my undergrad program director, an intellectual historian himself, a mustachioed, jolly, brilliant person like a character from a David Lodge novel. After I hit Send, I did a kind of mental dusting of hands; surely my beloved professor would get this thorny problem solved once and for all.

Looking back, I'm fascinated by my immediate instinct to find an expert—and a white male expert, at that. I had an impulse to farm out the problem, to seek an authority. The idea that no such authority existed did not cross my mind.

Hi John, [I wrote]

Hope all is well with you. I'm writing to you in your Herr Professor role, hoping you might be able to help me with a question. . . .

I find myself working on a long piece of writing (I hesitate to call it a book) about Roman Polanski. . . . One of the things that's arisen attendant to Polanski: the

problem of the artist whose work we love and whose morals we loathe. I'm sure there's lots of writing on this area but I'm not sure where to start. I mean, aside from Arianna Huffington's Picasso book. Any suggestions?

Hope you don't mind my shamelessly exploiting your expertise. . . .

Yours,

C

Well, John *couldn't* help.

He wrote back suggesting I read up on V. S. Naipaul, who was personally pretty awful, or think about great artists who were fascist sympathizers, like Ezra Pound.

No, that wasn't what I wanted exactly. I'd spent my life being disappointed by beloved male artists: John Lennon beat his wife; T. S. Eliot was an anti-Semite; Lou Reed has been accused of abuse, racism, and anti-Semitism (these offenses are so unimaginative, aside from everything else). I didn't want to compile a catalogue of monsters—after all, wasn't the history of art simply already that? I had a dawning realization—I was trying to find out not about the artists, but about the audience. Polanski had become not his own problem, but my problem. I had a glimmer of a thought: I wanted to write an autobiography of the audience.

Such a book was a little mysterious to contemplate. It would take place where, exactly? Inside my head? Within my living room as I read or watched television? In my car as I listened to music? In a theater or a museum or a rock club? Suddenly all these humdrum locations seemed like sites of drama.

. . .

I f I were writing an honest autobiography of the audience—I mean the audience of the work of monstrous men—that autobiography would need to balance these two elements: the greatness of the work and the terribleness of the crime. I wished someone would invent an online calculator—the user would enter the name of an artist, whereupon the calculator would assess the heinousness of the crime versus the greatness of the art and spit out a verdict: you could or could not consume the work of this artist.

A calculator is laughable, unthinkable. Yet our moral sense must be made to come into balance with our art-love (the Germans, of course, have a term for this or so I am told: *Liebe zur Kunst*). I wanted for there to be a universal balance, a universal answer, though I suspected maybe that balance is different for everyone. A friend who was gang-raped in high school says that any and all work by artists who've exploited and abused women should be destroyed. A gay friend whose adolescence was redeemed by art says that art and artist must be separated entirely. It's possible that both these people are right.

W e don't always love who or what we're supposed to love. Woody Allen himself famously quoted Emily Dickinson: "The heart wants what it wants." Auden said it more nicely, as he said almost everything more nicely: "The desires of the heart are as crooked as corkscrews." The desires of the audience's heart are as crooked as corkscrews. We continue to love what we ought to hate. We can't seem to turn the love off.

. . .

I began to see that these questions had been haunting me for years—as a film critic, a book critic, simply a viewer and consumer and fan of art. For a long time, this question seemed my private purview—a lonely puzzle of pleasure and responsibility, almost a kind of hobby, like needle felting or co-rec soccer. The question seemed personal, and the answers contingent—upon my mood, upon the individual artist and the specific work.

In those years, the years leading up to 2016, I didn't know we were about to enter a new landscape where heroes would fall, one after another, and the response to their failures would no longer be a private sadness but a collective outrage. I didn't know that our private pain was about to become political or that our world was about to seem a lot more fragile. The cruelty of the world, over the next few years, would become much more visible. It almost seemed to burst into view, like a villain entering stage left. But of course the cruelty was not new—it had been there all along. Some of us were just ignoring it.

While in the grip of my Polanski mania, I was asked to record a contribution to a radio documentary about *Rosemary's Baby*. The night before I was due to go into the recording studio, I re-watched the film. It took me for*ever*. I lay on my couch, making my way through the film with delicious slowness, pausing almost frame by frame, enraptured by the shapes on the screen, the way Polanski shot the scenes of John Cassavetes and Mia Farrow's apartment from the floor, so the audience is given a hell's-eye view. I marveled at the film's humor, its beauty,

its idiosyncratic performances, its evocation of a very female terror.

Rosemary, in her chic little white dresses and Vidal Sassoon hair, hurtles toward her own doom. She's goaded on her way by her husband, her doctor, all the men she is meant to trust. This tightening noose of male control is recognizable to any woman who's ever felt herself reduced to the role of mother and subtly encouraged to ignore her own feelings or intuition—in other words, it's a very ordinary experience here made menacing and extraordinary. Rosemary's pregnancy erodes her health with weight loss and cramping; at a party her friends take her in the kitchen, barricade the door against her husband, and coax her into telling them what's really happening—the kind of sisterly truth-telling you might see in a consciousness-raising session or a hair salon. Rosemary, ill and drawn (because she's growing the *devil* in her *belly*), sinks into a kitchen chair and confesses she is not well. The women gather around her, looking like anything but revolutionaries in their flower-colored dresses and smooth hair and made-up faces. But they create a small army of compassionate resistance around Rosemary as they pet her, wipe away her tears, soothe her, and, above all, tell her that what's happening is not right—that her doctor and her husband (that is, the men, the establishment) are hurting her. Once the women leave, though, Rosemary is subsumed back into the web of patriarchy, and her fate is sealed. It's a startlingly feminist vision from a man whose biography seems to pit him against feminism.

Engrossed in the film, madly taking notes, I stayed up way too late and woke the next morning bleary-eyed with fatigue. It was all I could do to haul myself out of bed and head to the radio studio.

It should be noted that *Rosemary's Baby* is known as the most cursed movie ever made. Its making and its aftermath were crowded with terrible events. A few months before the release, the composer of the film's score got a coma-inducing injury while, I kid you not, rough-housing, and he died the next year. The producer William Castle almost died of kidney stones, of all things, just after the June 1968 release. Writer Ira Levin's marriage fell apart that year; so did Mia Farrow's. Then came Charles Manson's murder of Polanski's pregnant wife.

I, a mere watcher of the film, did not emerge unscathed. Walking through downtown Seattle on my way to the radio station, Magoo-like with lack of sleep, I clumsily, sleepily tripped, twisted my ankle brutally, and, in shock from the pain of the twist, blacked out. The thing about fainting from a standing position is this: There's nothing to break your fall. So if you happen to fall on, say, your face, well then your face is what takes the full force of the impact.

When I came to, blood was everywhere. I found that my teeth had perforated my lower lip. There was a hole in my face that had not been there before. Nothing was where it belonged.

A cluster of people stood nearby, gazing at me in horror. Even in those first moments, it was already clear that they belonged to one country—the country of the whole, the uninjured, the well—and I belonged to another country, the country of the broken. It was clear I was going to be living in this new country for a long time. I fell midway down a city block—at the beginning of my journey down that block, I was a trench coat–clad matron, a serious middle-aged person in charge of my house and children and career; twenty-five yards later I was an animal. I had become something that terrified other people.

I crouched on the pavement, my face a gaping wound, my teeth rearranged, my skin scraped clean. Clearly, the curse of *Rosemary's Baby* had come upon me. Whether I liked it or not, there I was, on my knees before my muse, my beloved, my monster.

ROLL CALL

WOODY ALLEN

I started keeping a list.

Roman Polanski, Woody Allen, Bill Cosby, William Burroughs, Richard Wagner, Sid Vicious, V. S. Naipaul, John Galliano, Norman Mailer, Ezra Pound, Caravaggio, Floyd Mayweather, though if we start listing athletes we'll never stop. And what about the women? The list immediately becomes much more tentative: Anne Sexton? Joan Crawford? Sylvia Plath? Does self-harm count? Okay, well, it's back to the men, I guess: Pablo Picasso, Lead Belly, Miles Davis, Phil Spector. Add your own; add a new one every week, every day. Charlie Rose. Carl Andre. Johnny Depp.

They were accused of doing or saying something awful, and they made something great. The awful thing disrupts the great work; we can't watch or listen to or read the great work without remembering the awful thing. Flooded with knowledge of the maker's monstrousness, we turn away, overcome by disgust. Or . . . we don't. We continue watching, separating or trying to separate the artist from the art. Either way: disruption.

How do we separate the maker from the made? Do we undergo a willful forgetting when we decide to listen to, say,

Wagner's Ring cycle? (Forgetting is easier for some than others; Wagner's work has rarely been performed in Israel since 1938.) Or do we believe genius gets special dispensation, a behavioral hall pass?

And how does our answer change from situation to situation? Are we consistent in the ways we apply the punishment, or rigor, of the withdrawal of our audience-ship? Certain pieces of art seem to have been rendered unconsumable by their maker's transgressions—how can one watch *The Cosby Show* after the rape allegations against Bill Cosby? I mean, obviously it's technically doable, but are we even watching the show? Or are we taking in the spectacle of our own lost innocence?

And is it simply a matter of pragmatism? Do we withhold our support if the person is alive and therefore might benefit financially from our consumption of their work? Do we vote with our wallets? If so, is it okay to stream, say, a Roman Polanski movie for free? Can we, um, watch it at a friend's house?

These questions became more urgent as the years went by—as, in fact, we entered a new era. Here's the thing about new eras: You don't really recognize them as they show up. They're not carrying signposts. And maybe "new era" is not quite the right phrase. Maybe we entered an era where certain stark realities began to be clearer to people who had heretofore been able to ignore them. One such reality was made clear on October 7, 2016. I sat in my living room, the same room where on sunlit afternoons and black evenings I guiltily lost myself in the films of Roman Polanski, and I watched the *Access Hollywood* tape over and over.

This was a very specific way of being an audience—watching

something compulsively, as if you could somehow change it or take responsibility for it by keeping your eyes on it. I remembered it from the two Gulf wars, and from 9/11, and before that from my early childhood, when my family gathered around the TV to watch the Watergate trials. As if watching could Do Something.

I drank coffee and ate buttered toast and watched as the Republican presidential candidate talked about grabbing women by the pussy. You don't need me to remind you.

I watched with all the old memories inside my body, the kind of memories so many women have. And the denial of the memories was in there too. The denial was so deep that when I heard . . .

Grab 'em by the pussy. You can do anything.

. . . I didn't even realize he was describing assault. Didn't realize until I went on social media to monitor the response to the news and some dude named it: "This is assault."

On that awful day, one good thing happened, a thing that foretold a growing movement: it happened on the Twitter feed of Kelly Oxford, a model and bestselling author, the kind of person who normally sort of chaps my hide. Where does she get off being so pretty and bestselling? But Oxford tweeted this out: "Women: tweet me your first assaults. They aren't just stats. I'll go first: Old man on city bus grabs my 'pussy' and smiles at me, I'm 12." Especially powerful was one little word in Oxford's original tweet: "first." It implied a list.

I had my own list—my first assault, by a family friend, happened to me when I was thirteen. The first. Followed by two attempted rapes, multiple physical assaults on the street, and god knows how many unwanted gropings. I followed avidly as, over the next fourteen hours, Oxford received more than a mil-

lion tweets from women describing their first assaults. At one point she was receiving a minimum of fifty tweets per minute. This was a year before the #MeToo movement exploded.

All these women sorta rubbed their eyes and looked around and said, "Hunh. What she just called assault is what happened to *me*." A rock had been turned over and revealed a bunch of sex pests, scuttling around in the newly bright light.

That day felt, at the time, like a moment of horizontal static on the smooth screen of reality. Surely this was just a glitch, a campaign-ending unforced error. Surely Hillary Clinton would be elected and everything would return to normal. It was just newly dawning on me that normal was not so good, anyway; that what the election of Hillary Clinton would mean was a continuation of a reality that was growing more unforgiving for everyone; that liberalism was a failed plan for protecting ourselves from ourselves.

Even so, I didn't want *this*. Didn't want this particular disruption of the smooth screen of accepted reality. In any case, it didn't matter what I wanted. The Trumpian static turned out to be, in fact, our new reality. The demoralizing and sick-making effect of the tape only increased over the next month as it became clear that it would have absolutely zero effect on Trump's viability as a candidate. The static was where we lived now.

And so, amid that static, in the context of that static, feeling pretty staticky myself, I asked more and more often: what ought we to do about great art made by bad men?

. . .

But hold up for a minute: who is this "we" that's always turning up in critical writing? *We* is an escape hatch. *We* is cheap. *We* is a way of simultaneously sloughing off personal responsibility and taking on the mantle of easy authority. It's the voice of the middlebrow male critic, the one who truly believes he knows how everyone else should think. *We* is corrupt. *We* is make-believe. The real question is this: can I love the art but hate the artist? Can you? When I say "we," I mean I. I mean you.

I knew Polanski was worse, whatever that means. But Woody Allen was the person who engendered the most soul-searching in the average audience member. When I brought up the idea that an artist's behavior might prevent us from consuming their work, Woody Allen was the reference point. Almost everyone had a position on the Woody thing.

Real quotes:

"*Midnight in Paris* was glorious. I just put the other stuff out of my mind."

"Oh, I could never go see a Woody Allen film."

"I grew up watching his movies. I love his movies, they're part of my life."

"It's all a plot cooked up by Mia."

"I'm just glad his stuff sucks now, so I don't have to worry about it." (Okay, this one is from me.)

A lot of rumors and accusations floated around Woody Allen's small person, like a halo of flies. His daughter Dylan Farrow, backed by one sibling, disavowed by another, has held firm in her accusations against Allen, saying he molested her when she was seven years old. We don't know the real story, and

we might never know. What we do know for sure: Woody Allen slept with Soon-Yi Previn, the child of his partner Mia Farrow. Soon-Yi was either a high school student or a college freshman the first time he slept with her, and he the most famous film director in the world.

Today the debate rages on about the accusations made by Dylan Farrow, but the Soon-Yi story was the one that disrupted and rearranged my own viewing of Allen's films. I took the fucking of Soon-Yi as a terrible betrayal of me personally. When I was young, I *felt* like Woody Allen. I intuited or believed he represented me on-screen. He was me. This is one of the peculiar aspects of his genius—this ability to stand in for the audience. The identification was exacerbated by the seeming powerlessness of his on-screen persona: skinny as a kid, short as a kid, confused by an uncaring, incomprehensible world. (Like Chaplin before him.) I felt closer to him than seems reasonable for a little girl to feel about a grown-up male filmmaker. In some mad way I felt he belonged to me. I had always seen him as one of us, the powerless. Post–Soon-Yi, I saw him as a predator.

Sleeping with your partner's child—that requires a special kind of creep. I can hear you arguing this, you Woody-defenders, even now, in my brain, saying that Woody was not Soon-Yi's parent, that he was her mother's boyfriend, that I'm being hysterical. But I have a special knowledge of this kind of relationship: I was raised by my mother and her boyfriend Larry. And I assure you that Larry was my parent.

Woody elicited in me an emotional response, which arose from a very specific place. As a kid growing up in the 1970s, I experienced my share (what's a share, in this case?) of predatory adults, but none of them were my parent.

In fact, to accept the idea that Woody was not Soon-Yi's parent does violence to the very idea of my relationship with Larry, one of the most cherished of my life. And perhaps that was the key to my response, when the news of Woody and Soon-Yi came out: I was even more disgusted by the whole mess than I might've been otherwise, because I myself had a mother's boyfriend in my life—in my case, someone I adore and respect to this day. The story of Woody and Soon-Yi—at least the way it came to me—perverted this delicate relationship.

In other words: My response wasn't logical. It was emotional.

Now, all these years later, I wanted to revisit Woody Allen, see if the work had been fatally disrupted. And so one rainy afternoon I flopped down on the living room couch and committed an act of transgression—I on-demanded *Annie Hall*. It was easy. I just clicked the OK button on my massive universal remote and then rummaged around in a bag of cookies while I waited for the movie to cue up. As acts of transgression go, it was pretty undramatic.

The black title cards rolled past, with their old-friend names Jack Rollins, Charles H. Joffe, spelled out in that familiar font, the second–most civilized font in the world (after that of *The New Yorker*, another venue where serifs do the work of congratulating the audience on its good taste).

Annie Hall was, it turned out, still good. I'd watched the movie at least a dozen times before, but even so it charmed me all over again. *Annie Hall* is a jeu d'esprit, an Astaire soft shoe, a helium balloon straining at its ribbon. *Annie Hall* is a frivolity, in the very best sense. It's no accident that the most famous

thing about the film is Annie's clothes. In her men's vest, tie, chinos, her unsure, down-dipping eyes peering out from under a big black hat, Annie is a thief of the serious clothes of serious men; she's snuck into manland and swiped its trappings. Not for empowerment, just for fun.

Style is everything in *Annie Hall*. That's the film's genius. Woody Allen's genius. Alvy is forever maundering away about the end of the world (Allen wanted to call the film *Anhedonia*), but it's Annie's nonsensical, almost nonverbal weltanschauung that lifts the movie into flight. Her smile, her sunglasses, her poignant undershirts are her philosophy and her meaning. The pauses and the nonsense syllables between her words are as important as the words themselves. "I never said 'La-di-da' in my life until he wrote it, but I was a person who couldn't complete a sentence," Keaton told Katie Couric in an interview, describing the way the character had been built around her. Annie's vernacular was Keaton's own prattle, but fine-tuned, amped up, scripted.

Even the love story stops making sense—it's a love story for people who don't believe in love. Annie and Alvy come together, pull apart, come together, and then break up for good. The End. Their relationship was pointless all along, and entirely worthwhile.

Ultimately Annie's refrain of "la-di-da" is the governing spirit of the enterprise, the nonsense syllables that give joyous expression to Allen's dime-store existentialism and the inevitability of the death of love. "La-di-da" means: nothing matters. It means: let's have fun while we crash and burn. It means: our hearts are going to break, isn't it a lark?

Keaton is daring to look like a moron; Allen is daring to burn

film on the spectacle of her goofiness; the two of them, director and actress, wobble their way through the movie. Equipoise is the ethos; the grace is in not quite falling.

Everything about Diane Keaton's performance in *Annie Hall* is inimitable, and we know that for a fact because what happened next was that every woman in America went around trying to imitate her—and failed. Style looks easy, but is not. This is true about *Annie Hall* across the board. All the things that look easy are not: the pastiche form; the integration of schlocky jokes with an emotional tenor of ambivalence; the refusal of a happy ending, tempered by the spritzing about of a general feeling of very grown-up friendliness.

Annie Hall is the greatest comic film of the twentieth century—better than *Bringing Up Baby*, better even than *Caddyshack*—because it acknowledges the irrepressible nihilism lurking at the center of all comedy. Also, it's really funny. To watch *Annie Hall* is to feel, for just a moment, that one belongs to the human race. Watching, you feel almost mugged by the sense of belonging. That fabricated connection can be more beautiful than love itself. A simulacrum that becomes more real than the thing it represents. And that's how I define great art.

Look, I don't get to go around feeling connected to humanity all the time. It's a rare pleasure. And I was supposed to give it up just because Woody Allen behaved like a terrible person? It hardly seemed fair.

As I said, Allen wanted to give *Annie Hall* an alternative title: *Anhedonia*. The inability to experience pleasure. My own ability to experience pleasure, specifically pleasure arising from

consuming art, was imperiled all the time—by depression, by jadedness, by distraction. And now I was finding I must also take into account biography; an artist's biography as a disrupter of my own pleasure.

The week after I watched *Annie Hall*, I went out to coffee with a former coworker, Sara. We sat in a dingy café on Seattle's Capitol Hill and talked about our kids and our writing. With her rosy cheeks and snapping black eyes, Sara looked like a character from a children's book about plucky pioneers caught in a blizzard; she was the very image of a sweetly reasonable person. When I mentioned in passing that I was writing about, or at least thinking about, Woody Allen, Sara reported that she'd seen a Little Free Library in her neighborhood absolutely crammed to its tiny rafters with books by and about him. It made us both laugh—the mental image of some furious, probably female, fan who just couldn't bear the sight of those books any longer and stuffed them all in the cute little house.

We made a plan: she would scoop up all the books for me so I could use them for research. I didn't think of it at the time, but an ill-gotten Woody Allen book was a book I hadn't paid for—the perfect way to consume the art of someone whose morals you question. We said goodbye, and as I got into my car I received a text from Sara:

"I don't know where to put all my feelings about Woody Allen," the text said.

Normally I might have rejected the word "feelings," with its weakness and its vagueness and its, its *womanliness*. But Sara was so smart that I read carefully what she texted. Sara was the

very model of an enlightened audience member. If she couldn't manage her feelings about Woody Allen, what hope was there for the rest of us?

I went on a mini tour of women. I told another smart friend, a voluble and charming tech executive, that I was writing about Woody Allen. "I have very many thoughts about Woody Allen!" said my friend, excited to share. We were drinking wine on her porch, and she settled in. "I'm so mad at him! I was already pissed at him over the Soon-Yi thing, and then came the—what's the kid's name? Dylan? Then came the Dylan business, and the horrible dismissive statements he made about that. And I hate the way he talks about Soon-Yi, always going on about how he's enriched her life."

These are feelings.

My friend had said she had many thoughts about Woody Allen, but that's not what she was having. This, I think, is what happens to so many of us when we consider the work of the monster geniuses—we tell ourselves we're having *ethical thoughts* when really what we're having are *moral feelings*. We arrange words around these feelings and call them opinions: "What Woody Allen did was very wrong." But feelings come from someplace more elemental than thought. The fact was this: I felt upset by the story of Woody and Soon-Yi. I wasn't thinking, I was feeling. I was affronted, personally somehow.

Here's how to have some complicated emotions: watch *Manhattan.*

Like many—many what? many women? many mothers? many former girls? many moral feelers?—I have been unable to watch *Manhattan* for years.

Of course I saw it when I was young. As a teenager, I was mostly baffled by it. I mistrusted and didn't believe in the central relationship—it seemed to me that the whole film was built on a lie or a fantasy—but I didn't have the words to say that. I second-guessed my own opinion. Meanwhile, I was enchanted with these things: Gershwin; black and white; Isaac's spiral staircase leading down to his cool living room; the Queensboro Bridge; Chinese food in bed. *Manhattan* was, after all, about Manhattan—a kind of travelogue for aspirational urbanites. I think now of E. L. Doctorow's devastating dismissal of Hemingway: reading the not-so-great posthumously published novel *The Garden of Eden,* Doctorow wrote in a review that he was "depressed enough to wonder if Hemingway's real achievement in the early great novels was that of a travel writer who taught a provincial American audience what dishes to order, what drinks to prefer and how to deal with the European servant class." *Manhattan* is just such a teacher's aid—you sense Allen wishing he could educate his own younger, greener self in the niceties of bourgeois consumption.

And so for a long time, over decades, I chimed in with the dominant opinion that it was Woody Allen's best film. Saying that was a way to demonstrate my own sophistication, my own refusal to be tethered by the earth-held bounds of feminism. It was a cultural version of Gillian Flynn's famous "cool girl" passage from the novel *Gone Girl:* "Men always say that as the defining compliment, don't they? She's a cool girl. Being the Cool Girl means I am a hot, brilliant, funny woman who adores football,

poker, dirty jokes, and burping, who plays video games, drinks cheap beer, loves threesomes and anal sex." And the movie *Manhattan*. Flynn goes on to say, "Men actually think this girl exists." The point is that she does not. The point is that she's performing a role, pretending she likes these things in order to please some imaginary (or not-so-imaginary) man—maybe a man in real life, maybe a man in her head. (Claire Vaye Watkins wrote well on this in her essay "On Pandering": "I have built a working miniature replica of the patriarchy in my mind.") So it was with *Manhattan:* I didn't trust my own initial response; I thought what I was supposed to think.

But there was an initial sense of unsavoriness, which prevented me from watching it again . . . ever. Even though I was and am an inveterate re-watcher of films I have loved.

Now, even in the thick of my thinking-about-Woody-Allen project, I still found *Manhattan* unapproachable. I watched nearly every movie he's ever made (I skipped *Celebrity*—I'm not a maniac) before I faced the fact that I would, at some point, need to re-watch *Manhattan*.

And finally the day came. As I settled in on my couch once again, the first Cosby trial was taking place. It was June of 2017.

Trump had been in office for months. People were unsettled and unhappy, and by people I mean women, and by women I mean me. The women met on the streets and looked at one another and shook their heads and walked away wordlessly. The women had had it. The women went on a giant fed-up march. The women were Facebooking and tweeting and going for long furious walks and giving money to the ACLU and wondering

why their partners and children didn't do the dishes more. The women were realizing the invidiousness of the dishwashing paradigm. The women were becoming radicalized even though the women didn't really have time to become radicalized. Arlie Russell Hochschild first published *The Second Shift* in 1989, and in 2017 that shit was truer than ever, or that's how the women saw it.

The dishes were really getting me down.

Even though I felt that I was as jam-packed with anger as one medium-sized human could possibly be, this feeling of rage was in fact growing and growing. It grew, initially, out of my status as a woman and a feminist. As I said, I felt personally affronted on that score. But my rage was casting its net wider; on wobbly-faun legs, my rage was going forth and finding new objects: the very systems that allowed inequity to flourish. Trump radicalized the right; what I was experiencing was a radicalization in another direction. A questioning of the status quo that was uncomfortable, even awkward.

Despite this growing bolus of opinion, of feeling, of rage, I was determined to try to come to *Manhattan* with an open mind. After all, lots of people think of it as Allen's masterpiece, and I was ready to be swept away. And I was swept away during the opening shots—black and white, with jump cuts timed perfectly, almost comically, to the triumphal strains of *Rhapsody in Blue*. Moments later, we cut to Isaac (Allen's character), out to dinner with his friends Yale (are you kidding me—"Yale"?) and Yale's wife, Emily. With them is Allen's date, seventeen-year-old high school student Tracy, played by Mariel Hemingway.

The really astonishing thing about this scene is its nonchalance. NBD, I'm fucking a high schooler. Sure, Woody Allen's character Isaac knows the relationship can't last, but he seems

only casually troubled by its moral implications. Isaac is fucking that high schooler with what my mother would call a hey-nonny-nonny. Allen is fascinated with moral shading, except when it comes to this particular issue—the issue of middle-aged men having sex with teenage girls. In the face of this particular issue, one of our greatest observers of contemporary ethics—someone whose mid-career work can approach the Flaubertian—suddenly becomes a dummy. Isaac makes a few noises about his ambivalence about the relationship: "She's seventeen. I'm forty-two and she's seventeen. I'm older than her father, can you believe that? I'm dating a girl, wherein, I can beat up her father."

But those lines feel like posturing in order to disarm the viewer, rather than doing any real work of interrogating the morality of the situation. The specific posture would be butt-covering. One senses Allen performing a kind of artistic grooming of the audience, or maybe even of himself. Just keep saying it's okay, until somehow miraculously it becomes okay.

I n high school, even the ugly girls are beautiful." A (male) high school teacher once said this to me. (He later mentioned that sometimes he had to go into the bathroom and jerk off because of those high school girls and their high school beauty.)

Tracy's face, Mariel's face, is made of open flat planes that suggest fields of wheat and sunshine (it's an Idaho face, after all). Tracy's character is written with a similar gorgeous plainness. Allen sees Tracy as good and pure in a way the grown women in the film never can be. Tracy is wise, the way Allen has written her, but unlike the adults in the film she's entirely, miraculously untroubled by neuroses.

Tracy is glorious simply by being: object-like, inert. Like the great movie stars of old, she's a face, as Isaac famously states in his litany of reasons to go on living: "Groucho Marx, to name one thing, and Willie Mays . . . those incredible apples and pears by Cezanne, uh, the crabs at Sam Wo's, uh, Tracy's face." (Watching the film for the first time in decades, I was struck by how much Isaac's list sounded like a Facebook gratitude post.)

Allen/Isaac can get closer to that ideal world, a world that has forgotten its knowledge of death, by having sex with Tracy. Not that she's a mere sexual object. Because he's a great filmmaker, Tracy is allowed her say; she's not a nitwit. "Your concerns are my concerns," she says, reassuring Isaac about the good health of their relationship. "We have great sex." This works out well for Isaac. He gets to hoover up her beautiful embodied simplicity and he's absolved of guilt.

The women in the film don't have that advantage. The grown women in *Manhattan* are brittle and all too aware of death; they're aware of every goddamn thing. A thinking woman is stuck—distanced from the body, from beauty, from life itself.

In *Manhattan,* Diane Keaton has grown up, swanned her way free of the bildungsroman of *Annie Hall.* Her Mary is a full-grown woman, and an intellectual at that. Allen's portrayal of her is a needling send-up of pretension—for instance, when he mocks her pronunciation of "Van Gogh," with its guttural, almost mucus-y hard *G* at the end. When she and Isaac are at an art opening, she asserts that a particular piece is "brilliant":

Isaac: The steel cube was brilliant?
Mary: Yes. To me it was very textual, you know what I mean? It was perfectly integrated, and it had a mar-

velous kind of negative capability. The rest of the stuff
downstairs was bullshit.

The joke is that Mary is *too smart.* Ha ha ha. This satire
might be funnier if it weren't contrasted with Allen's adulatory
vision of sweet uncorrupted Tracy. Of course Allen had lav-
ished his gaze on Diane Keaton in the past, but with complexity.
Annie Hall is a great film because Woody Allen built the thing
around one specific woman's shimmering, weird personhood.
He refracts some of his own humanity through Annie. Allen
gives the same attention to Tracy he once gave to Annie, but
because she's object rather than person, his vision ultimately
feels, to me, claustrophobic, constraining. I'm trying not to write
"pervy."

In *Manhattan,* the women are allowed to be beautiful objects
(Tracy's face finds its place in a litany with apples and crabs), or
they're frustrated, impotent, ridiculous—in short, caricatures.

The most telling moment in the film is a throwaway line
delivered in a high whine by a chic woman at a cocktail party: "I
finally had an orgasm and my doctor told me it was the wrong
kind." Isaac's (very funny) response: "Did you have the wrong
kind? Really? I've never had the wrong kind, ever. My worst one
was"—he wags his finger—"right on the money."

Every woman watching the movie knows it's the doctor
who's an asshole, not the woman. But that's not how Woody/
Isaac sees it.

If a woman can think, she can't come; if she can come, she
can't think.

· · ·

J ust as *Manhattan* never authentically or fully examines the complexities of an old dude nailing a high schooler, Allen himself—an extremely well-spoken guy—is wont to become inarticulate when discussing Soon-Yi. In a 1992 interview with Walter Isaacson of *Time* about his then-new relationship, Allen delivered the line that became explosively famous for its fatuous dismissal of his moral shortcomings:

"The heart wants what it wants."

It was one of those phrases that never left your head once you'd heard it; we all immediately memorized it whether we wanted to or not. Its monstrous disregard for anything but the self. Its proud irrationality. Woody goes on: "There's no logic to those things. You meet someone and you fall in love and that's that."

I moved on her like a bitch.

Things being what they were that summer, I had a difficult time getting through *Manhattan*. It took me a couple of sittings. I mentioned this difficulty on social media, this problem of watching *Manhattan* in the Trump moment. (I fervently hoped it was a moment.) "*Manhattan* is a work of genius! I am done with you, Claire!" responded a writer (older, white, male) I didn't know personally. This was a person who had remained silent in the face of many of my more outrageous social media pronouncements, some of which involved my desire to chop up the male half of the species, Valerie Solanas–like. But the minute I confessed to having a funny feeling when I watched *Manhattan*—I believe I said the film made me feel "a little urpy"—this man stormed off my page, declaring himself done with me forevermore.

I had failed in what he saw as my task: the ability to overcome my own moralizing and pettifoggery—my own emotions—and

do the work of appreciating genius. But who was in fact the
more emotional person in this situation? He was the one storm-
ing from the virtual room.

I would have a repeat of this conversation with many men,
smart and dumb, young and old, over the next months: "You
must judge *Manhattan* on its aesthetics!" they said.

I f it was hard to watch *Manhattan* because it was too close to
Woody's real-life creepiness, the opposite held true as well.
It was virtually impossible to watch *The Cosby Show* because
of how far beloved gruff Cliff Huxtable is from what we know
about Bill Cosby.

These conversations became more heated over the next
months. Maybe it just seems this way in retrospect, but there
was a feeling of water pushing at the dam, until it burst in Octo-
ber 2017. I often think about the strange fact that it was Harvey
Weinstein who brought us into this new era. It's not like we
were short on reasons to have a collective rage-fest: the Cosby
trial, as I mentioned, had been going on for some time; we'd also
had stories about Bertolucci, Roger Ailes, Bill O'Reilly, and of
course the seemingly never-ending Trump accusations.

Nothing seemed to happen, nothing seemed really to matter.
But, in fact, something had to matter, and it turned out to be this:
Weinstein. Jodi Kantor and Megan Twohey broke the Weinstein
story—a story of ongoing, systemic, repercussion-free abuse. For
some reason this was the story that turned the tide. The Me Too
movement had been in existence for a decade previously, founded

by the Black activist Tarana Burke as a support system (largely off-line, compared to what was to come) for women who'd been through assault and sexual discrimination. After the Weinstein allegations went public, the #MeToo hashtag became widespread within a matter of days after the actress Alyssa Milano used it in a tweet. The million tweets from the night of October 7, 2017, multiplied and multiplied again. In the next weeks came the accusations against Louis C.K., Matt Lauer, Charlie Rose, Al Franken, and men across all industries—including my own.

I complained earlier about the way the word "we" can be used to imply or even coerce agreement. This was another way the word "we" can be used. The word "we" can be an offensive strike on shame. It can be a magnifying glass, a megaphone.

In the aftermath, people were left wondering what to do about their heroes. My lonely purview suddenly became public domain. The "do we separate the art from the artist?" field opened up to include, well, everyone.

As I wrote in my diary when I was a teen: "I don't feel great about men right now." I didn't feel great about men in the fall of 2017, and a lot of other women didn't feel great about men either. A lot of men didn't feel great about men. Even the patriarchs were sick of patriarchy.

. . .

Not all of them, though! A male writer and I discussed *Manhattan* over dinner one night—at dinner in, appropriately enough, Manhattan. This writer was one of those men of letters who like to play the part, ironically but not—ties and blazers and low-key misogyny and brown alcohol in a tumbler. He always intimidated me a bit. We were dining in a cold, marble-lined, very expensive restaurant at the bottom of the Met Breuer. We were eating something more interesting than steak, something that runs or hops free through the meadows and the forests. We were basically at the pinnacle of civilization. Maybe we should've been more worried about our status as apex predators than what ought to be done about poor Mariel Hemingway.

I felt nervous, as if I were going to be found out. Found out as what? A woman?

Our conversation was like a little play:

Female writer: "Um, it doesn't really hold up."

Male writer, sharply: "What do you mean?"

"Well, it all seems a tad blasé. I mean, Isaac doesn't seem too worried she's in high school."

"No no no, he feels terrible about it."

"He cracks jokes about it, but he certainly does not feel terrible, or not terrible enough."

Male writer: "You're just thinking about Soon-Yi—you're letting that color the movie. I thought you were better than that."

The male writer was in august company. I'd studied literary theory. I knew that critics have been arguing the biographical fallacy for decades—the work of the New Critics, Americans writing mostly in the first half of the twentieth century, did a lot to promulgate the idea that the work ought to be fastidiously

divorced from its maker (recalling the nutty Protestant idea of *sola scriptura,* which asks that we treat the Bible as the sole source of all doctrine and practice—and we all know how that works out). In *The Well Wrought Urn,* Cleanth Brooks (possessor of the coolest name that's ever belonged to anyone who wasn't a blues musician) wrote that a poem ought to be considered apart from its historical—and therefore biographical—context, or at least that we ought to try to make "the closest possible examination of what the poem says as a poem." Which makes me want to respond like the snotty thirteen-year-old I used to be: As *if.* A professor of mine once gave a critique of the critique, saying that perhaps the New Critical severance of work from its maker had less to do with some moral or aesthetic ideal than with the fact that these critics were scattered across the American prairies, far from the libraries of Europe, not a primary source in sight. This historically shaped ideal reading is maybe part of why we now have dudes telling me how I ought to watch *Manhattan.*

But I didn't think about that in the restaurant that night. I wasn't thinking dispassionately. Quite the opposite. I didn't argue against the whole set-up. I didn't stop to question who was served by insisting that biography ought not to color our experience of the film. I could feel something wrong with the construct, but I hadn't thought about it very much, and also I'd had a martini. Instead, I sidestepped the issue. I mean, the female writer sidestepped the issue.

"I think it's creepy on its own merits, even without knowing about Soon-Yi."

"Get over it. You really need to judge it strictly on aesthetics."

"So what makes it objectively aesthetically good?"

Male writer said something smart-sounding about "balance and elegance."

There was a clink of silverware around the room, as if the knives and forks were having another conversation, a clearer and cleaner conversation, underneath or above the meaty human rumble, with its confusion of morals and aesthetics and feelings.

I wish the female writer then delivered some kind of coup de grâce, but she did not. She doubted herself.

Which of us was seeing more clearly: The one who had the ability—some might say the privilege—to remain untroubled by the filmmaker's attitudes toward females and his history with girls? Who had the ability to watch the art without committing the biographical fallacy? Or the one who couldn't help but notice—maybe couldn't help but feel—the antipathies and urges that seemed to animate the project?

I'm really asking.

And were these proudly objective viewers really being as objective as they thought? Woody Allen's usual genius is one of self-indictment, and in *Manhattan* he stumbles at a crucial hurdle of self-indictment, and also he fucks a teenager, and that's the film that gets called a masterpiece?

What exactly are these guys defending? Is it the film? Or something else?

I think *Manhattan* and its pro-girl anti-woman story would be upsetting even if Hurricane Soon-Yi had never made landfall, but we can't know, and there lies the very heart of the matter.

The men say they want to know why Woody Allen makes women so angry. After all, a great work of art is supposed to bring

us a feeling. And yet when I say *Manhattan* makes me feel urpy, a man says, *No, not that feeling. You're having the wrong feeling.* He speaks with authority: *Manhattan* is a work of genius. But who gets to say? Authority says the work shall remain untouched by the life. Authority says biography is fallacy. Authority believes the work exists in an ideal state (ahistorical, alpine, snowy, pure). Authority ignores the natural feeling that arises from biographical knowledge of a subject. Authority gets snippy about stuff like that. Authority claims it is able to appreciate the work free of biography, of history. Authority sides with the male maker, against the audience.

I noticed something: I noticed that I'm not ahistorical or immune to biography. That's for the winners of history (men) (so far).

The thing is, I'm not saying I'm right or wrong. But I'm the audience. And I'm just acknowledging the realities of the situation: the film *Manhattan* is disrupted by our knowledge of Soon-Yi; but it's also myopic and limited in its own right; and it's also got a lot of things about it that are pretty great. All these things can be true at once. Simply being told that Allen's history shouldn't matter doesn't achieve the objective of *making it not matter.*

I wanted to tell the story of the audience. The audience wants something to watch or read or hear. That's what makes it an audience. And yet, as I looked around, I saw that the audience had a new job. At the particular historical moment where I found myself, a moment awash in bitter revelation, the audience had become something else: a group outraged freshly by new mon-

sters, over and over and over. The audience thrills to the drama of denouncing the monster. The audience turns on its heel and refuses to see another Kevin Spacey film ever again.

It could be that what the audience feels in its heart is pure and righteous and true. But there might be something else going on here.

When you're having a moral feeling, self-congratulation is never far behind. You are setting your emotion in a bed of ethical language, and you are admiring yourself doing it. We are governed by emotion, emotion around which we arrange language. The transmission of our virtue feels extremely important, and strangely exciting.

Reminder: not "you," not "we," but "I." Stop sidestepping ownership. I am the audience. And I can sense there's something entirely unacceptable lurking inside me. Even in the midst of my righteous indignation when I bitch about Woody and Soon-Yi, I know that on some level, I'm not an entirely upstanding citizen myself. In everyday deed and thought, I'm a decent-enough human. But I'm something else as well, something more objectionable. The Victorians understood this feeling; it's why they gave us the stark bifurcations of Dorian Gray, of Jekyll and Hyde. I suppose this is the human condition, this sneaking suspicion of our own badness. It lies at the heart of our fascination with people who do awful things. Something in us—in me—chimes to that awfulness, recognizes it in myself, is horrified by that recognition, and then thrills to the drama of loudly denouncing the monster in question.

The psychic theater of the public condemnation of monsters can be seen as a kind of elaborate misdirection: Nothing to see here. I'm no monster. Meanwhile, hey, you might want to take a closer look at that guy over there.

. . .

This impulse—to blame the other guy—is in fact a political impulse. I talked earlier about the word "we." "We" can be an escape hatch from responsibility. It can be a megaphone. But it can also be a casting out. Us against them. The morally correct people against the immoral ones. The process of making someone else wrong so that we may be more right.

THE STAIN

MICHAEL JACKSON

I called these men monsters, and so did the rest of the world. But what did the word actually mean?

There were things I liked about the word: It is balls-out, male, testicular, old world. It's a hairy word, and has teeth. It's a word that means: something that upsets you. The dictionary has it as something terrifying, something huge, something successful (a box-office monster).

"Monster" took on new meaning for me after I read Jenny Offill's novel *Dept. of Speculation*—read, in particular, a passage about what Offill called "art monsters." This passage came to be much shared among the female writers and artists of my acquaintance: "My plan was to never get married. I was going to be an art monster instead. Women almost never become art monsters because art monsters only concern themselves with art, never mundane things. Nabokov didn't even fold his own umbrella. Vera licked his stamps for him."

I mean, I *hate* licking stamps. An *art monster,* I thought when I read this. Yes, I'd like to be one of those. My friends felt the same way. Victoria, an artist, went around chanting "art monster" for a few days.

The word "monster" was seeming more and more complicated—and yet, at the same time, it seemed too simple, too easy.

I began to push against the restrictions of the word and the way it (monster-like) stomped all over nuance. A monster, in this usage, is something other. A monster is not me, and not us. Monster implies—insists—that the person in question is so terrible that we could never be like them. Like him.

During that first bitter season of #MeToo, when victims were gathering strength from one another and making their accusations, a seemingly never-ending parade of monsters was marched through the public square. We began to see (though we'd always known) these men were everywhere. This meant that their victims, too, were everywhere. The more I thought about the silent, invisible hordes of victims, the more I began to think that the word "monster" puts the focus in the wrong place. "Monster" keeps the focus on them—the charismatic megafauna, eating all the air. It would be easy to list all the monsters and all the terrible things they did, but to what end? I wondered: wasn't calling them monsters, writing about their monstrousness, enumerating their monster sins, just a way of keeping them at the center of the story?

I myself was guilty of doing just that—I was the one, after all, who kept returning to Polanski over and over, using him as a kind of emotional straw man in my last book, and then circling around him again in this book, making him my monster.

The feminism I knew of was a feminism that found fault. That pointed—*j'accuse*. As I understood it, there were two ways of being: you could be a feminist who called men monsters, or you could ignore the problem. I considered myself a feminist, but at the same time I had an uneasy feeling that the pointing

was not the whole story. A feminism that denounced, that punished, was starting to feel like a trap. My feminism, which was in essence a liberal ideology, was coming into conflict with my increasingly leftist politics, my growing desire to look at a bigger picture of where and how material power coalesces. These two parts of my political self sat awkwardly, side by side. In any case, calling someone a monster didn't solve the problem of what to do with the work. I could denounce him all I wanted, but Polanski's work still called to me. This insistent calling— and my unwillingness to throw away the work—disrupted my idea of myself. It made me (and others) question my claim to feminism.

I had asked, at first, what we should do with the art made by monstrous people. But, as I thought about it more, I realized I wasn't looking for a prescription, exactly. I have published two memoirs, which means I am, I suppose, a memoirist, though it's a very uncomfortable label. As a memoirist, I struggled for years to separate prescription from description. Good memoir describes the writer's life; it doesn't tell the reader what to do with her own life. I was noticing that same impulse at work here: I was less interested in a clear-cut solution than in anatomizing the problem. What *happens* when we consume this work?

The word "monster" doesn't hold up well in the face of such dispassionate curiosity, such drive to understand. It starts to seem a little silly or overblown or, let's go all the way with it, hysterical.

And of course no one is entirely a monster. People are complex. To call someone a monster is to reduce them to just one aspect of the self.

(Which was perhaps part of Offill's point—women don't get

to be just this one thing: an art monster. They don't get to forget the rest of life.)

I realized that for me, over the past few years of thinking about Polanski, thinking about Woody Allen, thinking about all these complicated men I loved, the word had come to take on a new meaning. It meant something more nuanced, and something more elemental. It meant: *someone whose behavior disrupts our ability to apprehend the work on its own terms.*

A monster, in my mind, was an artist who could not be separated from some dark aspect of his or her biography. (Maybe it works for light aspects too. Maybe there are golden monsters. But it seems very unlikely, or at best very rare.)

These shortcomings of the word "monster" were clarified to me one day when I was messaging with a historian and music critic friend about the Michael Jackson problem. He wrote (in a telegraphic message-language that seemed elegant to me):

> i am currently trying to do the aesthetico-moral calculus thing re. MJ's music, like, is the Jackson 5 stuff okay? oh but then in a different sense that also involved child abuse or exploitation too—michael himself. how about the 'don't stop til you get enough', 'rock with you' era—surely he wasn't at it then? but does the stain work its way backwards through time? I expect in practice it'll be hard to resist the pull of the music when you hear it out and about. like with the Polanski films.

This image of the stain immediately took hold of my brain (an especially poignant image in the context of Michael Jackson and the bleached anti-stain of his skin).

The word "monster" is like a suitcase packed full of rage—the rage that gives rise to its utterance, the rage with which it is heard, whether by friend or foe of the monster in question. The stain is something else again. The stain is just plain sad. Indelibly sad.

No one wants the stain to happen. It just does.

I thought of the critic's note about Michael Jackson a couple weeks later, when I was eating breakfast at a diner and "I Want You Back" by the Jackson 5 came on. I bopped a little on my stool, I couldn't help it. It was exactly as my critic friend had said—I found it hard to resist the pull of the music, borne on the air. And yet the moment was ruined too. I was placidly forking hash browns and all the while feeling like something terrible was (sort of) happening.

That's how the stain works. The biography colors the song, which colors the sunny moment of the diner. We don't decide that coloration is going to happen. We don't get to make decisions about the stain. It's already too late. It touches everything. Our understanding of the work has taken on a new color, whether we like it or not.

The tainting of the work is less a question of philosophical decision-making than it is a question of pragmatism, or plain reality. That's why the stain makes such a powerful metaphor: its suddenness, its permanence, and above all its inexorable realness. The stain is simply something that happens. The stain is not a choice. The stain is not a decision we make.

Indelibility is not voluntary.

When someone says we ought to separate the art from the artist, they're saying: Remove the stain. Let the work be unstained. But that's not how stains work.

We watch the glass fall to the floor; we don't get to decide whether the wine will spread across the carpet.

The stain begins with an act, a moment in time, but then it travels from that moment, like a tea bag steeping in water, coloring the entire life. It works its way forward and backward in time. The principle of retroactivity means that if you've done something sufficiently asshole-like, it follows that you were an asshole all along. This cool-sounding formula codifies what I have hotly lived. My own life has shown me that a current moment can remake the past anew, can imbue the past with new truth. A woman says what happened to her, an abuse is revealed, and the stain travels backward, affecting and defining the perpetrator not just at the time of the abuse, and not just after the abuse, but before he committed the crime. Our knowledge of the crime affects the person he was all along. The knowledge is a time traveler—because our idea of that person is affected by our new knowledge.

Strange idiosyncratic personal rules arise from such knowledge—I personally have a much easier time watching films that Polanski made before he raped Samantha Gailey. And yet, at the same time, Polanski—predator, rapist—collapses into Polanski, preternaturally talented Polish art student, *wunderkind*, Holocaust survivor. When we stream *Knife in the Water,* we wish we could give our few dollars to that blameless young Polanski. We wonder: how can we bypass this terrible old criminal? We can't. We can't even bypass our knowledge of what he's done. We can't bypass the stain. It colors the life and the work.

Does the stain go so far that it touches the child who will become the monster? And what about that child's own experience of having things done to him? As my critic friend pointed

out, the child MJ grew up in an exploitative milieu. That exploitation travels through time too—travels forward. We call it causality. We yearn for a reason behind the terrible acts of men, and we rest in the explanation. We tell ourselves: MJ's crime grew out of his exploitative childhood; Polanski's crime grew out of his survival of the Holocaust and the grisly murder of his wife; R. Kelly's crime grew out of his own (probable) childhood sexual abuse. In this way we explain the monstrousness.

In any case, we're left, like it or not, with the stained work. The deed colors all it touches. (And at the same time, "I Want You Back" sounds as good as it ever did.) None of us *want* to know the things about Michael Jackson that we know. We wanted to keep loving him. When the *Leaving Neverland* documentary came out, no one really even wanted to watch it. It was a dreary task we thought we ought to do. We felt we should witness the survivors and their stories. (But why am I resorting to "we"? Because it felt like a shared responsibility?)

Too weary of monstrousness, of stains, for months I didn't watch that documentary. But nevertheless I knew what it contained—the information came to me the way information does now, through the internet, which means less that I somehow consumed it than that it happened to me or that it entered my skin on a pore level or that I breathed it in like a vapor. The confirmation of Jackson's predation was something that I received whether I liked it or not. Now I knew. Did I want to know?

The problem is, we don't get to control how much we know about someone's life. It's something that happens to us. We

turn on *Seinfeld,* and, whether we want to or not, we think of Michael Richards's racist rant. This movement toward knowingness began with the birth of mass media, grew in the last century, and has flowered in our moment. There is no longer any escaping biography. Even within my own lifetime, I've seen a massive shift. Biography used to be something you sought out, yearned for, actively pursued. Now it falls on your head all day long.

When I was young, it was hard to find information about artists whose work I loved. Record albums and books appeared before us as if they had arrived after hurtling through space's black reaches, unmoored from all context.

We bought albums for no better reason than the fact we liked their covers. We lost hour after hour at the record store, flipping through the bins until something—a font or a photo or a mood—caught our attention. An album was an inscrutable object. If it wasn't worthy of *Rolling Stone* or NME's notice, then it was well-nigh impossible to know what exactly you were holding in your hands.

Biography was elusive. A friend tells of haunting the bookstore as a child in the late 1970s and early '80s, hoping, hoping there would be a new book about the Beatles. But there never was.

It was hard even to find the art itself. You had to hunt. We had a vague unsettled sense there was art occurring, if you could only get your hands on it. Maybe it felt different in New York or some other capital, but in Seattle—a briny backwater—you sort of groped your way toward cultural knowledge.

Certain documents that gave you information about art were imbued with an almost occult power.

Friends sent postcards of paintings they'd seen at faraway museums; these were hoarded and pinned to my bulletin board.

In my dorm room at college, I kept on my desk a biography of Diane Arbus, a book I handled like a fetish object. She'd been a *person*. Imagine that.

As a teenager, I got a job at the newsstand in Seattle's University District. Between customers I endlessly thumbed through the British magazines *NME* and *Melody Maker* and *i-D*, looking for signs of life (and music) elsewhere. Occasionally I purchased a copy, and hung on to it for months or years.

From my high school history teacher, I borrowed—okay, stole—a copy of the cultural history *Fin-de-Siècle Vienna* by one Carl Schorske. This was another fetish object. Remember, you could not see images of art on the internet. Carl Schorske was as a god to me. A cultural historian. It sounded like a dreamy way to spend one's life. I ran my fingertips over the reproductions of Klimt and Schiele paintings, images that had not yet become shopworn by millions of clicks.

Most of what I knew about movies I learned from my obsessive reading of the newsprint calendar from the Neptune repertory theater. Each calendar day got a little square describing the scheduled screening; from that grid, with its tight little paragraphs, I learned about George Cukor and *Eraserhead* and Sam Peckinpah and *I Am Curious (Yellow)*. Every repertory house in every town in the country had these posters, I would learn later when I went away to college. In good liberal homes from Newtonville to Palo Alto, the two-tone calendar from the local art house was magneted to the refrigerator; the light stuff of the newsprint flapped in the slightest breeze.

Such documents were important in finding out about the

mere *existence* of works of art, let alone the biographies of their makers.

That's not how it is anymore. Now it seems impossible to shake work loose from biography. We swim in biography; we are sick with biography.

This is a modus vivendi for contemporary artists—an artist like, say, Harry Styles must maintain whatever mystery he can in the avalanche of information that has been shared about him over the past decade. Indeed, what mystery he possesses comes from our knowledge of the wondrous fact that there's an actual person, a *soul*, hidden somewhere in the midst of all this information.

This biographical reach extends to older artists as well. Now my Beatles-mad friend can know anything at all that he would like to know about the Beatles, from the outré to the mundane. Would you like to know the precise location of John's great-grandfather's wedding? That can easily be provided to you.

Does this knowledge improve my friend's experience of his beloved music?

Everything is everyone's business—there's a market for every piece of information, just as (not coincidentally) there's a market for every kind of porn.

And perhaps I come to you with my own kind of stain—the stain of being a certain kind of white middle-class feminist. Maybe you think my solutions will be typical of such a person. Maybe I thought the same thing. Maybe I assumed at first that my findings would reassert the tenets of liberalism. Maybe we'll both be surprised.)

. . .

The inevitability of monstrousness is a central occupation of the internet, which hums along, fueled by biography—the internet is made of disclosure about ourselves and about other people's selves. The very phrase "cancel culture" presupposes the privileging of biography—a whole idea of *culture* built on the fact that we know everything about everyone.

We live in a biographical moment, and if you look hard enough at anyone, you can probably find at least a little stain. Everyone who has a biography—that is, everyone alive—is either canceled or about to be canceled.

The stain—spreading, creeping, wine-dark, inevitable—is biography's aftermath. The person does the crime and it's the work that gets stained. It's what we, the audience, are left to contend with.

THE FAN

J. K. ROWLING

A truism of our moment in history is that we live in the time of the fan. As biography rises, as its shadow called cancel culture escalates, fan culture also ascends. In the accelerated endgame of the age of mechanical reproduction, the fan is both debased and exalted. The work, designed to be reproduced, needs a large body of consumers. The "I" of the audience must become "we" in order for the market to work. As fans, we are crucial and yet not special. We are never alone; we are in a crowd. Our tears for the Beatles were always collective tears.

Despite the fan being necessarily part of a multi-unit organism, she believes herself to be uniquely intense in her fandom. An audience member is a consumer of a piece of art; the audience member is not *defined* by that piece of art. A fan, on the other hand, is a consumer plus, a consumer beyond, a consumer who is also being consumed. She steals part of her identity from the art, even as it steals its importance from her. She becomes defined by the art. A fan has a special role and bestows upon herself a special status. (A status that culture producers are happy to co-opt, distribute, sell, monetize.)

． ． ．

I t is a commonplace of our era to become "obsessed" with things. "I'm obsessed with the early novels of Iris Murdoch." "I'm obsessed with the brisket at Phở Bắc." "I'm obsessed with this eyeliner."

In this construction, obsession has a very specific function: to indicate our special status as the most intense appreciator of this particular thing/work/item. It means I am a fan, a super-fan, an intergalactic fan, I am verily defined by this thing, it is my personality, it is me, I am it. What you like (i.e., what you consume; i.e., how you participate in the market) is not just more important than who you are: the two things are one and the same.

This usage is a denatured version of obsession. It's not the obsession I've known all my life. It's not *real* obsession. Real obsession is a thrum in your head that won't go away no matter how hard you try to banish it. It's a well you fall down, with no hope of climbing out. It's an illness that feels terminal.

Obsession, real obsession, is not how you feel about labra-doodles or Cool Ranch Doritos or even something truly great, like the poems of Richard Siken. Real obsession has tendons and guts and, and, and *consequences*.

This new usage wants to steal the stakes of real obsession, and apply those stakes to something consumed. As a dedicated obsessive, I resent this!

Yet this fandom, mysteriously, doesn't make us more likely to prioritize the work over the biography. When what you like becomes important, becomes defining, becomes an obsession, then an artist's biography has even more power than before. You

have not just admired, not just consumed the art, you've become it. And therefore you have some new, much closer relationship with its maker. We, the fans, perceive ourselves as allied with the artists. And so biography isn't just omnipresent, it's actually important. The stain comes to have meaning in our lives; we feel . . . some kind of way about the stain. We feel hurt.

The importance of our relationship with the artist's biography is reaffirmed everywhere and all the time. Its signal quality is *intimacy*.

The knowledge we have about celebrities makes us feel we know them. We feel we have the right to some intimate access to them. This feeling, I've observed, has only grown with time. Every year we are on the internet, we grow more enmeshed with public figures.

The phrase "parasocial relationship" is a previously somewhat obscure sociological term that has been batted about the internet with greater and greater frequency—a spreading usage reflecting the increase in the phenomenon it describes: the belief that we have real emotional connections with the artists whose work we love.

We all know how this feels. It's a different feeling from simply loving an artist's work—it's the feeling that you know this artist personally, as a friend, and, what's more, *they possess the same knowledge of you.* You are immersed in their biography and by some strange irrational emotional logic you believe that they too are immersed in your biography. It's a piece of obviousness that the internet has exacerbated this false-yet-extremely-real-feeling connection; indeed, it could be said that this feeling of

connection is the main product of social media; the commodity it is selling and re-selling.

If that sounds creepy, it is, a little. This intense engagement with the biographies of the famous can be fun, but, like many fun things, it isn't necessarily healthy. In a 2010 paper on the nature of parasocial relationships, the sociologist John Durham Peters explores the way the phenomenon arose in the era of broadcast journalism. Radio and TV broadcasters seemed to be directly addressing each person in the audience—a kind of address that was a break, historically speaking, from previous forms of public speaking, when a speaker or actor would address a crowd en masse. It was hard not to feel these broadcasters were speaking directly to you! Peters delivers a stunningly deadpan line: "How we take broadcast personae is a measure of mental health." In other words, our brains aren't necessarily well equipped to handle this feeling of being spoken to directly even as the speaker is actually addressing multitudes. Combined with our extensive knowledge of celebrity biography—knowledge we inhale as much as acquire—this leads to massive category errors.

We now exist in a structure where we are defined, in the context of capital, by our status as consumers. This is the power that is afforded us. We respond—giddily—by making decisions about taste and asserting them. We become obsessed with this thing, mega-fans of that. We act like our preferences matter, because that is the job late capitalism has given us. And here's the funny thing—our choices and our preferences *do* matter, because something has to. Our selves are constructed from the shitty stuff of consumption, but we remain feeling people nonetheless. We feel things about people who don't know us (and, like protagonists in a terrible late-capitalist love triangle,

they themselves are probably busy feeling things for people who don't know *them*).

The idea of connecting with the other in a bodiless fashion (the basis for the entire internet economy) has been the dream of technology since its earliest days. According to Peters, the early pioneers of radio technology were preoccupied with how transmissions could flow directly from one brain to another.

The ideal, for early technologists, was telepathy: the ethereal transmission of thoughts, the most elegant solution possible to long-distance human connection (or any human connection). All distance between us, collapsed, just like that.

The problem with broadcasting, or with art, is that the flow only occurs in one direction. From the speaker to the receiver; from the artist to the audience. Telepathy, perfect union, is what we seek. Art—unlike broadcasting or the internet—becomes a *meaningful* stand-in for that union. The artist undergoes the rigor of making, and that creates the conditions for the audience to consume. The audience member sets aside her own ego, her own self, and participates in the dream built by the artist. There is a right relationship there—the relationship takes place on the page or the canvas. Parasocial relationships don't operate in that way, though. They create a state of confusion in the consumer: a belief in a relationship that exists outside the art.

We're all wandering around in a mistaken daze of failed telepathy.

This can benefit the artist (she sells more books); but mostly it benefits tech behemoths that monetize these relationships and—in the words of the social psychologist and philosopher Shoshana Zuboff—use your information to trade on "behavioral futures markets." In this sense, all of us who participate in para-

social relationships are workers creating money for somebody else.

This dynamic makes the stain more destructive—the more closely we are tied to the artist, the more we draw our identity from them and their art, the more collapsed the distance between us and them, the more likely we are to lose some piece of ourselves when the stain starts to spread.

In the first two decades of this century, the Harry Potter books took over children's imaginations. That's an easy way of saying something more poetic, more difficult, stranger. Children who came of age in the aughts and the teens (and even now) had their imaginations, their dreams, their very sense of themselves invaded by Harry Potter.

I was the parent of one such child. I accompanied my child to midnight drops of new HP titles. I attended Harry Potter conventions. (Hard to imagine a more delightful sight than the bland corporate halls of the Oregon Convention Center filled with shrieking eleven-year-olds swooping around in cloaks.)

My kid barreled through each book as it was released, then read and reread until it became a part of her. I read more slowly, and even more slowly still I read each book out loud to the youngest child in our family. So I read Book One at the same time that I was reading, say, Book Five, and could see how Rowling had seeded elements of the later books' plots right from the beginning. The reader is left with a sensation of an ordained universe, a place where things make sense if you just pay attention. It's

easy to see how appealing this could be for young readers—especially for YA readers, people who might be starting to feel that the world doesn't make sense at all.

Also addictive were the books' two systems for ordering people. First you divide the muggles from the wizards, then you divide the wizards into houses. Everyone is chosen. Everyone has a special identity. It speaks to the same drive that makes adults take Myers-Briggs tests, an endless fascination with the parameters of one's own selfhood—and that fascination is rewarded with the fantastical idea of belonging to an imagined tribe of people (or wizards) who also hew to those same parameters.

In other words, the books offered a navigable system for belonging—alluring, perhaps especially, for a person who didn't entirely feel like she belonged in the real world. Which describes a lot of preteens, and especially a lot of preteens with a dawning sense of their own queerness. Harry Potter fan-ship twined with the growth of the Tumblr platform, which in turn twined with the growth of a new kind of LGBTQ+ movement . . . kids who found solace in un-embodied community, whether it was Hogwarts or online. It wasn't quite telepathy, but it was the dream of telepathy.

Reading has always been a one-way communion, but the kids in question solved that by talking back—to each other. They wrote endless fan fiction, reams and reams of it. They created their own art in response to Rowling's work. They gave birth to a Potter-centric DIY movement where they were in artistic conversation with the books: I took my kids to Harry and the Potters shows—the band that founded "wizard rock" or "wrock"—and to live performances by Potter Puppet Pals, an online parodic series spinning off from the books.

This was all done with silliness but also great seriousness. I remember one particular performance by Harry and the Potters, an actually really great band led by two brothers who mostly sang their (very funny, very catchy, somewhat punk) songs from the point of view of Harry himself.

On an August afternoon I stood in the back of a small, hot, airless box of a venue in Olympia, Washington, filled with hipster parents and their kids. The kids in the audience were wild with happiness, singing along to every song, vowing to fight Voldemort's agents of darkness, joyfully overheated in their capes and their long Hogwarts scarves.

I happened to lock eyes with the singer at one point. I gave him an indulgent, conspiratorial smile, as if to say, *Aren't these kids and their Harry Potter obsession adorable?* He stared back at me stonily—his look said he was utterly committed to the collective fantasy the room was having. There was nothing adorable about it—it was serious stuff. Something useful and real and powerful was happening there—something that was helping these kids. (One of the brothers went on to join the queer communist hardcore band Downtown Boys, which makes perfect sense on further reflection—Harry Potter culture was, in many ways, about stickin' it to the man.)

The notion of belonging to a club—the notion of *having been sorted*—tied these children and young people together in shining bonds of connection. They reached each other box to glowing box throughout the night. This is a common story for us all, of course. We're doing our best to practice telepathy, living up to the legacy of Alexander Graham Bell. But for these kids—especially these queer kids—the Harry Potter fandom was an intensified kind of identification, and it took place in an imag-

ined world whose geography was as real as—realer than—that of the world where they lived.

I n 2021, J. K. Rowling began to signal that she was aligned with the growing "gender identity" movement in England. Rowling argued that gender was determined by sexual organs, and moreover that denying this truth endangered the lives of girls and women. Rowling wrote a statement on her website worrying about " 'inclusive' language that calls female people 'menstruators' and 'people with vulvas.' " She argued: "I want trans women to be safe. At the same time, I do not want to make natal girls and women less safe. When you throw open the doors of bathrooms and changing rooms to any man who believes or feels he's a woman—and, as I've said, gender confirmation certificates may now be granted without any need for surgery or hormones—then you open the door to any and all men who wish to come inside."

The backlash across the internet was a great fury. Many of the former Potter kids were trans and they were rightly very angry. But underneath the fury was a deep sadness; the sadness of the staining of something beloved. Rowling's tale of a place where otherness was accepted didn't in the end include them.

I f you are a trans person, or love a trans person, or simply disagree with Rowling's language, what then to do with that part of your childhood that had become intertwined with Harry Potter? Children had been part of a mass marketing phenomenon—after all, were the HP books really any *better* than, say, the witchy

novels of Eva Ibbotson? These kids were scooped up in a dream that had been rocket-fueled by the internet and by the coalescing power of capitalism. The good news was that it was a dream of love—that was what the Harry Potter books were ultimately about: a dream of a place where outsiders were accepted and where love triumphed over evil.

Some of these children grew up to be adults whose dreamscape was taken away from them. Did they lose an imagined landscape where great swathes of their childhoods had been spent? I'm picturing a hillside, strip-mined.

I wondered, too, about shame. The threat of being shamed lurks at the edges of all of internet life. What role does shame play in this dynamic between fan and fallen artist? *Shame* is noun and verb; it's something I can feel inside myself, but it's also something I can do to you. When we love an artist, and we identify with them, do we feel shame on their behalf when they become stained? Or do we shame them more brutally, cast them out more finally, because we want to sever the identification? Maybe shame is the ultimate expression of the parasocial relationship. Our emotions, collapsed together with those of the artists we love, leave us vulnerable in ways that are entirely new in the internet era. No wonder we don't know how to behave in this new landscape, or even how to feel.

CHAPTER 4

THE CRITIC

When I was in seventh grade, I had an English teacher we'll call Ms. Smith. Ms. Smith was in possession of a tweed blazer and a halo of chicly permed brown hair and a lot of vinegary opinions. She looked like she might smoke the chalk. She purported never to read bestsellers. I didn't realize it at the time, but she was the first female intellectual I ever met, and it would be a long time before I met another.

I think maybe Ms. Smith is the person who made me that weird beast, a professional critic. Partly because of the allure of her opinions, glittering and hard, tossed carelessly before us seventh-grade swine—but also because of something she said to me one day after class. Leaning back in the chair behind her desk, her tone not at all gentle—rather, sharply observant—she said, "Claire, you think about a situation or a person or a book as hard as you can and you keep thinking about it and you don't stop until you find something wrong with it. You might find that difficult as you go through life."

This she said to a doughy twelve-year-old child dressed in yellow Dickies painter's pants and a baseball jersey. I am cer-

tain I stared at her speechless from under my enormous mop of tangled, unbrushed hair. But I never forgot what she said. Did she see something true in me, even then, something restlessly critical, or did she make me a critic with those words, cursing me as if she were an evil fairy?

This is how the memoirist and essayist Vivian Gornick describes her own relentless critical faculty: "My voice, forever edged in judgment, that also never stops registering the flaw, the absence, the incompleteness."

This is the voice I would grow up to possess. But it's not exactly the voice of authority. Just a never-ending flow of judgment, which nestles together with subjectivity.

The emotional aspect of the consumption of art seemed more and more important.

I was beginning to feel that I wasn't going to solve this problem of monstrous men by thinking. In fact, I was beginning to wonder if it might be solved instead by feeling. Not by referring to authority, but by referring to my own subjective responses. I needed to be more like those kids at the Harry and the Potters show, giving myself wholeheartedly to the experience.

This tension between authority and subjectivity has marked my whole life as a critic—which is to say my whole life—as Ms. Smith so rightly (if inappropriately) observed.

In my mid-twenties, I started my career as the film critic for the local alternative paper—a high-profile job for a young

woman. My real colleagues were not the staff at my paper, but
the film critics for the other Seattle papers. We met most week-
day afternoons in a secret little red velvety screening room hid-
den underneath the Seattle Opera offices—a door floating in the
sheer side of an anonymous-looking building; you clambered
down there on a metal staircase that grilled the wall like a set of
braces. A nearby candy factory off-gassed the grandma smell of
butterscotch—an old-fashioned smell, and going to the movies
was becoming an old-fashioned activity. Cinema appeared to be
concluding right at that exact moment. We were a secret cabal,
practicing a dying ritual.

In the screening room, the front-row center seats belonged
to the two daily papers, papers given human form in the persons
of two white men of unblinking mien. We lesser beings, repre-
senting publications of smaller circulation, sort of salted our-
selves back from there. To a man, each arranged himself in the
exact same pose: slouched down in seat, head propped in hand,
as if they were all too ennui-ridden even to hold upright their
respective bearded noggins. They all remained stuck in that pos-
ture for the duration of the film. If it was the funniest movie
ever, they might give a tiny involuntary smile-less shudder. If it
was the scariest movie ever, they kept their eyes open extra wide
and remained motionless, to show they could take it. I always
sat toward the back, popping snacks and cracking up and cover-
ing my eyes during the scary bits. I knew I was supposed to be
a cultural arbiter, but I kept slipping up and being the audience.

I tried to hold still and focused on remembering to scribble
my notes. This was before the internet; my reviews were built
on whatever I walked out of the theater with. The fact was, I
had to tank up on quite a bit of coffee to do my job. Though I
had what is pretty much the textbook definition of a fun job,

I sometimes grew weary of film, I'll be honest. I got sleepy. The film critic life was not the life for me. My co-critics said things like: "If you sit here long enough, all of life will pass before your eyes." I wondered what the point was of sitting in the dark and waiting for life. Why not just go out and, you know, live it. Cut out the middleman. I grew tired of having my days filled with night. But then something would happen—a movie would give me something that was not life exactly, but life with extra light-bulbs turned on.

In any case, I somehow never was able to transcend the sense that I was an audience member, rather than a professional.

I was young—young enough to stumble out of the darkened theater on glittery platform heels, to live on popcorn, to worry what the boys might think. Seattle, then, was still a boys' club. This was the mid-nineties, when the city was in a growth spurt, like an awkward teenager—suddenly famous. Even so, it was the same old town where I'd grown up, a town where boys did things and girls watched. I dimly intuited that my authority was undermined by my very girl-ness. And maybe it was true. Or maybe my authority was undermined by my stubborn sense of myself as an audience member.

I struggled with the problem of authority. I was supposed to tell readers what now? I was supposed to tell them what to think? How on earth did I know what they ought to think? And why should they listen to me? I was a person who'd watched a lot of movies, sure. I had taken a couple of film theory classes in college because it seemed like something you should do if you wore as much black as I did. But I'd been hired for my writing. I could write well, and so I was given this plum job. But how on earth did that qualify me to opine? What was my job, exactly?

Over cheap take-out teriyaki, I wondered aloud about all this to an older film critic, who patted me a little impertinently, told me I had a great raw talent, and gave me a copy of Andrew Sarris's book *The American Cinema*. How happy I was to receive that book! Now I would be able to study up on how to have authority.

The American Cinema is not a book to be read, exactly, and I found it resistant to my attempts. I ended up installing it next to the bathtub, where I was eventually able to polish it off in a series of grim, damp tussles. Sarris is the person who took the French term *auteur* and applied it to American moviemaking. Sarris's book introduced auteur theory to film enthusiasts in 1968, making way for the idea that a film had an author—the director—who could and should be venerated.

The thing was, I couldn't find a truly operational theory in the book's pages. Theory and her earnest, helpful twin sister praxis, that was what I was after. Something to let me know how to proceed, critically. I all but held the book upside down and shook out its pages, but no helpful strategies fell out of it. I pretzeled myself trying to understand this so-called theory and how the theoretical might be applied to the actual films I was viewing, which were largely Tarantino-inspired rip-offs involving car chases, girls in brown matte lipstick, and pistol whippings. (I chose a really miserable time to be a critic—it seemed like in the mid-nineties every single film released had a pistol whipping in it. You're watching a romantic comedy—suddenly a pistol whipping! Musical—pistol whipping!)

Surrounded by male critics, watching mostly films made by men, my brain stuffed with auteur theory (not actually a theory), I felt my job was in service to the great man. The auteur or the director knew something I didn't; it was my job to correctly read

his meaning and then explain it and why it was important to the audience.

(This was for art films. Hollywood films I was supposed to make fun of. Though the serious critics allowed themselves, even prided themselves on, occasional shocking counterintuitive bursts of support for some mainstream gem. "*Tin Cup* is the film of the decade!" The trick was to reference either Howard Hawks or Douglas Sirk.)

Anyway. This was how critic culture worked. It was not just that you, as a critic, were dispensing opinions. You were also a kind of priest, channeling and translating the word and the work of the he-man auteur.

liked a film by Julie Dash once, and a male critic said sneeringly, "I see you went for that." Fell for it, was the implication. The critical stance was one of great suspicion. As far as I could tell.

Love, hate, feelings—this was not the stuff of criticism as it was practiced by the other critics. What they were after was authority. For my part, I groped for it but it eluded my grasp.

n lieu of authority, I learned a structure for reviewing: What is the film trying to do? Does it succeed? Was it a worthy objective in the first place? This critical structure has been in place for a long time. As early as 1819, the Italian poet Alessandro Manzoni was neatly articulating the problem of the reviewer, in his preface to his tragedy in verse *The Count of Carmagnola:* "Every work of art provides its reader with all the necessary elements with

which to judge it. In my view, these elements are: the author's intent; whether this intent was reasonable; whether the author has achieved his intent."

This trinity of questions, a sturdy and seemingly eternal three-legged stool, is a useful structure for reviewing. But does it actually bring us any closer to objective truth about a work? The three questions attempt to anatomize the process of determining whether or not a work of art is great. Our typically messy, emotional responses to art—picture me squirming in my theater seat—are thereby put through a formulaic process for determining quality, so that we may authoritatively proclaim and feel secure in that proclamation.

And yet. Even armed with my Three Useful Questions, I found it hard to make critical pronouncements. The other critics seemed to make pronouncements all the time. This was the best, that was the worst. This was worthy, that was not. You went for *that*?

Me, I wasn't able to muster such surety. I thought this was because I simply was doing it wrong. I felt stuck in my own subjectivity, unable to ascend to empyrean heights of critical authority. I knew I was different from the other critics, and I thought my difference was something to be hidden. My subjectivity seemed incontestable, yet shameful. I couldn't get past it, or gainsay it, or pretend it didn't exist. Without thinking it through, I foregrounded the "I" in my reviews, undermining my authority even as I asserted it—these were just the thoughts of one person, is what the "I" said.

(When I started writing criticism for *The New York Times*, the august editor of the *Book Review* told me I was not allowed to use swear words and moreover the pronoun "I" was strongly

discouraged. He was eager to see how I'd manage; probably not well, his tone implied.)

I didn't see it at the time, but this "I" was a reaching for an authentic, maybe even heartfelt, response to the work. A desire to reflect on the page the emotions wrought in me by the work, with an understanding that my emotions, my experience, are not yours, and yours are not mine.

In fact, I was arriving at this "I" via a critical tradition, though I felt like its misbegotten bastard child. The critical writing I loved as a reader was relentlessly, proudly subjective. From the time I was a kid, I read critical writing compulsively, looking for that little frisson of recognition that came when the critic described something I'd felt. As a preteen, my favorite writer was Pauline Kael. She took the material I was consuming and reflected it back to me.

When a character in a novel or even a memoir thinks as I think, behaves as I behave, acts as I act, it doesn't stop me short or amaze me. I just barrel along with my reading and don't give it another thought; the story is all. But when a critic does that—articulates my own feelings or responses—it has always jostled me, excited me, moved me. Probably because critic and reader share the same experience. They (we) watch the same movie, read the same book. The frame of reference and the landscape are entirely shared. That knowledge of shared experience has always made reading criticism an intimate act for me. I and a faraway stranger have consumed the same art—in my case, usu-

ally gripped more by feeling than by thought—and then I get to have my feelings explained to me. There's real pleasure and even consolation in this.

This pleasure—one of my deepest reading pleasures—gets its charge from subjective writing. The intimacy—the thrill— doesn't come when a critic is acting as arbiter or judge. Michiko Kakutani, for instance, has never mitigated my particular loneliness, not even a millimeter. There are other, sportier pleasures to this more judging-centric kind of criticism, which often gets described with the language of action. The critic who is an arbiter *does* stuff: takes down a beloved writer; elevates an unknown. As a reader of such criticism, I'm happy enough to spectate the action. Like I said, it's a sport. But it doesn't do this other business of including me, sharing with me, connecting me to my own responses and feelings.

I didn't know it when I was a young critic, but I now know this: my subjectivity is the crucial component of my experience as a critic, and the very best thing I can do is simply acknowledge that fact. It was a hard thing to learn, as a young female surrounded by men who saw their role differently. Indeed, they never had to question their subjectivity, because of course it was perceived as the universal, default point of view, and often as not the same point of view as that of the artist himself. Hence they were able to make pronouncements that, when examined closely, have the whiff of insanity about them. "Definitive," "finest," "best of the decade"—it's bananas to make such statements.

I stated earlier in this book that *Annie Hall* is the greatest comedy of the twentieth century. I wrote that as a silly kind of joke on the whole idea of critical authority and objectivity. I don't really believe such things are knowable.

. . .

We are all bound by our perspectives.

Authoritative criticism believes in the myth of the objective response, a response entirely unshaped by feeling, emotion, subjectivity. A response free, in fact, of any kind of personal perspective. For the male critic, there's no need to question that response because the work is being made by someone *like himself.* The work is transmitted from one type of artist (that is, male) to the same type of viewer (also male). The artist has an ideal audience; the audience has an ideal artist; the rest of us are outside of that dyad. Not excluded; but not of the dynamic.

Of course we can do the same: we can make art centered around our own experiences, and leave out the men who've been centralized for so long—and they still won't understand that their point of view is non-central, one of many.

I thought of this in 2018, when a kerfuffle was unleashed by the BBC's comedy controller, Shane Allen (I love that the Beeb has a comedy controller, a laffs czar). Allen said, "If you're going to assemble a team now, it's not going to be six Oxbridge white blokes," referring to Monty Python. "It's going to be a diverse range of people who reflect the modern world." Monty Python's Terry Gilliam responded vehemently, saying, "I no longer want to be a white male, I don't want to be blamed for everything wrong in the world: I tell the world now I'm a black lesbian." John Cleese accused Mr. Allen of "social engineering." But of course giving a group of white male fancy-pantses all the breaks for years is the ultimate social engineering. Listen, I'd rather watch the Pythons than Gadsby any day of the week, but the point is this: None of these guys has the bandwidth to even entertain the

idea that a woman's or person of color's point of view might be just as "normal" as theirs, just as central. They seem incapable of understanding that theirs is not the universal point of view and that their own comedy has left people out. That exclusion is not necessarily a problem for me, it's just a fact. As lifelong excluders, they shouldn't use their own (ridiculous) feelings of exclusion as a critique of the work of people who look different from them.

The female artist—the female—yearns to see herself as an actor on the field. Yearns for examples. Same for the Black artist, the queer artist. The Pythons hadn't spent years looking for a face like their own. That's how I felt when I was a kid. I ached to learn about real females who did things. Everyone who was a girl in the 1970s knows this feeling: running your hand along the spines of biographies in the school library, looking for any title at all about a woman, and winding up reading about . . . Clara Barton? Fine, okay, Clara Barton. If that's all there is.

A Black friend recently got up from the table in the midst of a conversation about monstrous artists, saying simply, "What do I care? When I was a kid, I never read anything about myself. I never saw myself. I spent my whole childhood being asked to read books where there were no Black people." That's not bias; that's understanding that she's been excluded from the conversation. That's an acknowledgment that the work is neither for her nor written by someone like her.

The old-fashioned critic, like the Pythons, can't see that he's part of a group, because he's never been left out. He feels unbounded by his own biases; the critic doesn't even understand he has biases.

There's a perfect example of this in an aside in Richard

Schickel's really upsetting 2003 book *Woody Allen: A Life in Film.*
Schickel deals not at all with the idea that a woman's response
to Allen's work might be different than a man's. The idea that
the female response might be an important one—might, gasp,
be the primary one—is totally beyond the critic. At one point
he's talking about the great tolerance that has developed among
his generation—a generation that "can sympathize with, say,
feminism." This othering of feminism perfectly demonstrates
the total inability of the arbiter to understand that his point of
view is contingent upon his own extremely limited subjectivity.
It would never occur to him that his point of view might even
be, now or one day soon, non-dominant. He has not even con-
sidered that his point of view might be a narrow sliver, rather
than the whole pie.

This is how subjectivity declaims its own objectivity.

There's an essential falseness to Schickel's perspective, sim-
ply because he has not entertained the possibility of his own
falseness.

Better to be aware of who you are, where you come from, and
all that you bring to a piece of art. Better to acknowledge that
you respond from who you are and how you feel.

Think of the work of the music critic Greg Tate, who wrote
from the center of his own experience—his point of view as a
Black man and a thinker steeped in Black history and culture—
and in doing so helped elevate not just his own critical writing,
but hip-hop itself to an art form.

"What feeling do you have that is not tied up with history?"
The late writer Randall Kenan asked this question at a 2019 talk

at the University of Mississippi, and it's a line I think about all the time. Our feelings seem—they feel—sovereign, but they're tethered to our moment and our circumstance; and the moments and past circumstances that came before. I might well add: what response, what opinion, what criticism do you have that is not tied up with history? We are subject to the forces of history and the biography we ourselves are living out in the conditions of that history. We think of ourselves as ahistorical subjects, but that's just not so.

That goes for the Pythons, too, and for Richard Schickel. It's a painfully limited perspective to say straight white men shouldn't be heard from; it's also painfully limited for those white men to skip the part where they learn that their feelings, too, are tied up with history.

Remember that male critic who told me, over dinner, that I really ought to judge *Manhattan* on its aesthetic merits? The idea that his own experience shaped his response never occurred to him. He left that to me, the former girl. His own subjectivity was entirely invisible to him; a ghost in the critical machine.

All of this is to say: When I come to this question—the question of what to do with the art of monstrous men—I don't come as an impartial observer. I'm not someone who is absent a history. I have been a teenager predated by older men; I have been molested; I've been assaulted on the street; I've been grabbed and I've been coerced and I've escaped from attempted rape. I don't say this because it makes me special. I say it because it makes me non-special. And so, like many or most women, I have a dog in this particular fight: when I ask what to do about

the art of monstrous men, I'm not just sympathizing with their victims—I've been in the same shoes, or similar. I have the memory of those monstrous things being done to me. I don't come to these questions with a coldness or a dispassionate point of view. I come as a sympathizer to the accusers. I am the accusers. And yet I still want to consume the art. Because, out in front of all of that, I'm a human. And I don't want to miss out on anything. Why should I? Why should I be deprived of *Chinatown* or *Sleeper*? This tension—between what I've been through as a woman and the fact that I want to experience the freedom and beauty and grandeur and strangeness of great art—this is at the heart of the matter. It's not a philosophical query; it's an emotional one.

Donna Haraway says that objectivity is "a conquering gaze from nowhere"; "an illusion, a god trick."

If objectivity is a god trick, then maybe we can think of subjectivity as a human trick. It's our job to be humans, not gods.

Your aesthetic experience might be in fact the opposite of disinterested; it might be deeply emotionally *interested*. My answer is different from yours. I didn't dance to R. Kelly at my wedding reception; maybe you did. Maybe you want to revisit that memory. I didn't imprint on the Black excellence represented by Dr. Huxtable; maybe you did. Maybe you need that image.

Aesthetic experience is tied to nostalgia and memory—that is to say, to subjective experience. Lived experience expands and illuminates the art we take in. This is not ideal, perhaps, but it's real. The brilliant critic/poet Hanif Abdurraqib (writing about Kanye West) makes a case for uncoupling our personal

memories from the artists who seem to define them: "I think the political responsibility of the fan is to challenge that memory—challenge the desire for nostalgia and, in doing that, challenge the soundtracks that have latched onto this nostalgia." Abdurraqib is making a case for forgetting—or for letting go of the kind of amber-hued memory that seeks to hold everything just so, static, in place. This is, perhaps, as Abdurraqib says, a political responsibility—but it's not necessarily a responsibility we can fulfill, in the moment, when Michael Jackson comes floating across the air.

Nostalgia, personal experience—these things become meaningful in terms of calculating the badness of the act against the greatness of the work. Greatness isn't something that is simply agreed upon by authority—as we've seen, that authority too often runs contra to the interests or the experiences or simply the aesthetic tastes of too many people. What makes great art depends on who we are and what we live through. It depends on our feelings.

It's too easy, when we're running the calculus, to forget love. Love that is a quiet voice next to the louder call of (even deserved) public shaming. Critical thought must bow its knee to love of the work—if something moves us, whoever we are, we must give that something at least some small degree of fealty.

Whenever I talk at a college or university about this stuff, I get asked the same question over and over, with a fierce urgency: "Can I still listen to David Bowie?" Bowie was important to me when I was a weird teenager. David Bowie was the patron saint of weird kids. I played *Hunky Dory* every day of

tenth grade—it seemed to stave off the inexplicable howling aloneness—and then my daughter did the same. For kids like me, there was a sense of ownership; Bowie was *ours*. His very existence was an assertion that aliens walked among us—so that when we ourselves felt alien, we might take comfort in the idea that we lived among a secret race, our true family.

When Bowie died, I didn't know how to express my feelings about his death or the magnitude of my love for him. I considered writing an essay, but an internet essay seemed too degraded a form for what I felt. I posted a couplet from his song "Five Years" (*Your face, your race, the way that you talk / I kiss you, you're beautiful, I want you to walk*) and spent a few days going around feeling lower than I had any right to.

Then, in the weeks after Bowie's death, stories started to appear. The groupie Lori Mattix had published an interview late in 2015 telling how she lost her virginity to Bowie at the age of fifteen. The story resurfaced in the wake of Bowie's death. Mattix didn't begrudge Bowie her virginity; in fact, she spoke of the incident in rhapsodic language: "I was an innocent girl, but the way it happened was so beautiful. I remember him looking like God and having me over a table. Who wouldn't want to lose their virginity to David Bowie?" ("I remember him looking like God" sounds like a David Bowie line.) I believed her, and I was left feeling horrified and sad. Sure, Led Zeppelin and Mötley Crüe and Aerosmith—fine, go ahead and have sex with teens. And they all did—with such exhausting, utterly boring sameness that in the end I have not even included them in this book. But not *our guy*.

This is the very, very specific thing that students want to know: *Can they listen to David Bowie?* The question is urgent.

They need him. Young people are not dealing with nostalgia. They're dealing with their own all-too-current feelings.

For teenagers, music makes a kind of repository for feelings, a place for feelings to live, a carrier. So a betrayal by a musician becomes all the more painful—it's like being betrayed by your own inner self.

In certain ways this is a book about broken hearts, and teenagers are the world's leading experts on heartbreak.

In 2015, a band called PWR BTTM seemed to appear out of nowhere. Their music was raucous and joyful. They had one sweetly noisy song, "West Texas," which I listened to over and over at top volume in my Prius as I careened around doing my matronly errands.

PWR BTTM comprised just two people, a man (who now identifies as nonbinary) and a trans woman, who presented themselves as unabashedly queer. In fact, they called themselves queercore—and consequently developed a rabid following of LGBTQ teenagers, their straight allies, and all-purpose teenage weirdos across the country. (I speak as a former member of the club of teenage weirdos, and an ongoing fan of the breed.) The band's indie cred and queer identity allowed them entry to a tight-knit scene, some of whose population was pretty vulnerable. PWR BTTM played often in Seattle, and when they did, it was an occasion. Kids from the island where we lived would take the ferryboat into Seattle to see the band at the Vera Project, an all-ages venue. The band hung out after shows and befriended the young fans who gathered there.

The teens felt trapped on our safe, bosky island, with its

nature trails and its high SAT scores. The ferry to Seattle was an escape. They came home from shows in a kind of exultation, glitter in their eyelashes.

In the spring of 2017, PWR BTTM was poised to release a sophomore album. Just days before the release date, one half of the band was accused of initiating unwanted sexual contact with young female fans. The record company pulled the album. The accusations spread through the scene rapidly before they were picked up by the mainstream media. A kid who grew up in the scene told me that queer spaces tend to move quickly when a predator is suspected; safety is something that everyone is thinking about. The censure of fans and then of the music press was rapid, bitter, and heartfelt. There were stories like "Queer Kids Deserve Better Than PWR BTTM" on *Pitchfork* and "It's Hard Not to Feel Cynical About PWR BTTM" in *SPIN*.

The accusations terminally complicated their fans' relationship with PWR BTTM. How could they listen to this beloved music when they felt betrayed by its maker? The songs were soured, or stained. The band fell off thousands of playlists at once, a very specific kind of heartbreak.

PWR BTTM (like Bowie before them) brought with them the idea that you, too, can be free. Yes, even you. They promised a wider liberation, a liberation that could encompass us all. Their oddball joy promised your freedom. The accusations seemed to suggest that this band's actions were governed by the same set of codified behaviors followed by all the rock stars who'd gone before.

A year or so later my daughter Lucy and I went out to get crepes at a little café on our island. The young woman work-

ing behind the counter, Hannah, was someone Lucy had known in high school—where we lived, everyone knew everyone.

Hannah spread batter over the big flat crepe grill, and a cloud of buttery smoke rose in the air. Through the fragrant haze, she and Lucy discussed what they called "the PWR BTTM thing." Their voices rose with outrage and amazement until finally Hannah expertly folded the crepe into a neat envelope, handed it to Lucy, and said, "I still listen to them. I still love them. Even after everything."

Something in me chimed to the phrase: "even after everything." At this moment I felt a true Joycean epiphany, a sudden realization of the whatness of the thing. This girl, Hannah, had articulated the exact state I found myself in so often, vis-à-vis Polanski and Woody Allen and all the rest.

The crepe shop girl's voice was the voice of betrayal, and of resigned acceptance. Of heartache. These musicians—even the ones with the burnished indie halos—broke our trust, and left us with our dumb love. Even after everything.

What if we think of the crepe girl's voice as a critical voice? What if she was a critic who was able to do that most difficult of critical maneuvers: praising the art despite everything that is against it. What if criticism involves trusting our feelings—not just about the crime, which we deplore, but about the work we love.

We each bring our subjective experience to art and to love. If I were to give an exhaustive list of monsters and tell you my response to them, I would be acting out a kind of falsehood. I

would be suggesting there is a correct answer in each particular case. I would be telling you what to think, and, in telling you what to think, I would be telling you what to do. And I don't want to enshrine my own subjectivity in that particular way; don't want to cloak it in the garb of authority.

Consuming a piece of art is two biographies meeting: the biography of the artist that might disrupt the viewing of the art; the biography of the audience member that might shape the viewing of the art. This occurs in every case.

THE GENIUS

PABLO PICASSO, ERNEST HEMINGWAY

I noticed that a certain kind of person appeared to be immune to the stain. A certain kind of person demanded to be loved, no matter how bad his behavior—and we (oh, we) all agreed he was worthy of love. This was the person called *the genius*. This person might be stained—in fact almost always is stained—but the stain seems not to dent his importance. His primacy.

The genius is a proposition. He's a fantasy that we have collectively. The genius isn't so much a *kind* of person as a *status* of person: a person who can do whatever he wants.

A genius has special power, and with that special power comes a special dispensation. Genius gets a hall pass. We count ourselves lucky he walks among us; who are we to say that he must also behave himself? Our fandom is a necessary ingredient of his greatness.

"Genius" is a spectral, sacred word, yet it lands with the thud of fact. Remember that guy who got so furious at me online, saying he was done with me forever because *Manhattan* made me feel *urpy*? He invoked the word "genius," with all its vague majesty. Genius is the name we give our love when we don't want to

argue about it; when we want our opinion to become fact. When we want to push our obsession onto the next guy. When we don't want to hold our heroes accountable.

This happened to me early on, with my feverish Polanski viewing. The word "genius" came to my mind like a brisk wind from the north, a word that blew away all my worries and all my guilt. Polanski was a genius, after all, so the chips must fall in his favor. When it comes to balancing the greatness of the work against the badness of the deed, the word "genius" simply breaks the calculator. It's a glittering absolute set into a dreary dutiful system of relative worth. And that's to the advantage of the genius. I thought of this a lot in the winter of 2018, when men were being accused and realizing that perhaps their free and easy ways were not so free and easy for everyone else— I'm thinking of Uma Thurman's descriptions of how Quentin Tarantino bullied her on the set of *Kill Bill:* she described his treatment of her as an actor as "dehumanization to the point of death." The shock was this: my own stubborn sense that these men were acting within their rights. Tarantino was a genius, no? Such things were to be expected of men like that. They needed to be free in order to do their genius work. It was going to take some doing to deprogram myself from the idea that genius follows its own rules.

This idea of genius, and what it is allowed, attaches itself to certain specific people. Hint: they aren't women. Genius is an exclusive club, with stringent standards for membership, not all of which (gentle cough, slight averting of the eyes) have to do with the work itself.

· · ·

was maybe six or seven years old. I was lying on my stomach in the TV room, tracing the blue flowers in the carpet, watching the laurel leaves shift and rustle in the great mysterious hedge outside the casement window, thumbing through *The Best of LIFE* photo book. I looked at the book the way I watched the leaves or traced the carpet—it was just there, something to be consumed absentmindedly, part of the serene eternity of life in the TV room. Its images became a part of my brain, as though the pictures were thoughts of which I was the thinker. I didn't know it at the time, but these were indelible images of the twentieth century.

Famous men were black and white. Picasso crouched like an animal, squiggling light into a shape—a centaur appeared in the air between him and me. My eyes stared into his black-currant eyes through the shape made of light. Picasso scared me a little, but he also excited in me a fellow feeling. He certainly was no child, but with his tiny stature, his too-awake eyes, and his crouching stance, he looked ready to play, animal-ish.

Turn the page and there was Hemingway, kicking a beer can eternally down a road, framed by the snowy hillsides of the Wood River Valley in Idaho—a place where my father had lived, in his own mythical pre-me past. It was a confusing image, this white-haired, bearded man, kicking that can with his whole self, like a little kid. Hemingway was entirely in his body, but what was his body expressing? Anger? Jouissance? (*Not* a word I knew then.) But it was clear, he was more than just a brain. Like Picasso, he was a body, a joyous, furious body, designed to move through space, designed to do so much more than just sit and write.

The men were physical, extra-alive, moved by some spirit

outside of themselves. They clearly were connected to some kind of greater energy. This was what genius looked like.

The twentieth-century image of the great artist is both physical and free—eggheads (and girls) need not apply.

This image comes from somewhere in particular.

Picasso, monkeying around half-naked on a beach, black eyes snapping.

Hemingway, bearded and barrel-chested, standing next to a giganto fish (which, it turns out, was caught not by Hem but by another guy altogether).

Muscular, unfettered, womanizing, virile, cruel, sexual. Our contemporary idea of the artistic genius owes a lot to Picasso and Hemingway, and to all those meaty men who brawled their way through the last century, embodied and magical.

The contemporary ideal of the genius is a two-headed figure: both master and servant.

He presents himself as a master—that's the first thing you notice about him. The genius dominates and controls his environment and the resources at his disposal, whether that resource is paint or words or people. This mastery or control shows in his work. The paint handling that somehow seems not just to portray but to channel light; the magisterial overwhelming movements of a symphony; the novel whose phrasing disrupts the very idea of the sentence and whose plotting rearranges the stranglehold of time itself. The master manipulates the material—and the audience. The master holds a leash.

The genius, in full flower, is immensely powerful, the kind of person who is willing and able to put hordes of other people

to work in the name of his vision. A film director, for instance, is in his element bossing around a small army of people, including very famous actors, demigods. Or think of Kanye West's *My Beautiful Dark Twisted Fantasy*. The track "All of the Lights" is not so much a song as a train station—Grand Central at rush hour, crowded with hordes of celebrities: Drake, John Legend, Alicia Keys, Fergie, Elton John, Rihanna.

The genius dominates, but he has another face, too: he's also a servant. A servant to what? Well, to his own genius. His genius is a force that overtakes him, and he is powerless before it, and must serve its demands. He's visited by a force greater than himself, something even more powerful than a muse. This is the job of the modern genius: to create circumstances that are conducive to his free reception of the energies that might rise in him or descend upon him.

The image of the genius in the throes of creation is easy to conjure. When I hear the word "genius," I think of Jackson Pollock flinging paint around like a tough-guy loon. He's not in his right mind. The genius is the one who is able to exert control over his materials and his helpers while simultaneously *absolutely* losing control over himself. He is masterful at performing a servitude to something greater than himself.

In the tarot, the Magician card is the card signifying the artist. The symbols assigned to each of the four suits of the tarot—a wand, a cup, a sword, a pentacle—lie on a table before the magician. Everything in the universe is at his disposal, the world a provider of tools for him to use. This person is the master. But that's not what makes him a magician. He also holds one hand over his head. His upraised hand is drawing something from above; something divine, something huge, is pass-

ing through him. Over the magician's head hovers an infinity sign. The magician knows how to use the tools to channel this infinitude.

The tools that lie before him, representing mastery, are important, but so is the mysterious force traveling through him. His subservience to something outside himself is hallowed. In the genius we call this subservience the artistic impulse. The impulse has a vast importance; without it, he's just a craftsman. The artist needs the impulse; he needs to do whatever it takes to keep it flowing. When your job title is "genius," your impulsiveness becomes the source of what is good in your life.

Picasso's hand moves quickly, freely through the air, leaving behind the light-drawn image of the centaur.

The thing is, freedom and energy can become confusing, morally or ethically speaking. If you are handsomely rewarded for giving in to *some* of your impulses, doesn't it begin to seem like *all* your impulses ought to be honored? Especially because it's hard to tell the good from the bad. Why would you quash an impulse, no matter how savage or destructive, when it might be one and the same thing as the impulse that allows you to do this mysterious, free thing that everyone says is genius?

What follows logically from there is the idea that the artist ought to be free in all his doings. Otherwise, if he constrains himself, he might turn off the energy. He might somehow accidentally sit on the muse and squish it to death.

In his wonderful study *The Success and Failure of Picasso*, the critic John Berger talks about the way a young genius first encounters his own gift, making explicit the idea that there is an exterior energy that flows into the magician-like artist: "To

the prodigy himself his power also seems mysterious, because initially it comes to him without effort. It is not that he has to arrive somewhere; he is visited. Furthermore, at the beginning he does things without understanding why or the reasoning behind them. He obeys what is the equivalent of an instinctual desire. Perhaps the nearest we can get to imagining the extent of the mystery for him is to remember our own discovery of sex within ourselves."

That sexual analogy isn't accidental. The genius surges with energy, and it overtakes him—hence the image of Pollock and his spurting paint, going all over the place.

The experience of channeling something, of being a servant to something bigger than oneself, isn't just for the prodigy, or even just the young—Picasso retained it throughout his life. Berger again: "Picasso, at the age of eighty-two, has just said: 'Painting is stronger than I am. It makes me do what it wants.'" Part of Picasso's lifelong practice was to give himself to this greater power. This freedom was actually part of his job—paradoxically, part of his discipline. The harnessing of freedom is the key gesture of the contemporary genius. Think of Pollock and his fractaling paint: freedom and control working in tandem.

The image of artistic genius is above all free. Picasso's work satisfyingly reflects the kineticism of the man who made it. A viewer gets a buzz just looking at it. The work is unnerving, or rather extra-nerving: *Les Demoiselles d'Avignon*, with its hot pink bodies and its grimly animal faces and its hostile-feeling distortions, makes us jumpy and energized; we mimic, internally, the state of the artist. Picasso's friend the poet André Salmon wrote that *Les Demoiselles* "unleashed universal anger" when it was first unveiled, and I have to admit I still feel a little pissy when I look at it. A kind of jumped-up feeling.

The interweaving of art and person is part of what makes Picasso not just an artist but a figurehead of genius. Duchamp and his readymades changed the idea of what constitutes art just as radically as Picasso did—more so—but Duchamp didn't inhabit this sexy and highly commercial ideal of freedom. To put it another way, I certainly can't conjure an image of Duchamp's face in my mind's eye; I've never seen a Duchamp poster in a dorm room. The genius we want to see is the genius who both expresses and embodies freedom.

It's the triumph of the Dionysian over the Apollonian. Earlier artists who are considered great—Caravaggio, Bosch—had of course also embraced the Dionysian, but always in subject matter. You might depict a scene of total abandon, but the depiction itself, in order to be considered a work of genius, must be executed with total mastery.

What changed in the twentieth century was the triumph of freedom—not just in terms of content, but in terms of form. Freedom of form became the greatest good.

James Joyce
Picasso
Pollock
Elvis
Led Zeppelin
Jimi Hendrix
Allen Ginsberg
Jack Kerouac

These men inhabit our idea of genius. More formally constricted artists don't get valued in the same way: Larkin will

never be as widely known as Ginsberg; Duchamp will never have the worldwide fame or ability to sell out a major museum that Picasso possesses.

And yet—isn't the genius the person who changes everything about his or her field? Thomas Kuhn called this a paradigm shift, before the word "paradigm" got taken over by corporate dipshits and lazy undergrads. If you go by that definition, Duchamp is actually a greater artist than Picasso. If a Renaissance artist time-traveled to the twentieth century, he would've recognized what Picasso was doing as painting. But Duchamp would've made zero sense to him as art. Duchamp changed everything. But Duchamp doesn't fulfill an image that we have in our minds of genius.

The fact that Picasso embodies our image of the genius is not an accident—or maybe it is an accident of history. Picasso's rise was contemporaneous with the explosion of mass media. Picasso became the image of art itself, transmitted via newsreel ("Picasso Sees a Bullfight") and magazine until he was indisputably the most famous artist in the world. His image and his persona were perfectly matched to the moment. His maleness, the expressiveness of his gestures, his black-button eyes, his compact, coiled physique—it all read on-screen.

The genius, presented for public consumption, was not an entirely new phenomenon. Dickens was as mass market a phenomenon as could be managed with the tools at hand in his era. Oscar Wilde, too, shaped his own image, touring America and having photographs made of himself, as far back as 1882. Wilde is supposed to have announced, upon arrival in America,

"I have nothing to declare but my genius." That's debatable, but he certainly spoke often, if parodically, of his genius, almost as if it were an animal, and wrote, "The public is wonderfully tolerant. It forgives everything except genius."

Dickens crafted the persona Public Genius; Wilde ironized it. But his twentieth-century counterparts seemed not to get the joke. Picasso carried on with the job of publicizing his own genius, but he rid the process of wit. This was a great success and soon everyone knew his name.

By the 1970s I, a tubby grade-schooler with a Prince Valiant hairdo, could've identified one artist and one artist only. Not his work—though I might've been able to finger, as at a police line-up, a sideways-faced lady or whatever—but his short and frightening self.

Picasso found himself at the beginning of a movement— the movement toward biographical saturation. If we live in a biographical moment, Picasso helped launch and also rode that moment. Picasso and the screen rose concurrently, and the screen is what collapsed boundaries between people. A screen is what created the idea that we really *know* these people.

Picasso didn't just appear on-screen—like that other early genius of image, Chaplin, he became a screen himself. In Picasso's case, he was a screen upon which the audience could project its ideas about what an artist ought to look like. And it was a capacious, expansive image too, like all the best images, the ones that are really indelible. It had that paradoxical quality of mutability combined with recognizability: he is this one thing, always and forever, infinitely reproducible, but he can also

be anything. Wrote Berger, "The associations around Picasso's name create the legend of the personality. Picasso is an old man who can still get himself young wives. Picasso is a genius. Picasso is mad. Picasso is the greatest living artist. Picasso is a multi-millionaire. Picasso is a communist. Picasso's work is nonsense: a child could do better. Picasso is tricking us. If Picasso can get away with it all, good luck to him!"

What was Picasso getting away with? Generally being a rat.

A few years ago I took our kids to see *Picasso: The Artist and His Muses,* a show at the Vancouver Art Gallery. Lucy loves museums—has been drawn to them her whole life, maybe because I used to take her for free-range crawling sessions at the Frye Art Museum in Seattle on rainy days when she was barely a year old. I have come, through her eyes, to see the museum as a site of great beauty but also of moral drama, a palace of constructed meanings, a space that is at once public and private. If much of the plot of the autobiography of the audience has taken place at my house, as I wrestle with a book or a film or a song, then the museum is the place where that plot becomes manifest.

As we walked through the museum, I had a mounting feeling of discomfort. The paintings were not the cause of the discomfort—or not any more than you'd expect, given Picasso's determination to discomfit the viewer. No, it was biographical information, telling us what Picasso had done to each of the women in his life, that was causing the uncomfortable feeling. I read with a strange growing dismay. My children, who at this time possessed the fierce moral sense to be found in teenagers

and maniacs, were starting to look a bit nettled. They were omi-
nously silent. Something was fomenting.

The inherent *coolness* of the museum—its marble stillness—
made the hot, terrible news about Picasso all the more unpalat-
able. The children frowned. They crossed their arms over their
chests. They did not care for this one little bit.

Jonathan Richman and the Modern Lovers' song "Pablo
Picasso" is dependent on the idea that everyone but everyone
already has an image of Picasso in their heads. It depends on
the idea that everyone knows Picasso was a womanizing power-
house. And of course "was never called an asshole" implies that
he was one.

> And girls could not resist his stare and
> So Pablo Picasso was never called an asshole . . .

But of course Pablo Picasso was an asshole. (Otherwise the
song would make no sense.)

He reportedly said to his mistress Françoise Gilot these ridic-
ulously villainous lines: "Woman is a machine for suffering. . . .
For me, there are only two types of women, goddesses and door-
mats." The used-up women in his life make a fleshy pig-pile,
so much so that it can be hard to remember which is which:
Fernande Olivier, Eva Gouel, Olga Khokhlova, Marie-Thérèse
Walter, Dora Maar, Françoise Gilot, and Jacqueline Roque. Two
killed themselves—and so did Picasso's grandson, Pablito—and
most of the rest were left with their lives shattered after their
time with Picasso. Dora Maar became a highly religious recluse

(after being treated by Lacan, of all people!), reportedly saying, "after Picasso, only God." Picasso's granddaughter Marina wrote in her memoir: "He submitted them to his animal sexuality, tamed them, bewitched them, ingested them, and crushed them onto his canvas. After he had spent many nights extracting their essence, once they were bled dry, he would dispose of them."

It's no crime to love a lot of women—even if it makes the women in question cross or jealous or crazy or suicidal. But of course Picasso was also abusive toward these women (beatings and burnings), and moreover he was a predator of young girls, who fascinated him and whom he used as models.

I can feel arguments burbling up—what about his friendship with Gertrude Stein? What about his tender regard for his children and then his grandchildren? Yes, and at the same time, Picasso's asshole-ness is essential to our experience of his work.

The exhibit at the Vancouver art museum started to seem less like an art show and more like a war memorial to the sacrifices of Fernande Olivier, Eva Gouel, Olga Khokhlova, Marie-Thérèse Walter, Dora Maar, Françoise Gilot, and the rest. Making our way through the galleries, we learned exactly how Picasso had destroyed each woman's life. Each room further reinforced the story of Picasso-as-asshole: the constant womanizing, the cruelty, the self-interest and invective. By the time we got to *Femme au collier jaune* (*Woman with Yellow Necklace*)—which shows Françoise Gilot, cheek burned by Picasso's cigarette—the kids had *had it*.

I myself was hoping to discuss the, you know, tension between Picasso's work and the biographical information we were reading on the placards. I wanted to have a meaningful discussion.

"Ugh, this is so depressing," said one. "What a disgusting creep," said the other. "Can't we leave?" And we went out for ice cream, blinking as we stepped from the cavernous dim of the museum lobby into the bright thin northern sunlight.

Picasso's freedom—the freedom to be anything—had an antecedent in the story of Gauguin. Gauguin, who abandoned his wife and children to flee to Tahiti, where he didn't know the language or the religion or the customs, none of which prevented him from sleeping with young Tahitian girls, an act of sexual colonization that he himself was only too happy to mythologize. He sent back to Paris, through both his painting and his writing, a mythology of the noble savage, evoking a world of available women and girls through which he moved freely. He wrote in his famous *Noa Noa* diaries: "Concealed among the stones the women crouched here and there in the water with their skirts raised to the waist. . . . They had the grace and elasticity of healthy young animals." Amazingly, *his diaries were plagiarized.* Think about that—that's about as pure as mythologizing gets. You're not just controlling your own public image—you're controlling your own private image. (Not that I haven't lied to my diary in hopes of appearing deeper or more experienced or cooler to my imaginary audience. But not since I was *fourteen.*)

Gauguin was like a savant of image creation—he conflated his life story with his paintings. The historian Wayne V. Anderson wrote in *Gauguin's Paradise Lost:* "Gauguin 'created' a style of painting in the sense that he gave it its life force; and the vitality of his art was matched by the potency of his personality, by the loudness of his actions." Vitality, potency, loudness—is it any accident that we call important works of art *seminal?*

Perhaps it was no accident that Gauguin was possessed of a near-insane self-confidence. He wrote in a letter to his wife Mette, "I am a great artist and I know it."

Picasso followed in Gauguin's virile tradition. Good luck to him! Picasso owned a copy of *Noa Noa*, and, as with Gauguin, eventually Picasso's persona would come to pervade the perception of his art. The stain is indelible in this one—the work immediately conjures the man.

Picasso's masculinity colors every part of our viewing. You could argue that his masculinity justifies his effete interest in experimentation, even in beauty. Picasso is the man who had sex with two separate women on the same day, and painted them both. The sex is as important as the painting.

Picasso made overt this connection between a brutal masculinity and art. From Arianna Huffington's madly dramatic book, *Picasso: Creator and Destroyer:* "Everything, the whole of creation, was an enemy, and he was a painter in order to fashion not works of art—he despised that term—but weapons: defensive weapons against the spell of the spirit that fills creation, and offensive weapons against everything outside man, against every emotion of belonging in creation, against nature, human nature, and the God who created it all. 'Obviously,' he said, 'nature has to exist so that we may rape it!'"

Picasso is the victim of, the servant to, his own impulses.

Masculinity, glamour, cruelty, brilliance, media-awareness: Picasso had a literary counterpart in all these qualities. If Picasso was the most famous painter in the world, Hemingway

was the most famous writer. Both their names became more than just a household word, they became stand-ins for the entirety of their art: Hemingway means writer, Picasso means painter. Hey, Hemingway, you might say to a person at a typewriter. That guy's a real Picasso, you might say of a daubing painter. (Why you'd be talking like a 1940s tough guy, I don't know.)

We now think of Hemingway as someone surrounded by contemporaries (Fitzgerald, Pound), but at the time he was on a little mountaintop all by himself. His fame, which ran parallel to and concurrent with Picasso's, was unthinkable for a writer today. The most famous literary writer in the world—until recently, probably Philip Roth—couldn't touch Hem's, well, hem when it comes to fame. Marlene Dietrich wrote a piece about him for the *New York Herald Tribune*: "The Most Fascinating Man I Know." Somehow Jonathan Safran Foer's emails with Natalie Portman don't quite measure up to that level of glamour.

In 1948, Hemingway's onetime bosom friend Archibald MacLeish wrote in the poem "Years of the Dog":

> And what became of him? Fame became of him.
> Veteran out of the wars before he was twenty:
> Famous at twenty-five: thirty a master—
> Whittled a style for his time from a walnut stick . . .

Fame became of him—this could be a one-line eulogy for Hemingway. He became his own fame, a fame that was interwoven with his masculinity. He became a human synecdoche for the condition of literary virility.

Hemingway's reputation for asshole-ness, like Picasso's, precedes him—or, rather, his work. Hemingway's name is synony-

mous with brawling and womanizing and glamorous violence: the running of bulls, the catching of really big fish, the stalking of lions, the battering of women and children. Like Picasso, he created a kind of multi-car pileup of women over the decades. He had four wives, who gave him three sons, sons whom he loved and bullied terribly. He and his child Gregory became increasingly estranged, until at the end they were unable to meet for fear of the violence they would do each other.

Hemingway was a hitter, a beater-upper, an insulter. He decked friends and enemies alike. Mary—Hemingway's fourth wife—said proudly at one point, "It is more than a year since he actually hit me." No one is solely a monster, after all, and Hemingway had complicated relations with wives, friends, children. The fact that they always seemed to end in divorce, estrangement, recriminations, tears doesn't mean that these relationships weren't tender and vulnerable.

Hemingway lived his life as an alcoholic and killed himself, just as his father did; this destructive legacy was passed down and seemed not to become diluted: his child, born Gregory, sometimes known as Gloria, died in a Florida jail cell; his grand-daughter Margot/Margaux Hemingway drank herself into a deep depression and eventually killed herself.

Hemingway was also just plain mean. *A Moveable Feast* is full of hilarious and cruel takedowns of his fellow writers, including a description of overhearing his good friends Gertrude Stein and Alice B. Toklas having sex, after which he claims to have severed his friendship with the two women, so traumatized was he by the sounds emitted from behind the closed door. He can be mean to men too. Here he is on Wyndham Lewis: "Walking home I tried to think what he reminded me of and there were

various things. They were all medical except toe-jam." The fact
that he's clever and charming doesn't make it any less cruel. He
wrote the meanest poem in the world about Dorothy Parker, in
which he mocks both her suicide attempt and her abortion—
the title gives some idea of its nastiness: "To a Tragic Poetess—
Nothing in her life became her like her almost leaving it."

Like Picasso, Hemingway was fascinated by bullfighting,
and there's some sense that he experienced the world as a kind
of hostile arena, where you might get gored at any minute and
you'd better gore first. Both Hemingway and Picasso found a
deep beauty in that most bloodthirsty of sports. Hemingway
wrote in *Death in the Afternoon:* "Bullfighting is the only art in
which the artist is in danger of death." (Makes wanking gesture
with hand.) You can feel him yearning toward that kind of abso-
lute male danger. Bullfighting feels like a metaphor, but the met-
aphor can be read two ways. Hemingway and Picasso were the
death-obsessed artists, of course, but they were also the bulls.
They were not exactly oafs or lugs, but *brutes.* Brutes with depths,
brutes of sensitivity, brutes whose inner tenderness the brutes
kept revealing, again and again, to an enraptured public. There
is a special human thrill—perhaps a female thrill—in locating
the tender heart of the brute. There's a physics, an achievement,
an Olympics to being gifted enough to appreciate what's tender
on the inside. But of course this dynamic doesn't work without
the brutishness.

The fucking, the hardness, the cruelty, the masculinity, the
brutishness shaped the image, and, following on from there, our
idea of what a genius really is.

. . .

Even Hemingway's writing seemed to become infected by his own image. Not always, and certainly not at the beginning. The early work is vivid, funny, strange, full of tossed-off-seeming beauty and a kind of off-kilter prose that expresses a huge brashness; the fact that you as the reader will follow is assumed—and you'll be glad you came. To reread this work is to be amazed at its humor, even its silliness at times. *The Sun Also Rises* is full of jokes. (It's also full of anti-Semitism.) A very small aside—my leftist kids make the joke "direct action" all the time. "Direct action" one of them might say as they remove the ice cream from the freezer. Guess who got there first? Two characters are sitting around drinking, and one pours them both some rum punch—instead of thanking him, the other character says, "Direct action. It beats legislation."

But the Nobel came to Hemingway when he was acting most Hemingway-ish—most like the man who whittled a style for his time from a walnut stick.

Hemingway's particular stain was a kind of brutish, careless masculinity; this was the image that accompanied him. In *The Old Man and the Sea,* he seems to be doing an impersonation of himself, bringing that toughness and vigor to the page. *The Old Man and the Sea* is nothing if not terse, oracular, male. The spectacle was, upon revisiting the work, deeply embarrassing.

It didn't help that, instead of reading it, I listened to an audiobook, which unfortunately featured Donald Sutherland reading the thing in a portentous, not-quite-Spanish accent. I felt a little sheepish just listening to it over earphones as I took my daily walk through the woods, worried that somehow someone might hear this ridiculous voice intoning this shamefully muscular prose.

The old man is much given to thoughts like this: "You did not kill the fish only to keep alive and to sell for food, he thought. You killed him for pride and because you are a fisherman." It's as if Hemingway wrote the thing by taking dictation from his public image. The novel is a long persona poem, and the persona is "Ernest Hemingway, terse and masculine author"—in fact, the persona of the author conflated with that of the tough old man, circled by sharks (sharks that some readers have read as a metaphor for Hemingway's own critics). Whatever else you might think about author and character, first and foremost they're fighters.

I n fact, it's often been observed that Hemingway's masculinity grew from and into a kind of victimization. (He was, after all, a servant, subject to the demands of his demons.) As his onetime great friend Gertrude Stein said: "He was 'tough' because he was really sensitive and ashamed that he was."

Was Stein right? Did his overbearing masculinity grow from sensitivity and shame? Or was he perhaps attempting to compensate for an overweening sense of his own femininity? After all, in his early childhood his mother often dressed him as a girl. These are not new questions (as you can see, Stein got there long ago).

Hemingway's posthumously published novel *The Garden of Eden* deals in themes of gender and often gets mentioned in the discussion of Hem's masculinity. Hemingway started the book after World War II, and continued writing it until his death in 1961. When it landed on the editor Tom Jenks's desk at Scribner's in the mid-1980s, it was fifteen hundred pages long. Jenks

brought it down to a couple hundred and released it to a critical drubbing. Over the following decades a more thoughtful reappraisal allowed the book's theme of gender fluidity to infect and influence thinking about Hemingway.

This conversation was hindered by the fact that most people did not read the book on account of it's just not very good. I'm here to say I've read it and it seems to be 90 percent about people getting haircuts. To put it differently: there's an ostensibly frivolous preoccupation with appearances here—a preoccupation that is in fact deadly serious. Are people really what they appear to be? The main character, David Bourne, is a kind of inside-out Hemingway man, who presents with all his Hemingway parts intact but is not quite what he seems. In fact, David is being turned into a woman by his wife, Catherine. Things start out with—*bien sûr*—a haircut. Catherine trims hers to look more like a boy; armed with her new, boyish hair, at night she does things to David, "devil things." She calls herself Peter, and makes David be the girl. David participates but balks (as perhaps Hemingway would like us to think he himself would balk at such goings-on).

What *are* these devil things, anyway? Writing in *New York* magazine in 1986, Eric Pooley describes these scenes as "anatomically vague but emotionally precise," and I don't know what book Eric Pooley read because emotional precision is just what this book doesn't have. What it does have: pegging, and the pervasive sense that Hemingway is rooting around somewhere deep inside himself.

Given what's on the page in *The Garden of Eden,* critics (and the book's editor) have posited the idea that Hemingway was self-aware about the construction of his own gender identity—i.e., he was aware of the way he transmitted a robust, not to say

oppressive, masculinity. But to read the book is to witness some-
one who seems not *in control of* but *at the mercy of* gender—as
if masculinity was something that happened to him, and he's
dreaming of a way out.

The essayist John Jeremiah Sullivan spoke in an interview in
a jolly way about Hemingway's torments: "Recently I got sucked
into a research project in northern Michigan, and it led me to
reread Hemingway for the first time since college. It was fun.
All these recent biographical attacks have made him interest-
ing again. He was, as we know, fantastically tormented about
sex, and gender, and his own masculinity. If you had asked me
about him 20 years ago, I would have said what I'd been taught
to say: 'It's about the work.' Which—and I've learned this—is
what people say when there's something they want to avoid. The
something is, with a freakish regularity, sexual."

As fantastically tormented as Hemingway was, his mascu-
linity was always ascendant in his image. The male mask was
the visage that was presented to the world, no matter what sen-
sitivities lurked beneath.

The performance of masculinity, and its conflation with
genius, has not been a great thing for women, who are simulta-
neously the genius's victims and forever excluded from the club
of genius. But *The Garden of Eden* makes us wonder about the
cost to the genius himself. What did it cost Hemingway to be so
much one thing (a man) and never its opposite?

Why does all this matter? Because genius informs our idea
of *who gets to do what*. Who gets to have license. Who gets
to give in to their impulses. Whom we choose to aid and abet

when they do indulge in those impulses. When genius is tied to masculinity—a masculinity that continually reasserts itself—then someone is being left out.

All of which is to say, the genius is not you. Not me. The genius, as we understand it, is not the person who spends most of her time, and I mean that quite literally, thinking about childcare. My major artistic concern for the past twenty years has been childcare, it has preoccupied me more than any other subject; even now that my children are mostly grown I'm still not sure I managed it well, I lie awake worrying about it, and meanwhile old Pablo was putting out cigarettes on his girlfriend's face.

In *The Golden Notebook*, Doris Lessing says, "That sacred animal the artist justifies everything, everything he does is justified." Just to be clear, she is not saying this in an approving manner.

The genius's freedom does not concern itself with the care or schedules or feelings of other people. The genius has absolute license. The genius gets to do what he wants. When I tried that, all I ended up with was a drinking problem and a lot of annoyed friends.

We allow the genius to give in to his impulses; he is said to have *demons*. Demons are cousins to the artistic impulse. The Devil card in the tarot inverts the symbols of the Magician; he's pulling energy up from down below; he wears an inverted pentagram instead of an infinity sign. The devil made me do it, we say—and is that really so different from the experience of being inspired by a muse?

The genius's demons can err on the side of insanity. We

want our genius to have a dark side. Great art can only be made with the help of the demons—and the demons can push you to insanity.

Of course, when license goes too far, it can devolve into lunacy. The question is, I suppose, whether lunacy makes a great artist, or whether all that freedom makes a person crazy.

Did you ever know a genius? I knew one, and she spiraled into schizophrenia. And then I knew another, and he was the most regulated person I ever met—his rules for himself a kind of bulwark against the chaos inside of him.

Are brilliant people more apt to be crazy? Are geniuses more apt to be miserable? Are the really talented also generally mentally unwell? Of course there's a whole literature on this subject. For my part, I'm reminded of a quote from the singer-songwriter Loudon Wainwright. Wainwright has a famously baroque personal history—famous mostly because he keeps writing songs about it. He was married to the folk singer Kate McGarrigle, then was involved with the singer Suzzy Roche, then was married to yet another woman, then divorced, and is now partnered with Susan Morrison of *The New Yorker*. All the hairpins and low moments along the way are memorialized in songs like "Unhappy Anniversary" and "Drinking Song." In an interview with *Vanity Fair*, Wainwright said: "Married and the father of two small children, I was never home, drunk a good deal of the time, and apparently felt it necessary to sleep with every waitress in North America and the British Isles. But guess

what. All these beans have been spilt in song. . . . Now we've stumbled onto the big, important question: Is it necessary to feel like shit in order to be creative? I'd say the answer is yes—unless you're J. S. Bach."

Is it necessary to feel like shit in order to be creative? To what degree does an artist need to slip the confines not just of societal conformity, but of mental or emotional conformity as well? This idea of the artist outside the norms of society can be anesthetized or smoothed or made pretty in the image of the free spirit, the Byronic hero. Once again, this image is only available to certain people, who happen to be men.

Researching real-life scientists for a book about physics, a novelist friend told me she discovered that eminent scientists sometimes seem to cultivate the image of the genius who lives just on the other side of a partially collapsed wall from lunacy. She spoke of meeting great scientists who demonstrated a flagrant, near-hostile disregard for conventions of dress or conversation, scientists who prided themselves on walking away mid-sentence. (Of course these scientists were never women. Women must continue to labor under the constraining, bland yoke of professionalism.)

I remember at the University of Washington there was a chemistry professor who wore two coats and at least as many suit jackets, a battered felt hat, and the general air of erosion that comes with sleeping outdoors. He wheeled a bicycle around campus, never riding it, always pushing it, with a puzzled expression on his face that suggested he didn't know exactly what it was for. He lived in the same leafy bourgeois neighborhood as my parents, though, and his reputation for genius was burnished, not diminished, by his disarray, by the rope he used as a belt.

In other words, lunacy can give a kind of cachet, as long it is practiced by the right person in the right way.

L unacy and license reached an apotheosis in the rock era, when wildness became a commodity. Hemingway's and Picasso's true descendants were the determinedly demonic men of rock. Rock stars enacted an escalating ideal of freedom, from Elvis gyrating his hips to Jim Morrison pulling his dick out onstage (which I always picture him doing with a puzzled look on his face: "What's this, then?"). They were given the license to behave with perfect liberty; they were also given the simultaneous pressure to perform that liberty—the liberty to be men in full; they could be silly or bombastic or mythical. (Watch the Led Zeppelin film *The Song Remains the Same* sometime if you want to see what I mean.)

Of course, rock star liberty, like the liberty of the genius, didn't and doesn't accrue to everyone. No one has expressed the exclusive nature of rock star freedom better than the benighted Kanye West in an interview with *Rolling Stone* magazine. When asked about being a rap star, West said this: "I am a rock star. Because rock stars don't need security, and I can go to dinner and chill. Rock stars can speak well, or hop on a plane to Paris if they feel like it. Rock stars can catch cabs, they don't need entourages and they don't have to pop out of limos all the time. Rock stars can wear the same clothes every day, they can get their shoes dirty and they don't need a fuckin' haircut."

This is the key image of rock star freedom—the idea that you can be barefoot and filthy and worth millions. Kanye goes on: "Rock stars can pull their dick out in public then go rock

20,000 people. Rock stars have a wife and kids. . . . Rock stars can give their fucking opinion without having to deal with . . . what's that thing I get dealt with every day of my life? Oh, yeah. Backlash."

West is here describing the elastic freedom of the white rock star. Rock stars are free, and that's what he wants to be. Rock stars—white men—are able to be everything and anything. They are able to be the fullest of humans. West's list recalls Berger's litany of associations around Picasso: "Picasso is an old man who can still get himself young wives. Picasso is a genius. Picasso is mad. Picasso is the greatest living artist. Picasso is a multi-millionaire. Picasso is a communist. Picasso's work is nonsense: a child could do better. Picasso is tricking us. If Picasso can get away with it all, good luck to him!" Picasso can be anything and everything.

West's quote, however, takes a hairpin toward the end. He starts out asserting "I am a rock star" (echoing his own song "I Am a God"). By the end of the quote, he's conclusively saying he's not a rock star, because they don't have to deal with what he has to deal with: ". . . Oh yeah. Backlash." He's talking about a racialized freedom—the freedom of the white man to do what-ever he wants, a freedom that is not quite available to him. He seems not entirely aware that he's undermining his own point over the course of the quote; but he makes that same point overtly, concisely, and brilliantly in his song "Gorgeous," when he raps, "What's a black Beatle anyway? A fuckin' roach."

When West went off the rails, no one at all said: *If Kanye West can get away with it all, good luck to him!*

. . .

In *The Society of the Spectacle,* the Marxist theorist Guy Debord writes about stars as "specialists of apparent life." This is what Kanye West is describing—the star's *enactment* of freedom. The rock stars and the genius, specialists of apparent life, embody freedom in their inconsistencies and their contradictions, their dirty shoes and their violent acts.

Debord calls stars "spectacular representations of living human beings," avatars who "embody the inaccessible results of social labor by dramatizing the by-products of that labor which are magically projected above it as its ultimate goals: power and vacations."

"Power and vacations"—! It's easy to imagine West uttering that immortal line when describing what he wants. What everyone wants: the very essence of freedom. And we need people to act out that desire on our behalf.

Freedom enacted is the history of rock, as West so succinctly explained in his interview. Every urge, every need satisfied as quickly as possible—this was the power of the rock star. The groundwork for this way of life was laid by Picasso and Hemingway, enacting their freedom on a global stage. The freedom to be anything—even mad or bad.

Lesley Frost—the daughter of Robert Frost—said this: "I think all kinds of artists who live on that ragged edge, between genius and what genius does to people, are on the edge of unreason. If you'd seen the quarrels and the jealousies and the fiendish attitudes of the group around Ezra Pound, it was just wild—they threw each other downstairs and threw things at each other all over the wording of a poem!"

. . .

We want to take in the spectacle of the virile wicked mad geniuses because they make us feel excited and alive. They flood us with a sense of possibility—the possibility of what? Maybe the possibility that whatever infinitude has touched them might likewise infect us. Maybe, too, the possibility that they might do something bad.

In the wake of #MeToo, we began to undertake a collective thought experiment—or maybe it was just me—in which we tried to imagine a world where maleness, virility, license, and violence were not required to make great art.

It's hard not to participate in a kind of fantastical utopianism when it comes to thoughts like these—if we could get rid of the gnarly old men, we'd live in an innocent world of good people making good art. A sanitized world. Theoretically speaking, it's easy to see that we should always choose the blameless woman over the violent man.

But it just might be that not everyone wants to live in that world.

As we made our way through our historical moment of bitter revelation and endless disappointment, I found myself coming to an uncomfortable realization, or maybe just an acknowledgment of a fact that is no fun to say out loud. The sometimes-truth is that we are interested in and, yes, even attracted to bad people. When the latest news comes out and we're all aflutter with outrage, we're ignoring a truth: Part of the reason so much attention has been trained on men like Picasso and Hemingway is exactly *because* they're assholes. We are excited by their asshole-ness. Wasn't that what we saw with Trump? We kept

pointing out, over and over: *This guy is an asshole.* And of course that was what people loved about him in the first place.

Even when I was a little kid, lying on my tummy, flipping through the *LIFE* photo book, I recognized *something* in these men, something different. Something that made them subject to different rules than the rest of the adults were following.

We want the asshole to cross the line, to break the rules. We reward that rule-breaking, and then we go a step further, and see it as endemic to art-making itself. We reward and reward this bad behavior until it becomes synonymous with greatness. Not just because the gatekeepers and publishers and studio heads have traditionally been men, but also because we ourselves yearn for plot and action. We yearn for events!

And then we are furious when this eventful asshole commits a crime.

Here, again, obviously, I am employing the word "we" to protect myself. *I* want these things. *I* drink in the spectacle of bad behavior. *I* have a penchant for assholes. Which is an uncomfortable thing to say. But important. To pretend that there's no allure to bad men is to sidestep reality. The women around these men stack up like cordwood. Certainly some part of the allure comes from the man's badness. Even George and Jerry knew the power of the Bad Boy. I myself have had any number of truly terrible boyfriends and paramours. Their terribleness was their calling card. Life is so dull. With a bad man around, *something* is very likely to happen.

It's easy to think of the quality of genius as justifying bad behavior, but maybe it works the other way around too. Maybe we have created the idea of genius to serve our own attraction to badness. Maybe we ask these artists to live out our darkest

fantasies—and if we give it the label "genius," then we don't have to feel guilt for enjoying the spectacle. We can get off on the performance of badness, we can consume the biography, and remain in good taste. Well, he's a *genius*. You can't blame him. (Or me.)

CHAPTER 6

THE ANTI-SEMITE, THE RACIST, AND THE PROBLEM OF TIME

RICHARD WAGNER, VIRGINIA WOOLF, WILLA CATHER

One cold winter night at the end of 2017, I gathered with a bunch of women from my island to drink bourbon and watch the moon rise over the water. I was trying to warm myself by jumping up and down on the rocky ground in a pair of clogs while drinking bourbon, a potentially disastrous move. A woman I didn't know well said—predictably—that we should try meeting the Trumpists with open hearts. Maybe we had something to learn about white working-class anomie . . . you don't need me to go into the details. I'm sure you had many such conversations as you made your own away across the wasteland.

I was already very weary of this kind of argument—especially because I had a growing sense that looking toward the middle wasn't going to solve anything.

My friend Rebecca, however, had an answer at the ready. "Why?" she said. "They don't want to understand me. They want to hurt me. It's always been like this for Jews. I'm afraid to go to the synagogue. And it's not like that fear is a new thing. It's the same old thing."

Rebecca got me thinking about the past. Were we better than we used to be? Or were we worse?

*E*veryone used to be such a jerk. This is an easy and natural thing to think. As I mulled over monsters and stains, I realized that often discussion of various crimes hinged on a central idea: the idea that we, as a society, simply didn't know any better at the time the crime was committed. That society was simply jerkier then. Hemingway didn't know any better; neither did Picasso.

We see this sentiment expressed all the time. When Dave Meinert—a bar owner entrenched in the Seattle music scene—was accused of rape in the wake of #MeToo, the response was exactly this. At first it seemed incredible that he'd been accused—multiple times, by multiple women. He was a guy everyone knew. He was a guy who was one of us. Surely the Seattle rock scene was better than this. Surely we didn't harbor monsters in our rainy, liberal city full of perpetual ironists. On Facebook, before the accused went silent and his page went dark, the men of Seattle rock defended and comforted him. They said things like *oh man* and *we didn't know what we were doing* and *times were so different back then.* The accusers were painted as unfair—how could they blame these guys, who didn't know any better? Somehow it escaped commenters—and other critics of *soi-disant* cancel culture—that we only know better now because people have spoken up. It's not like people just wake up one day enlightened.

. . .

One of the great problems faced by audiences is named the Past. The Past is a vast terrible place where they didn't know better. Where monstrous behaviors were accepted. Sometimes the Past seems incredibly far away, sometimes it seems to have ended last year or even last week; more difficult to accept is the idea that we are living in it *right now*—if by the Past, we mean a moment in history when injustice and inhumanity reigned.

The Past is the place where anti-Semitism and racism and misogyny were woven into the very warp and weft of literature; where women were filed into boxes like so many loose buttons— various, sure, but ultimately *classifiable;* where abuse was normal and if you performed it, you were only asserting your own normality. When we read or consume works from the Past, we discover a world filled with garden-variety assholes: wife beaters, child abusers, racists. The Past is Bing Crosby beating his kids; it's Jim's "Negro" dialect; it's *The Birth of a Nation*. We tell ourselves that was the Past and it was normal then. We tell ourselves they didn't know. We use the word "mores."

In other words, our reckoning with the past is dependent on two central ideas:

1. These people were simply products of their time.
2. We're better now.

Sitting in my cozy house, a house wrapped in the endless shimmering ribbon of social media, I feel I'm at the apex of history. I know things no one knew before. Or if I don't know something, then I can find it out quickly, easily, with no trouble at all.

This is part of why I kept trying to solve the monster problem by thinking harder, by finding an expert, by applying reason,

by building a calculator, by locating the correct answer. Because of this feeling that I must be the natural outcome of the Enlightenment. I am a citizen of the Present, where we know better.

I kept toying with this idea—the idea that I was writing the autobiography of the audience. But I wasn't seeing myself as an audience member clearly—was only dimly aware that my perspective from my perch in the Present was not necessarily enlightened. An autobiography of the audience should be subject to the same rules that govern all memoir, including the rule that the writer of memoir must be *onto herself.* Which is to say that bad memoir happens when an author is a little in love with herself—when she can't see her own faults. The same thing could be said of the audience: we think we're fantastically enlightened, but are we really so much better than the people who came before us?

I was confronted with this idea when I watched an old documentary that Stephen Fry, the perpetually delightful actor and *bon vivant* (how rarely one gets to use that term with any accuracy!), made for the BBC about Richard Wagner. My father, who was of German descent, was fascinated by Wagner. My dad and I streamed the Fry documentary in our separate houses and had a kind of book club afterward.

In the documentary, Fry positions himself as a citizen of a more enlightened era, the Present. He speaks of wishing he could travel to this other place, the Past, to prevent his beloved Wagner from expressing anti-Semitic views—specifically to prevent Wagner from writing the famously hateful essay "Judaism in Music." Fry is sure if he could travel back in time he could

explain to Wagner, he could make him *understand*. Fry positions himself as someone free from the blinders of history—he's unwittingly illustrating the liberal ideal of the ahistorical present.

He says with his usual charming shambolic diffidence: "I have this fantasy—it's typically pathetic, I'm typically a fantasist so it's very me—in which I go back in time as an Englishman and I write letters to Wagner in which I say 'I have to talk to you. Listen, you're on the brink of becoming the greatest artist of the nineteenth century and future generations will forget that, simply because of this nasty little essay that you're writing, and because of the effect it'll have.'"

"The effect it'll have" is benign language for the effect it did have—the way Hitler and the Nazis treated Wagner's music like a theme song and the festival at Bayreuth like their house band. Hitler, along with his leadership, attended the Bayreuth Festival every July from 1933 to 1939; Wagner's music and writings became entwined in the Nazi ideology.

Fry is certain he could save Wagner, or at least try to, because he, Fry, knows better.

Someone else who knew better? Wagner. It goes against every belief we have about the Past, but the fact is, Wagner was well aware of the arguments against anti-Semitism. We know this why? Because he told us so.

Which is not to say Wagner was not anti-Semitic. (Double reverse backflip there, but you see my point.) Wagner was *consumed* by anti-Semitism. Simon Callow, in his really enjoyable study of the composer, sums it up like this: "Wagner's

anti-Semitism . . . was more than a bizarre peccadillo, beyond a prejudice: it was an obsession, a monomania, a full-blown neurosis. No conversation with Wagner ever occurred without a detour on the subject of Judaism. When, towards the end of Wagner's life, the painter Renoir had a sitting with him, Wagner interrupted his own pleasant flow of small talk with a sudden unprovoked denunciation of Jews which rapidly became rancid."

Wagner also wrote at length about his obsession—that essay Fry would have liked to forestall, "Judaism in Music," was published anonymously in 1850, the same year *Lohengrin* premiered. It describes the nature of "the Jew musician"—we've barely gotten started and we're already in choppy waters. The use of the word "Jew" as an adjective is generally speaking not a good sign. My friend Alex Blumberg once observed to me as we walked through the Chicago neighborhood historically known as Jew Town: "The word Jew is fine as a noun, starts to be a problem as an adjective, and is totally not okay as a verb."

Writes Wagner, "The Jew—who, as everyone knows, has a God all to himself—in ordinary life strikes us primarily by his outward appearance, which, no matter to what European nationality we belong, has something disagreeably foreign to that nationality: instinctively we wish to have nothing in common with a man who looks like that."

Wagner is ramping up, working himself into a frenzy, and the modern reader in turn feels a mounting abhorrence, as well as a kind of lofty disdain for what we perceive as his cluelessness. But we tell ourselves he didn't know better.

And yet Wagner bases his entire rant on the fact that he *did* know better. He positions his screed as a dose of Limbaughesque *real talk* in the face of liberal platitudes calling for an end

to anti-Semitism: "We have to explain to ourselves the involuntary repellence possessed for us by the nature and personality of the Jews, so as to vindicate that instinctive dislike which we plainly recognise as stronger and more overpowering than our conscious zeal to rid ourselves thereof."

He's making the point that he and his brethren don't *want* to revile Jews. This is some real "I'm the victim here" shit. Wagner insists that he possesses—we *all* possess—a "conscious zeal to rid ourselves" of the "instinctive dislike," but an honest man must wrestle with these feelings of "involuntary repellence." Hey, man, he's just describing how everyone really feels. Incidentally, this is an example of how insidious the word "we" can be—by employing it, Wagner normalizes and universalizes his own demented and hateful perspective, and suggests that all those fighting against anti-Semitism are simply deluded or evasive when it comes to their own natures.

From Wagner's perspective, to say one is *not* anti-Semitic is to lie: "Even to-day we only purposely belie ourselves, in this regard, when we think it necessary to hold immoral and taboo all open proclamation of our natural repugnance against the Jewish nature. Only in quite the latest times do we seem to have reached an insight, that it is more rational (*vernünftiger*) to rid ourselves of that strenuous self-deception"—he means here the self-deception that we actually might not be repelled by Jews— "so as quite soberly instead to view the object of our violent sympathy and bring ourselves to understand a repugnance still abiding with us in spite of all our Liberal bedazzlements."

Well! "A repugnance still abiding with us in spite of all our Liberal bedazzlements." It's a piece of rhetoric that seems curiously contemporary, leaving aside its curlicued Germanic sen-

tence construction. This was exactly what voters loved about Trump—the way he flew in the face of political correctness, which is simply a different name for "Liberal bedazzlements." They told reporters this over and over: "He says what we're thinking," as one fan told the BBC. Wagner's statement undermines Fry's idea that people didn't know better then—he's overtly saying he did know better, and he thought those who accepted Jews were lying, if only to themselves. Just as the racists who voted for Trump think that "we" are all filled with a like-minded racism, *if only we'd just admit it.*

Wagner had the opportunity to know better—just as Trump's voters did—and he chose otherwise.

Stephen Fry is clearly riven with love for Wagner, and his genial, bluff anguish fuels his documentary. He tells us, "I'm Jewish and lost relatives in the Holocaust. So before I take my seat in the theater, I want to be sure I'm doing the right thing." In other words, he wants, somehow, to have his role as an audience member approved by some mysterious expert, some external sense of rightness. His pursuit of sureness takes him eventually to Nuremberg.

Tourists climb the stairs to stand where Hitler stood as he gave his addresses. Fry can't bring himself to climb to the podium. Instead, he perches outside the stadium and wrestles with ghosts, worrying the problem of Wagner until he eventually lands—as I myself did—on the image of the stain: "Imagine a great beautiful silk tapestry of infinite color and complexity that has been stained indelibly. It is still a beautiful tapestry of miraculous workmanship—gorgeous color and silken texture, but

that stain is real and I'm afraid Hitler and Nazism have stained Wagner. For some people that stain ruins the whole work, for others it is just something you have to face up to."

I'm sympathetic to Fry's ruefulness here . . . his sense of loss but also his enduring sense of the beauty and importance of Wagner's work. And yet, even in this statement, Fry says that it's Hitler and Nazism that have stained Wagner. But Wagner wasn't stained by history, he stained himself—his anti-Semitism isn't wrong because it inspired Hitler; it's wrong in and of itself.

After Wagner's death, Bayreuth became the site of Hitler Youth "*Strength Through Joy*" festivals and a gathering place for Nazi leadership.

The refusal to deal with Wagner's anti-Semitism has been a hallmark of his family up until the twenty-first century. Wagner's staunchest defender, though, was Winifred Wagner, his English-born daughter-in-law who ran the festival at Bayreuth from 1930 until the end of the Second World War. The question of the Past, and knowing better, comes up quite overtly in the astonishing 1977 documentary *The Confessions of Winifred Wagner*. The filmmaker Hans-Jürgen Syberberg simply trained the camera on Winifred Wagner's face as she talked about Wagner, Nazism, and her great friend (and rumored lover) Hitler.

Winifred, her face framed by a cloud of white hair, is the very picture of a *gemütlich* grandma (if a person can be *gemütlich*). She laments that Hitler had "no cozy home of his own," and tells how she tried to provide one for him on his annual visit to Bayreuth.

She recalls Hitler visiting their *cozy home:* "He was always

free and easy with the children, would go up to visit them in their beds"—the world's nightmare as jolly uncle. In fact, she calls him just that: "the good uncle with the pistol in his pocket." She laughs, showing her strong teeth: "We said *du* to each other. I couldn't possibly admit that in public. I called him Wolf and he called me Wini. We were on *du* terms. The children also said *du* to him, they called him Wolf."

She becomes animated, grinning naughtily, and then pulls herself together and reasserts: "But I don't want to divulge these purely personal things to the public."

I sat at my desk and streamed the documentary on my computer. The Winifred of the film is a chilling spectacle. She's a still-lovely woman despite her years, with strong good teeth and an upright carriage. Whether or not speculations about an affair are true, her joy at her relationship with Hitler remains pure and evident. The footage was shot in 1975—when anyone would know better. And yet she doesn't. You can see it in her naughty grin, her conspiratorial asides about what can and cannot be shared with the public.

She is gleeful when she describes how Hitler let her drive him around in her car, despite his pathological mistrust of women drivers. She says, "He used to shout 'Look out! Woman driver!'" when he saw other women at the wheel. She glows with pride at being the exception. This is truly a female monstrousness— the joy at being accepted where others of your kind are not. It's cousin to my desire to "be cool" about *Manhattan* when I was young. Making yourself the chosen one is a strategy: a bright circle drawn against almost all of the rest of the world.

Winifred visibly tamps down her delight at being Hitler's chosen one. One assumes this self-restraint is in deference to

the expectations of the present day, but it's clear she has con-
tempt for the moment she finds herself in—you can hear it
when she says "the public" wouldn't understand. To her mind,
things were not only better but *realer* in the old days, when we
didn't pretend politics were so important—what she calls "the
fuss." Like Wagner before her, she presents her anti-Semitism
as a kind of realness. In fact, she says of herself and Wolf: "We
used to laugh about all the fuss."

Winifred says she does not care for "politics." She complains
about the intellectualization and politicization of art that, to her
mind, started after World War II. The director here interjects an
apt quotation from Walter Benjamin—"Thus fascism aestheti-
cizes politics and communism answers with the politicizing of
art"—clearly indicting Wagner and his family as instruments
of fascism. The politicization Winifred decries is a response, an
"answer," to that fascism.

But of course Winifred doesn't see her role at Bayreuth as
an aestheticization of politics—like a good fascist, she believes
she and her kind are the ones who are free of politics, free of
"fuss." Winifred Wagner's attitude echoes her father-in-law's—
she believes she is only saying what's true, and those who don't
say it, don't *know* it, are simply not admitting the truth.

There is no regret, no sorrow, no compassion, no under-
standing. There is only this devastating impassivity, interrupted
by mischievous, chilling smiles.

Wagner is vilified for his own words, but also because those
words and his music became tied to the horror of the
Holocaust—because he contributed to the aestheticization of
fascism. But isn't his essay "Judaism in Music" bad enough in

itself? If language needs to have effected action in order to be objectionable, haven't we just let every raging bigot who doesn't actually hold political office off the hook? Anti-Semitism isn't only wrong when it contributes directly to a Holocaust.

Not long after I watched Fry's documentary, I found myself reading a collection of Woolf's diaristic writings titled *Carlyle's House and Other Sketches* in the great reading room of the University of Washington library. I won't enumerate her various flippant anti-Semitic remarks, but it turns out her diaries were pocked with them. It was a marital joke that she referred to her husband, Leonard, as "my Jew." For of course this is the complicating factor: Woolf was married to a Jewish man—and as one of the "Bloomsberries," she'd seem to be a model of tolerance. (Again, that bedazzling Liberalism!)

Perhaps she too thought that she was at the top of the heap of history; that she was too enlightened to be considered intolerant.

I mentioned to a Jewish friend that I'd rumbled Virginia Woolf's anti-Semitism and had been thinking about how this stained her work—or didn't. My friend replied matter-of-factly, "Well, if we give up the anti-Semites, we'll have to give up everyone."

Why has Woolf's anti-Semitism been forgotten? It's far from the first thing we think of when we think of her. And it's a small thing, a casual thing, a buried thing. As with T. S. Eliot and Edith Wharton and Dostoevsky, we think first and foremost of literary output. When confronted with their anti-Semitism, we think of it as something that has to do with their moment in history—as if the anti-Semitism were the weather of the era, and it simply blew over these writers.

Woolf's life has become important to us. Various films have

been made based on the Bloomsbury group's overlapping lives, set in the London neighborhood they are named for, or in the country houses they frequented (including the villa Ham Spray, an absolutely disgusting name for a house). The film *The Hours* gave us Woolf as a character—depressed, feminist, brilliant, elegant—an image reiterated in tote bags and gift books. Woolf-as-character has largely replaced Woolf as an actual writer.

We think of Woolf and the Bloomsbury group as bedazzling standard-bearers of liberalism. Doris Lessing wrote in her fore-word to *Carlyle's House,* "We all wish our idols and exemplars were perfect; a pity she was such a wasp, such a snob—and all the rest of it—but love has to be warts and all. At her best she was a very great artist, I think, and part of the reason was that she was suffused with the spirit of 'they wished for the truth'—like her friends, and indeed, all of bohemia."

This is the version of Woolf that has "won"—the bohe-mian who wished for the truth. We give her a pass because of her era, but in 1939, E. M. Forster, himself on the fringes of the Bloomsberries, published an article, "Jew-Consciousness," which concluded, "To me, antisemitism is now the most shock-ing of all things." How important, how poignant, is that brief word "now"—gesturing with a small hand at Europe in 1939.

We think it's ignorance, on the part of these people in the past. We imagine these poor deluded souls simply wait-ing for scales to fall from their eyes, but in fact what is really happening is that anti-Semitism and racism were often tied to a larger project of domination.

The racism in American classics like *Little House on the*

Prairie or *My Antonia* is hardly incidental. The settlers on Willa Cather's prairie are hyperaware of where their neighbors originally came from; that's part of the pathos of the book. In this book about Manifest Destiny, each character is defined by his nationality: German, Norwegian, "Bohemian" (Czech), Russian. The characters are marked by their heritage, but they are in fact full characters, regarded tenderly by their author. Their otherness is appreciated; when the narrator tastes some dried mushrooms his Czech neighbors have been hoarding, he imagines his way into their experience: "It was many years before I knew that those little brown shavings, which the Shimerdas had brought so far and treasured so jealously, were dried mushrooms. They had been gathered, probably, in some deep Bohemian forest." There's a humanity in these depictions—until we meet a Black character, that is. When the piano player Blind D'Arnault appears, suddenly Cather is a caricaturist: "He had the Negro head, too; almost no head at all; nothing behind the ears but folds of neck under close-clipped wool. He would have been repulsive if his face had not been so kindly and happy." Cather goes on like this for a few pages—D'Arnault is a creature, a savage, a "glistening African god of pleasure." The westward expansion of the Jeffersonian ideal was clearly not for everyone.

The same ethos is in place in the Little House books, in which the Wilder family make their way westward into what they perceive as an empty space: "There were no people; only Indians lived there." This is on the first page of *Little House on the Prairie* in the early editions—the title page features a Helen Sewell illustration of a sweet-faced Laura Ingalls, clutching a doll; you turn the page and a whole group of people is being dehumanized. Indians are a constant threat in the books; Pa unburdens him-

self of the ol' chestnut "the only good Indian is a dead Indian."
And in *Little Town on the Prairie,* we get the appearance of a gang
of white folks in blackface.

As a child, I loved *Little House on the Prairie.* I read and reread
the books until they were as known to me as my own history—
maybe more so. I pretended I was Laura. I *owned a sunbonnet.*
The freedom I dreamed of was white freedom. Of course I didn't
see it that way. But the racism was part of the project; the project
of making more freedom for white people. It's not accidental
that it was there; it was part of *the deal.*

We think they didn't know. And at the same time, we believe
we would've done better. This time-traveling impulse is
crucial: we, like, Stephen Fry, want to hurtle back in time and
sort of spritz our enlightened-ness all over the place.

At the dinner table one night, my father asked my kids if
they would've spoken out against Nazism had they lived in Wei-
mar Germany. My kids, supple thinkers and moral self-indicters,
thought the question through and answered: They hoped so? It
was impossible to know, but they certainly hoped so.

My dad answered: I would've fought against the Nazis! The
kids laughed about it later—they felt like Charlie Brown and the
football. They thought my dad was setting them up for serious
soul-searching, and then he trumped their careful honesty with
his enlightened sureness.

This kind of thinking is conditional: If I'd been in x place at
y time, I would've done z thing. There's actually a name for this
construction in grammar. It's called the third conditional tense,
and is explained thus: "The third conditional tense describes

something that did not happen, but could have happened given the right conditions."

Given the right conditions, we would've done the right thing.

The conditional seems absolute in the mind of the would-be do-gooder looking back on an earlier era, maybe while wearing a sunbonnet. We feel sure of what we would have done.

But for those whose families survived the Holocaust, the conditional is a lot more fraught and a lot more urgent.

I told my friend Tova about my dad's thought experiment with my kids, and she pointed out that it was like a mirror image of the conversation that was a common recurrence in her Orthodox family when she was growing up. "We would always ask about gentiles: 'Would they have hidden us? Would they hide us now?'"

The conditional starts to seem a lot more menacing when you look at it as Tova describes: someone's help or support is *conditional*—that doesn't sound like the kind of help you'd want to count on.

The liberal believes in the constant improvement of man. Liberalism has as one of its central tenets a teleology of goodness, a rising toward justice. We have an idea that somehow we're getting *better*.

This idea separates us from history—we are no longer subject to its forces. History is over there, or behind us, or beneath us. We are in a special position: its apex. From this apex, we know best.

· · ·

We imagine we would've been that person, the one who would've written the letter, who would've spoken out, would've hidden the Jews, would've provided the stop on the Underground Railroad.

We say this to ourselves as the world literally burns, as militarized police forces murder citizens, as children are held in camps at our own borders.

The idea of time—laden with the badness that came "before"—and our apex at the top of it is a way of distancing ourselves from the negative aspects of humanity. The idea of the Past functions in the same way the word "monster" does—it serves to separate us from all that is worst about humanity. We are the adults of the world. We have outgrown our worst behaviors. We are not monsters. *That* is not *us*. We cast history, and monsters, out from our enlightened circle.

This belief that we know better—a moral feeling, if ever there was one—is very comfortable. This idea of the inexorable, benign teleology of justice, of liberalism, of fairness, is seductive. So deeply seductive that it clouds our thinking and our awareness about ourselves. We are the culmination of every good human thought.

This idea of *getting better* is what tripped up the political scientist Francis Fukuyama and his ilk in the early 1990s, when they asserted that the Hegelian end of history had—ta-da!—arrived. In his book, aptly titled *The End of History*, Fukuyama wrote that communism had fallen in Russia and was being eroded by the forces of capitalism in China; ideologies of repression and religiosity were being replaced by the cultural juggernaut of market economics. Wrote Fukuyama: "Rather than a thousand shoots

blossoming into as many different flowering plants, mankind will come to seem like a long wagon train strung out along a road. Some wagons will be pulling into town sharply and crisply, while others will be bivouacked back in the desert, or else stuck in ruts in the final pass over the mountains. Several wagons, attacked by Indians, will have been set aflame and abandoned along the way." In other words, some might get left behind, but we're all headed somewhere better, together. (The "attacked by Indians" bit is . . . rough.)

Liberal capitalism is, in this model, where we have *arrived;* it is a destination, not a blip in history's ongoing timeline.

And then came, guess what, more history. It hadn't ended at all. Over the last few years it has seemed to be rubbing its hands together and announcing that it's just getting started. Or perhaps ending altogether—just not in the way we expected.

We think about Wagner and we ask the question: what should we do about sins from the past, now that we're enlightened? But what if we rephrased it: what should we do about sins from the past, when we haven't improved?

That's why the *Access Hollywood* tape was so shocking— not because it happened, but because no one really seemed to mind. There was no uproar. The nation did not rise up with a single voice to say: *This is not who we are anymore. We know better.* Instead, we elected the grabber president. Over the following years, the proof escalated that the things we thought we'd transcended were still there, lurking like bad fairies. But that makes them sound alien, and for the last few years we've been confronted with the fact that the evil fairies are us.

This wasn't news to Black Americans, or to Jewish Amer-

icans. But a lot of us spent a lot of time being, as has been extensively pointed out, a lot more shocked than we should've been. What we were seeing did not match the liberal ideal of improvement. Again, my friend Tova: "One of the passages of the seder that haunted me was 'in every generation an enemy will rise up to destroy us'—I was horrified that it wasn't just the past but would happen to me too. This feels so central to Jewish identity, this dark awareness of history as not getting better."

What do we do with the art of monsters from the past? Look for ourselves there—in the monstrousness. Look for mirrors of what we are, rather than evidence for how wonderful we've become.

Looking for ourselves in the monsters of the past can raise some uncomfortable specters: Is it accidental that so much vit-riol has been spilt on Woody Allen and Roman Polanski, two Jewish men, one accused, one convicted? Is there an anti-Semitic energy in our vilification of them? After all, the oldest trope of anti-Semitism is: they're coming to take our children. It's a question that must be asked, and is impossible to answer.

By 2018, we were no longer shocked by the things that had shocked us even two years earlier. When the Tree of Life shootings took place in Pittsburgh in October of that year, the general sentiment was surprise that something this terrible hadn't happened sooner in the Trump presidency.

A few days after the shooting, I drove across the island to the Kol Shalom synagogue to attend services. It was a brilliantly sunny October morning; I drove with my window open and

smells rushed in: salt water, cut grass. When I arrived I saw that the little hall was full—our island community had turned out for services, as if our soft aging gentile bodies could stop an act of violence.

The sunlight was pouring in the high windows of the temple. The rabbi said: *Before the world was made, God was complete and whole. If that's the case, then there was no space for something new to be made. So he blew himself up and out of the broken bits came the world.*

The world has always been broken. Even as we sat here, with our good educations and our good intentions, we were in the midst of learning a terrible lesson. We were learning that we were part of history after all.

When Stephen Fry describes the letter he'd like to write to Wagner—"*Listen, you're on the brink of becoming the greatest artist of the nineteenth century and future generations will forget that, simply because of this nasty little essay that you're writing*"— he's actually describing the dynamic that we call cancel culture. The very term "cancel culture" is hopelessly non-useful, with its suggestion that the *loss of status* for the accused is somehow on a par with the *suffering* endured by the victim. Stephen Fry's distance from the past—his assumed enlightenment—allows him to say something to a historical figure that he might not say to someone alive.

(I don't mean to pick on Stephen Fry. I admire his courage in wrestling with this question—on-screen, yet. He's unwilling to give up the work he loves, and he's unwilling to look away from the stain. He's trying to build his own calculator!)

What (miserably) gets called cancel culture is the contemporaneous act of telling someone that the thing they're doing or saying is, to use Fry's word, "nasty." Cancel culture is, from this perspective, the most sensible thing in the world—rather than fantasizing about confronting someone in the past, practitioners of cancellation are confronting someone in the present. And such confrontations should be welcome, right?

This is a hint that our self-concept of being at the apex of enlightenment is maybe a little off. Because if we were really so enlightened, wouldn't we celebrate that this *pointing out* has occurred? I don't mean to pretend an innocence that I don't really have. Of course I know that the pointing out of wrongdoing can become, has become, virulent. Of course I know that because of the way we process accusations, there now exists a culture of fear, a sense of imminent exposure. Personally, I regret things I've said, things I've written, things I've done. They're out there and I know I was wrong. I have a sense of fear that I might be shamed for my mistakes. Is this shame-in-waiting the price we pay for the reckoning of #MeToo? Is it some kind of Greek myth–like trade-off where we don't get one without the other? If so, is it worth my potential loss of status for victims to be able to say what happened to them? My answer is, tentatively: yes. Even though loss of status can be pretty fucking awful.

This trade-off is depressing and maybe even inhuman—but, to my mind, it's the bargain that's on the table right now. Some people endure shaming, deserved or undeserved, so that some other people can say what happened to them. Instead of accepting that bargain, we make up an insulting and increasingly dumb name—cancel culture—that invalidates half the equation: the half where people are able to say *something is wrong*. Perhaps

this is the wrong bargain; probably it is. But it's the reality we live in.

The liberal fantasy of effortless enlightenment simply assumes we're getting better all the time. But how on earth can we improve unless we listen to people saying what's wrong?

THE ANTI-MONSTER

VLADIMIR NABOKOV

A book from the Past that is almost universally perceived to be a problem is *Lolita*. We approach it tentatively, afraid to poke the beast. For *Lolita,* over the decades, has been alchemized into something truly strange: a text that is perceived, in and of itself, as an act of abuse.

To read the book is to engage with the monstrous. And surely the man who wrote the book must himself be a monster.

But was Nabokov a monster? When you squint at him, he certainly seems to possess a monster-shaped outline. Though he wrote three masterpieces, several merely great novels, and one gigantic stinker, he's best remembered as the author of a monster-portrait. Humbert Humbert, the child rapist, is so perfectly and totally depicted that he's become mixed up with his author: Only a monster could know a monster so well. Surely *Lolita* must be a kind of mirror of its author.

Was Nabokov a monster? When I first read him, I would have voted a Valley Girlish yes. I was thirteen. I knew *Lolita* was officially an important book, but it was about a girl my age. This seemed felicitous. I'd recently made a successful assault on another important and grown-up novel, *The Great Gatsby;*

flush with triumph, I thought I might give *Lolita* a whirl. I pulled it from the shelf and took it outside to my reading hammock, hung between two trees high above Puget Sound, a hazardous arrangement which—aptly, unknowingly—mirrored the opening line of Nabokov's *Speak, Memory:* "The cradle rocks above an abyss."

Well, I was horrified. Most of it was repellent, and even the non-repellent parts were upsetting: "She was Lo, plain Lo, in the morning, standing four feet ten in one sock. She was Lola in slacks. She was Dolly at school. She was Dolores on the dotted line. But in my arms she was always Lolita." Why did Lolita have so many names? She hardly seemed like a character at all. You never learned any real information about her. You never learned her point of *view.* Lolita, Dolly, Lo—Humbert went on and on about her, and yet you never learned what she was really like. Lolita was a destination never arrived at, a Zeno's paradox of a girl. On the other hand: Why did Humbert Humbert have only the one name, repeated like a mumbling stutter? And why did he *never shut up?* If the book was named after her, why—after a whole day of reading—did I only know him?

With the myopia of the very young, I looked for signs of myself. I was interested to see old HH set age parameters for nymphet-hood: "I would have the reader see 'nine' and 'fourteen' as the boundaries—the mirrory beaches and rosy rocks—of an enchanted island haunted by those nymphets of mine and surrounded by a vast, misty sea." (A landscape that recalls the utopian/menacing little-girl-world of Henry Darger.) By the metric of age, I myself was a nymphet—though it seemed there was more to it than that. There were, I found, requisites of nymphet-dom not visible to everyone: what Nabokov called "ineffable signs—the slightly feline outline of a cheekbone, the slenderness

of a downy limb, and other indices which despair and shame and tears of tenderness forbid me to tabulate." Clumsy, too tall, coarse-haired, overly preoccupied with where my next bowl of vanilla ice cream with chocolate sauce was coming from, I had my doubts about my own nymphet-dom. Yet I still felt this drive to locate a character with whom I might identify, and looked first to the girl my age, and at the center of Humbert's depiction of her I found . . . nothing. Just endless tar-black, curlicue thoughts about her, say, shoulder blades.

It all seemed pretty unsavory. By the end of that first day of reading, I was suffused with disgust: at Humbert, at Nabokov, and most of all at what I saw as the one-dimensional depiction of the girl in the book. Lolita was not what I thought of as a real character, and her failure to materialize made me angry.

My response was emotional: I was sad about Lolita's absence from *Lolita*.

The question I didn't ask: *why* had Nabokov disappeared her?

My tween reading conflated Humbert Humbert and Vladimir Nabokov. This conflation was perhaps or even probably invited by Nabokov, who well understood the physics of reading. *Lolita* is told in the voice of (fictional) memoir—Humbert speaks directly to the reader. By annexing the "I" voice—the confessional storyteller's voice—Humbert becomes the author of the book. Nabokov is playing with the formulation "Humbert Humbert, *c'est moi*."

If knowledge of an artist's biography affects the way we see his work, in this case knowledge of the work affects the way we approach his biography. What was the Venn diagram of Humbert's desires and Nabokov's?

From his early Russian work *The Enchanter* all the way through his posthumous novel, *The Original of Laura,* Nabokov shows us men having sex with very young girls, or trying to have sex with very young girls, or trying (not very hard) *not* to have sex with very young girls. Yet there is no evidence at all that Nabokov himself was a pedophile in his inmost heart. Nabokov himself of course would have had contempt for any attempt to guess what was in his heart. Even the idea of Nabokov having a heart is a bit hard to imagine. This reader wonders if maybe he had novels instead of a heart. In any case, he disdained a biographical approach to an artist's life in favor of what was left on the page: "The best part of a writer's biography is not the record of his adventures but the story of his style."

And yet: just how did Nabokov come to understand Humbert so perfectly? With that next question always lurking nearby: was Nabokov a monster? As a child reader I wondered that, without quite articulating it. I couldn't get past the idea, or rather the feeling, that Nabokov was infusing Humbert with his own criminality.

Looking back, my idea that Humbert *was* Nabokov seems a piece of youthful foolishness. Am I implying that such a reading—one that assumes Nabokov's own monstrousness—is childish? There's certainly an error involved, an error of confusing a thought with a deed, or rather condemning an author for having the thought and making up a story about the deed.

I thought—or rather felt—that Nabokov's subject matter made him a monster.

· · ·

We shouldn't punish artists for their subject matter.

But we do. We punish artists for their subject matter all the time. Now more than ever. Could *Lolita* be published today? I doubt it. The story of a serial predator who grooms a young girl, abducts her, takes her on a cross-country road trip, rapes her every night and in the mornings too, and prevents her escape at every turn? And we only get *his* point of view? It's impossible to know whether or not the book would be published now, but it's easy to imagine an outraged reception.

What we do know is that Nabokov made this monstrous subject matter his own. *Lolita* is the scorched-earth offensive of pedophile novels (and sometimes, it seems, of novels in general); it's hard to see why we need another one.

In the wake of #MeToo, in the backwash of the tidal wave of monstrous men, I came again to *Lolita*. I was no longer a nymphet myself; I was a mother struggling with the challenge of raising free children, children I wanted to go forth in a world that, at times, seemed teeming with predators. I was also a very weary woman; weary of the stories of men. I picked up a copy of *Lolita* from Magus Books in Seattle's University District; possibly the same place it had been bought the first time I read it. Magus is a place that connects me to my young-teen self; my girl-thoughts seem to swirl around up there in its dusty rafters.

Rereading the book, lying in bed and sipping bourbon as a kind of preventative measure as I made my way through its pages, I was forced by the prose into recognition of the greatness—the intentionality—of the book. Nothing here was an accident. We don't need to commit the intentional fallacy in order to wonder what Nabokov was up to. We ask what he was up to because we assume he has a finer mind than we do, and we want to under-

stand how it worked. And so I had to ask the question begged by the book:

Why did Nabokov spend all this time with Humbert?

It's a mistake to ask this question in search of a biographical answer. In other words, we need to ask the question not about Nabokov as a man, but about Nabokov as an author. We must ask, as we learned to do in lit class and as we yearn to do when we find ourselves trapped, clutching a glass of warm white wine, at interminable book groups where the idea of authorial intention is anathema: Why does the author choose to do this? *What is happening in this book, and why?* The biographical answer to such questions is a brick wall, where Nabokov is concerned. The only answer is the aesthetic answer.

To put it another way: why did Nabokov, possessor of one of the most beautiful and supple and just plain funny prose styles in the modern English language, spend so much time and energy on *this* asshole?

Maybe the answer can be found in the words of another asshole, Roman Polanski. In the klieg-light aftermath of his rape of thirteen-year-old Samantha Gailey, he said his desire to have sex with young girls was the most ordinary thing in the world. "I realise, if I have *killed* somebody, it wouldn't have had so much appeal to the press you see? But . . . fucking, you see, and the young girls. Judges want to fuck young girls. Juries want to fuck young girls—*everyone* wants to fuck young girls!"

Polanski, of all people, has given us a piece of wisdom here:

the desire to rape children is not so unusual. Why should Nabokov tell the story of Humbert? Because, as Polanski tells us, it's an ordinary human story. It's terrible and unthinkable and appalling and it happens all the time. That makes it fit subject matter for a writer.

But the ordinariness of Humbert's crime is not the *overt* story *Lolita* tells. From Humbert's point of view—that is, the book's point of view—his love for Lolita is something unique, without double. We know he and his love are extraordinary because he tells us so, at gassy, purple, gorgeous length. Only "an artist and a madman" can really see and love a nymphet—that is, a man outside of the ordinary throng of life. Humbert is not just outside that throng, but above it.

Humbert is, like a student at a progressive prep school, *special*. In fact, Humbert himself uses the word "special" to describe his case more than once. Doubling down on the idea of his uniqueness, he calls his pedophilia "an inherent singularity."

Humbert's inner life is elevated above all others—the book is, after all, presented as a memoir. If memoir is forever battling a reputation for narcissism, then Humbert, with his criminal self-involvement, is the ultimate memoirist. Memoir is, at its worst, a long howl about one's own specialness.

Not just his genre, but his language reaffirms this specialness. His language trumpets its own distinction; it's language with a great PR team. Humbert famously says, "You can always count on a murderer for a fancy prose style." His language is designed to set Humbert apart; to assert his extraordinary status.

In reality, as Polanski indicated, Humbert is far from special—not a "singular" monster, but just a run-of-the-mill child abuser.

Humbert tells us again and again of the specialness of his

love for Lolita. But of course that love is not special. Humbert's idea that Lolita is fated for him—chosen by the gods—is subverted before he even meets her. He first comes to Lolita's hometown of Ramsdale in pursuit of a place to live; he's been offered a room by a Mr. McCoo, the cousin of an employee of his deceased uncle, the flimsiest of connections. This uncle's employee's cousin writes to Humbert, telling him he happens to have not just a room, but a twelve-year-old daughter—to Humbert's mind an even better amenity. When Humbert hears of this McCoo daughter, he heads for Ramsdale so fast he practically makes a cartoon screeching sound. "I exchanged letters with these people, satisfying them I was housebroken, and spent a fantastic night on the train, imagining in all possible detail the enigmatic nymphet I would coach in French and fondle in Humbertish." When he arrives in Ramsdale, he is greeted with the news that McCoo's house has just burned to the ground, "possibly, owing to the synchronous conflagration that had been raging all night in my veins." The room—and with it the McCoo nymphet—is lost.

But then, oh then, just a few hours and four pages later—"the king crying for joy, the trumpets blaring"—Humbert encounters Lolita. "I find it most difficult to express with adequate force that flash, that shiver, that impact of passionate recognition."

Humbert's story (and he's sticking to it) is that Lolita stirs his soul because she reminds him of his first childhood love. But what about the McCoo girl? Doesn't his overnight conflagration suggest Humbert was primed to pounce on some girl—*any* girl—and experience that "impact of passionate recognition"?

If the McCoo house had not burned down, would the same fatefulness have befallen Humbert and the McCoo child?

What's so special about that?

. . .

On the other hand, it's true that, in one way, Lolita is perfect for Humbert. Lolita is perfect because she is improperly protected. Her perfection lies in her vulnerability, her availability, her *access*.

These are special qualities sought by that most ordinary of criminals, the pervert.

Humbert, in fact, realizes his own ordinariness in the end. The realization of his ordinariness comes contemporaneously with the realization that he's destroyed Lolita. Just before the fight scene with Quilty, he wonders parenthetically: "(Had I done to Dolly, perhaps, what Frank Lasalle, a fifty-year-old mechanic, had done to eleven-year-old Sally Horner in 1948?)." The question answers itself. Humbert is no more special than Frank Lasalle.

Nabokov then almost immediately revisits the theme of Humbert's non-specialness as we move into the passages about Clare Quilty; here H and Q are melded together, doubled. Quilty wears a purple bathrobe "very like the one I had," says Humbert. The two become one as they fight it out: "He rolled over me. I rolled over him. We rolled over me. They rolled over him. We rolled over us." There's a case to be made that Quilty is not a real person, but a figment—even so, his existence makes this point: Humbert Humbert is not so singular after all.

Lolita herself seems to understand Humbert's ordinariness. After the first time he rapes her, she herself names it as an ordinary crime: " 'You chump,' she said, sweetly smiling at me. 'You revolting creature. I was a daisy-fresh girl, and look what you've

done to me. I ought to call the police and tell them you raped me. Oh you dirty, dirty old man.' "

What could be more common than a dirty old man? Humbert and his fancy prose style are reduced in three words to a stock character. Nothing special.

What does Humbert's ordinariness mean to Nabokov?

It means that Lolita's victimization is a tragedy, precisely because it is not unique. Lolita is isolated, but not alone.

Everyone wants to fuck young girls.

Lolita has been defended from the time of its first publication, and the defense goes like this: Nabokov has found the humanity in a monster. This reading re-centers Humbert, and reifies Humbert's own self-concept as extraordinary. But Nabokov is clearly saying something different—Humbert is, in reality, ordinary as dirt. He's the dirty old man who walks by you every day, disguised in this case by a fancy prose style.

Humbert is not special. Humbert is not extraordinary. He's Frank Lasalle. He's everywhere.

If Humbert is ordinary, then Lolita is too. She too is everywhere. She's all around us—the girl whose life has been destroyed. The ubiquitous victim of the ubiquitous monster. And it's *her* ubiquity that ultimately concerns Nabokov.

The clue is in the title. The book is actually about what it says it's about: a mere girl.

The fact that we can't quite see her is part of the story. She's obscured from our view. We only see what Humbert wants to

see—or wants us to see. Humbert reduces Lolita to her downy parts; or, more correctly, to his own idea of her. But even as that's happening, Nabokov gives us—sneakily and not very often—her real, lived experience.

We catch a glimpse of her interior life every once in a while, through a Humbertian glass darkly. Here Humbert recalls their cross-country road trip: "And I catch myself thinking today that our long journey had only defiled with a sinuous trail of slime the lovely, trustful, dreamy, enormous country that by then, in retrospect, was no more to us than a collection of dog-eared maps, ruined tour books, old tires, and her sobs in the night—every night, every night—the moment I feigned sleep." This brief sob-clause is a glimpse of a girl's interior life; it's been hiding there all along, while Nabokov has been letting Humbert natter away.

The book is of course very plotty—road trips and rape and even murder—but rereading it as an adult, I almost viscerally felt the real plot to be Humbert's dawning recognition of Lolita's personhood. He has overlooked the person he is destroying. And we have too. We are implicated in the story; we too forget that Lolita is a person, until, with horror, we remember.

Humbert's dawning realization is told with typical flip grotesquerie as he's walking closely behind Lolita and one of her little friends, as always titillated (disgusting, apt word) by the proximity of children: "It struck me, as my automaton knees went up and down, that I simply did not know a thing about my darling's mind and that quite possibly, behind the awful juvenile clichés, there was in her a garden and a twilight, and a palace gate . . . lucidly and absolutely forbidden to me."

A garden and a twilight and a palace gate are fancy-prose-style ways of saying "soul," and everyone has one. The garden, etc., are guessed at, but of course we never get to see them.

Humbert's recognition that they might "possibly" exist only serves to remind us of all we haven't learned about Lolita. We yearn for a glimpse of her outside his perspective. Miss Pratt, the headmistress of Lo's school, calls Humbert in for a meeting, and gives him a lengthy rundown of all the teacher's opinions and observations of the girl. We thrill to this glimpse of Lolita in the world, unmediated by Humbert's gaze.

Humbert's growing apprehension of Lolita's personhood affects his behavior not at all. His growing understanding of his own monstrousness is all the redemption Humbert ever experiences. We expect redemption to mean the same thing as *cure*. Humbert is never cured—even toward the end, at a moment of crisis he says: "Rather abstractly, just for the heck of it, the ancient beast in me was casting about for some lightly clad child I might hold against me for a minute, after the killing was over and nothing mattered any more, and everything was allowed." He never becomes unstained by desire, but he eventually does recognize that Lolita is a real child who exists outside of his use of her—or existed, anyway, in the past tense, before he destroyed her.

Lolita's inner life is ignored by Humbert, and seems to be ignored by Nabokov. But her voicelessness becomes a glimmering, heartbreaking absence at the center of the novel.

The book is ultimately not (or not just) a portrait of a monster, but a portrait of a girl's annihilation.

And the theme of ordinariness serves to remind us: not just one girl's annihilation, but a whole world of Lolitas, ruined by a whole world of Humberts, ruined not just bodily but existentially.

Child rape is not just a sexual act, but the thievery of childhood itself. The annihilation of personhood is the act's terrible trace.

. . .

In one of the novel's most famous passages, Humbert is on a hillside above a small town, not long after he has lost Lolita, when he hears a din from the town below: "What I heard was but the melody of children at play, nothing but that, and so limpid was the air that within this vapor of blended voices, majestic and minute, remote and magically near, frank and divinely enigmatic. . . . I stood listening to that musical vibration from my lofty slope, to those flashes of separate cries with a kind of demure murmur for background, and then I knew that the hopelessly poignant thing was not Lolita's absence from my side, but the absence of her voice from that concord."

Humbert is contemplating here the species of lucky children who belong unthinkingly to the habitat of childhood. He has cast Lolita out from that group. If Humbert is not special—if he is in fact as ordinary as Frank Lasalle, if everyone wants to fuck young girls, if this is an *ordinary crime*—then we can think of Lolita as, unwittingly, a member of another, much less lucky group of children.

Lolita's absence from the novel is the sound these luckless, cast-out children make: the unquantifiable silence of the abused.

If Nabokov sides with a silent (though very talkative) victim in Lolita, does that place his sympathy with silent victims everywhere? Martin Amis has made the case that Nabokov aligned Humbert's pedophilia with the Shoah—that they were, in Nabokov's moral universe, on a kind of par.

Her lack of voice joins a concord of silence—the silence of all the other children who've had their childhoods stolen in this extremely ordinary manner.

. . .

When I read the book as a young girl, I was disturbed by the lack of what I would have called, with my eighth-grade Language Arts vocabulary, Lolita's "character development." I was freaked out by her absence. Rereading now, knowing what I know about being a girl who's been predated in the most ordinary, run-of-the-mill ways, I felt her absence again.

This time I felt its rightness, its truth. In my grown-up reading, Lolita's cypher-like presence throughout the book—her silence—seemed not only apt from a literary standpoint; it felt real. It felt like an evocation of my experience as a girl moving through the world.

My furious, fed-up thirteen-year-old reading of *Lolita* had actually been correct. Not the part of conflating Nabokov and Humbert. But the part where I had an almost visceral reaction to Lolita's lack of real presence in the novel.

I was reading the world's most adept depiction of the erasure of a girl. Maybe it scared me because I, like so many girls, was living this story, in a smaller, quieter way.

Nabokov denies our attempts to do anything so crude as identifying with a character. But I had the strange experience of identifying with a silence.

It's a piece of obviousness, but it bears stating: my vertiginous, scary, illuminating experience of reading female erasure was contingent upon Nabokov's decision to write *as the monster*. He

had to risk his own conflation with Humbert in order to make the reader see and feel Lolita's annihilation. This conflation is what raises the question: Was Nabokov a monster? Did he feel the things Humbert felt, think the things Humbert thought? (And after all, he visited these themes elsewhere.)

And if he did feel or think them, is that really monstrous? Or just ordinary human perversity? After all, thoughts are not deeds. Stories are not crimes.

The truth is: People harbor all kinds of terrible, not-useful, perverse feelings. For instance, every time I ride a ferryboat, I experience the strange desire to throw my car keys overboard. Moreover, occasionally I experience the desire to throw *myself* overboard. I don't act on these feelings—and no more, according to every extant biography, did Nabokov act on any feelings he might (or might not) have harbored.

And yet only by stepping into the role of a person with these feelings was he able to write *Lolita*. Every good artist knows this is true of the best work: It takes some plundering of the self. You go in there and you have a look around and you bring back something that might make people uncomfortable and you write it down—even if it's awful, even if people don't want to hear it, even if it makes you, the artist, seem like a freak.

Because the great writer trusts that the most terrible feeling is hardly unique.

The great writer knows that even the blackest thoughts are ordinary.

. . .

B ut for pete's sake, that doesn't mean you have to act them out. Nabokov and child rape: The writing exists and the action never did—does that mean the writing replaced the action? It's possible that Nabokov had monstrous desires, and channeled those desires into his own work. Which is not to say that his work was written from a therapeutic or cathartic standpoint—god forbid—but that he had the great artist's impulse to step toward what was most awful in himself, rather than away from it.

Thought is not action. Subject matter has been put on trial—Roth is called a sexist for (among other things) writing sexist men; James Salter's final book was decried for describing sex between a grown man and a young girl. These are reports from the vilest backwaters of male desire; but the reporting itself is not a crime.

Nabokov, in writing these dark desires, rejected the formula that genius deserves license. Greatness does not mean a free pass to do whatever you want. (And, again, we have no proof that having sex with children was something Nabokov wanted to do.) Earlier in this book, I quoted lines from Jenny Offill describing Nabokov as a kind of monster: an art monster. And this may well be so. He may have inhabited the role of the writer whose needs are primary. But when we think about the license enjoyed by genius, we can see that Nabokov refused the criminal possibility of his own monstrosity. He never became that particular kind of all-consuming gorgon.

Once *Lolita* was published, Nabokov cast the shadow of a monster. This was the risk he ran—the risk of being thought of as an ordinary criminal—so that he could tell this particular story.

. . .

I n the latter part of the book, there's a scene that raised my hackles as an adult reader of the book; scared me, in fact. Humbert is weighing his pistol in his hand and thinking back to the time, years ago, when he learned to use it. He remembers going out into the woods to shoot with his neighbor Farlow and an ex-cop named Krestovski:

"Farlow, with whom I had roamed those remote woods, was an admirable marksman, and with his .38 actually managed to hit a humming bird, though I must say not much of it could be retrieved for proof—only a little iridescent fluff."

That's the project of *Lolita*. To show us what's been destroyed.

Nabokov is in fact a kind of anti-monster. He was willing to have the world think the worst of him. By doing so—by telling the worst story, and letting himself be implicated in that story—he created a way for us to understand, to feel, the enormity of what it is to steal a childhood.

The book seems to be a portrait of a monster. But Nabokov has done something even more miraculous. He has caught hold of a bit of iridescent fluff—retrieved for proof of an ordinary life's destruction.

THE SILENCERS AND THE SILENCED

CARL ANDRE, ANA MENDIETA

Let's pause for a moment on the image of the hummingbird—or, as Nabokov would style it, "humming bird," which loses the speedy darting look of the run-together "hummingbird" but has one advantage: the added pause places an emphasis on the idea of *humming*.

Humming as in a sound, as in the opposite of silence. Nabokov wrote the (very chatty) silence of Lolita; but representing a silence is a weird chore. I wondered about that chore—how to do it—as the accusations/cancellations/#MeToos piled up. But what about the people whose work was ignored while criminal men hoovered up all the resources? What about the silence of the people whose work never got made?

The world is full of voices unheard. We think of Dora Maar or Shakespeare's sister, but of course we don't know what we don't know. The work made by people who never found publishers; the work un-made by people crushed by poverty and racism or just indifference.

Part of the problem is that we don't always think to notice these absences—even when it's us who's missing. In her memoir *Real Estate*, Deborah Levy writes: "In my late teens I had read the dusty literary journals my mother kept stacked on her shelves, dating back to the sixties and seventies. I was interested in the interviews with brilliant male writers and barely noticed there was not a single interview with a female writer." The monstrous man displaces other voices. But how do we find them and how do we hear them?

Levy is aware, as an adult, that she might have been one of those voices. "Yet I had glimpsed a shape for my life when I was quite young. I knew I was a writer. Who is *she* then, this writer girl/woman? To not have been offended at the absence of women in the pages of those high-end journals was a terrible disconnect from whatever I must have felt at *her* absence. It was just normal. It was normal to be disappeared."

How do we count silences?

Obviously it's impossible to describe art that didn't get made, but the death of Ana Mendieta makes a kind of parable about artistic silence. In 1985, Mendieta was a young, not-well-known artist who made what she called "earth-body works." Her work was also informed by feminism, by ideas about violence against women, and by her background as a refugee from Cuba, where her father had joined counterrevolutionary anti-Castro forces. Her work was eerie, confrontational, even angry. One video piece showed blood trickling from her scalp down over her face. Her best-known work, a series titled *Silueta*, shows a female form imprinted in the earth; Mendieta used her own body for these images.

Mendieta's career was both helped along and overshadowed by that of her husband, Carl Andre. Andre arranged humble, pre-made materials on the ground to create lateral patterns and shapes. His work, with its emphasis on the horizontal, was considered part of sculpture's radical breach with the pedestal in the late 1960s. The minimalist refusal of his forms was reinforced by the modesty of his materials. His work dating from this era processes across the floor, creating stunted cityscapes. They turn the viewer into a king, surveying his domain—and, at the same time, the viewer becomes a hausfrau, confronted by an eternal pattern of objects waiting to be picked up. The pieces play with the way we experience a room, a space. These works have great power and mystery. If you can join the consensus that they matter, you are rewarded with a vision of austere beauty.

Mendieta meanwhile was in the ascendant. She had begun to make a name for herself with her overtly feminist work—she created a 1973 piece, *Rape Scene,* when she was still a student at the University of Iowa. The work was a response to the rape of a fellow student; Mendieta invited viewers to her apartment, where, through a door left ajar, they sighted the artist in the position of the rape victim: bloody, bent over a table, and naked from the waist down.

Mendieta and Andre were married at the beginning of 1985. By that autumn, she was nowhere near eclipsing her husband, but she had recently received two of the art world's most prestigious awards, the Prix de Rome and a Guggenheim Fellowship.

Very early in the morning of September 8, 1985, a New York 911 operator received a call: "What happened was we had . . . my wife is an artist and I am an artist and we had a quarrel about the fact that I was more, eh, exposed to the public than she was

and she went to the bedroom and I went after her and she went out of the window."

What happened was . . . Ana Mendieta's body lay in a pool of blood on the sidewalk below their thirty-fourth-floor apartment window.

When the police questioned him later that day, Andre claimed that he and Mendieta had been watching a movie together in the living room, and she had left the room to go to bed and had somehow contrived to topple out a window in the bedroom. Even as he asserted that it was an accident, he also suggested that it had been suicide. Andre was arrested for her murder that night.

Two years of investigation followed until finally the case went to trial—a jury-less trial, at Andre's request. *The Village Voice* said that the art world line was "Carl got a Minimalist trial." He got a minimalist verdict too: Judge Alvin Schlesinger said he didn't have enough evidence to convict, though he later stated that Andre "probably did it."

In a depressing synecdoche for the ubiquity of male monstrousness, the trial took place down the hall from that of the Preppy Killer, a.k.a. the Central Park Strangler, a.k.a. Robert Chambers, the handsome and personable young man who strangled Jennifer Levin. Chambers's defense attorney intimated that Levin's desire for "rough sex" was what brought about her murder (a *New York Post* headline: "Central Park suspect's lawyer claims 'Jenny killed in wild sex.'"). Meanwhile down the hall Andre's defense team "tried to turn Ana into the stereotypical, hot-blooded, drunken Hispanic," according to one curator who

observed the trial. The mirror trials both involved drunken rage and a dead woman.

At the time, the painter Howardeena Pindell gave a précis of what was really going on: "What they did was try to degrade Ana because she's an artist of color. All that stuff introduced about her being interested in Voodoo, to show the judge she was 'other' and dragging out pictures of Ana with Castro in Cuba was an attempt to degrade her. The art world is segregated as it is. I know if Ana had been an Anglo and if Carl had been black, the art world would have lynched him. . . . Oh, sure, I see it as totally symbolic, your life isn't worth shit, is that direct enough?" Pindell's view is the realist view: here is what's *really happening*.

Writing a profile of late-career Andre twenty-five years later in *The New Yorker,* the critic Calvin Tomkins demonstrated a more refined but still embodied way of looking at Mendieta, writing that she "developed an original and somewhat morbid style of art-making which combined elements of performance art and earth art; she used her tiny but voluptuous body (she was four feet ten inches tall) in direct and visceral encounters with raw nature. Clearly talented, she had a compelling and vivid personality—volatile, enchanting, insecure, hot-tempered, and fiercely ambitious." Voluptuous, enchanting, insecure—these are not words that describe Mendieta as an art worker, but as an object.

Tomkins's profile has a telling howler: "It is hard to think of an artist whose career has been so affected by circumstances that have nothing to do with his art. In Andre's case, the precipitating event was the death of his third wife, Ana Mendieta, a young

artist who fell from the bedroom window of Andre's apartment, on the thirty-fourth floor of a high-rise on Mercer Street, in the early-morning hours of September 8, 1985." Hard to think of an artist whose career has been so affected by circumstances that have nothing to do with their art? Actually, Calvin Tomkins, I can think of one: Ana Mendieta.

It's like a little parable: the woman of color is not silenced just by the institution, but perhaps by her fellow artist. Her work disappears until young people—who also feel shut out of institutions—begin to speak out on behalf of the dead woman.

Starting as early as 1992, a group known as the Women's Action Coalition began a series of protests and interventions under the title "Where Is Ana Mendieta?" Meaning, where is she in the institution, in the museum? The question form of the title reinforced the idea of Mendieta's silence; the voice that has gone unheard. As the years went by and the actions continued, new protesters joined in, some of them surprisingly young. Although she'd died before many of them were born, they felt a kinship with her—after all, she too had been young, had been an outsider. By showing up and raising their voices about the life of a woman who'd died before they were born, their protest said something simple: Things hadn't gotten better. Not really. We had believed in the constant improvement of the American self—we were optimistic liberals after all—but now we were in the shit. These protesters were saying we were no better than we were on the day Ana Mendieta fell to her death.

The protests were heartfelt and oddball—they played with ideas about victimization, what is allowed to happen within a museum, and even what constitutes the language of protest.

Events took place from Los Angeles to Berlin. One of the most outrageous protests took place at Dia: Beacon, the elegant museum in Beacon, New York, housed in a former Nilla Wafer factory. The action was titled "Crying; A Protest." The Facebook event page for it, which is still extant at the time of this writing, had this under the "Details" header:

TEARS
TEARS
TEARS
TEARS
TEARS
TEARS
TEARS
TEARS
TEARS
TEARS
TEARS
TEARS
TEARS
TEARS of JOY
TEARS of TERROR
TEARS for ANA MENDIETA
come celebrate the last day of Carl Andre's DIA
 retrospective at a public cry-in/silueta party. bring your
 own tears.

And people did bring their own tears. Mostly young, mostly women roamed the halls of Dia: Beacon, prostrating themselves in front of Andre's installations and just flat-out *sobbing*.

The feminist writer Marisa Crawford chronicled her experience: "I walked into the exhibit's main room at 3:15 to end the performance with loud group crying. The space filled with a cacophony of sobs and wails and sniffing snot and choking back tears and gasping for air. It was stunning, and I started crying more intensely immediately, glancing from the artwork to the museum booklet and back again. Other museum attendees were stopped in all corners of the room, staring at us crying women and talking quietly to one another. Several performer/protesters collapsed on the floor, sobbing in front of individual installations like they were at a loved one's grave."

I don't know about you, but the very notion of this spectacle makes me *quite* uncomfortable. The idea of a bunch of women flinging themselves on the ground and weeping. And yet. It . . . worked? Until these people flung themselves on the ground, Ana Mendieta had mostly been forgotten. Her work had been tossed in the dustbin of history.

Institutional presence matters. Taking up space in cultural institutions is meaningful, whether that's as an artist or as an administrator. It's not a perfect solution to the monster problem. It's wrongheaded to think that people from historically oppressed groups will never be monstrous. A person's identity does not automatically make them bad; and it does not automatically make them good either. I don't think that if institutions start supporting women and people of color and queer people and trans people, all those people will turn out to be good. But I do think the *institutions* will be better, simply because they will be fairer.

When we find ourselves excluded from institutions, we can stake our claims in ways that are institutionally approved. But

that doesn't always work. Sometimes we have to make our institutional assaults in ways that are embarrassing, loud, uncool.

The protesters' tears—ridiculous, melodramatic, over-the-top—reminded the world of the existence of the artist who got lost when a man silenced her, the courts didn't vindicate her, and institutions forgot her. The weeping protesters reminded me of the girl I met in the crepe shop, who allowed herself to feel love for the musicians who had disappointed her, even after everything. Like the crepe girl, the protesters were writing their own kind of criticism: a criticism made of feeling. They made a humming bird hum that got louder and louder.

AM I A MONSTER?

Am I a monster? I've never killed anyone. Am I a monster? I've never promulgated fascism. Am I monster? I didn't molest a child. Am I a monster? I haven't been accused by dozens of women of drugging and raping them. Am I a monster? I don't beat my children. (YET.) Am I a monster? I'm not noted for my anti-Semitism. Am I a monster? I've never presided over a sex cult where I trapped young women in a gilded Atlanta mansion and forced them to do my bidding. Am I a monster? I didn't anally rape a thirteen-year-old.

Look at all the awful things I haven't done. Maybe I'm not a monster.

Even so, I've bumped along through life, like any human, totting up at least my fair share of bad behavior. And moreover I've done this: Written a book. Written another book. Written essays and articles and criticism. And maybe that makes me monstrous, in a very specific kind of way.

The critic Walter Benjamin is said to have stated: "At the base of every major work of art is a pile of barbarism." I wonder: At the base of every minor work of art, is there a, you know, *smaller* pile of barbarism? A lump of barbarism? A skosh? (Further investi-

gation reveals that what Benjamin actually wrote was closer to this translation: "There has never been a document of culture, which is not simultaneously one of barbarism." This tightens the noose a bit, I think.)

There are many qualities one must possess to be a working writer or artist. Talent, brains, tenacity. Wealthy parents are good. You should definitely try to have those. But first among equals, when it comes to necessary ingredients, is selfishness. A book is made out of small selfishnesses. The selfishness of shutting the door against your family. The selfishness of ignoring the pram in the hall. The selfishness of forgetting the real world to create a new one. The selfishness of stealing stories from real people. The selfishness of saving the best of yourself for that blank-faced anonymous paramour, the reader. The selfishness that comes from simply saying what you have to say.

I have to wonder: maybe I'm not monstrous *enough*. I'm aware of my own failings as a writer—indeed I know the list to a fare-thee-well, and worse are the failures that I know I'm failing to know—but a little part of me has to ask: If I were more selfish, would my work be better? Should I aspire to greater selfishness?

Every writer-mother I know has asked herself this question. I mean, none of them says it out loud. But I can hear them thinking it; it's almost deafening. Does one identity fatally interrupt the other? Is your work making you a less-good mom? That's the question you ask yourself all the time. But also: is your motherhood making you a less good writer? That question is a little more uncomfortable.

As a child, I believed there were four kinds of person you could be, and I had them not-quite-consciously ranked in my head:

man
boy
girl
woman

I dreaded being a woman. And maybe I was onto something. Almost all the grown-up women I knew were mothers, and even then I balked at the selflessness that motherhood seemed to call for. Motherhood seemed to me a dead end, a death of the self.

It's interesting that I, like many children, was fascinated by orphans. When I was in grade school, I wrote and illustrated multiple little novels about pioneer girls with dead parents. It's generally believed that the orphan fantasy is a way of metaphorically killing off a repressive parent. But I wonder if I was up to something else—*obliterating* a future (becoming a mother) that was unsavory to me in the extreme. I didn't want to be that unselfish; didn't even know if I could do it.

As an adult, I've found the unselfishness of motherhood one of my great trials and my great gifts. The erosion of the self that comes with motherhood has been very difficult on every meaningful level—personally and politically. (What a world of pain is contained in those cool words.) But it's also been the making of me. It's taught me how to be a person who is *for* something other than myself. I'm not saying the childless don't learn that lesson as well—I'm saying that, in my case, it was motherhood that taught it to me.

The exigencies of motherhood are inexorable. You will be forced into selflessness, once you've become a mother.

But what if you also happen to be an artist?

. . .

For the everyday kind of artist—not your groupie-fucking rock star or what have you—the drama of selfishness gets played out within a particular context: the context of the family. What the artist or writer or musician needs desperately is time. And what the family needs is time. This conflict is not necessarily solvable. In her aphoristic memoir 300 *Arguments,* Sarah Manguso writes: "It can be worth forgoing marriage for sex, and it can be worth forgoing sex for marriage. It can be worth forgoing parenthood for work, and it can be worth forgoing work for parenthood. Every case is orthogonal to all the others. That's the entire problem." The art/family problem is, or feels, orthogonal. (Though that word makes me feel a little like I'm a project lead at Microsoft.)

The truth is, art-making and parenthood act very efficiently as disincentives to one another, and people who say otherwise are deluded, or childless, or men.

If you happen to read a think piece on the subject of parenthood and art, you inevitably will bump into some kind of reference to the "pram in the hall." (Sharp-eyed readers will notice that I myself have used it above.) The inescapable pram made its original appearance about halfway through *Enemies of Promise,* Cyril Connolly's *impressively* unreadable 1938 book describing the perils of the artistic life. The actual line goes like this: "There is no more sombre enemy of good art than the pram in the hall." It's become a literary cliché for a reason. The line chimes—like little else in that basically silly book—because parenthood is so patently and undeniably *orthogonal* to art.

To be clear, Connolly is talking about male artists, as is made obvious in lines like this: "Writers choose wives, not for their money nor for their appreciation of art but for their beauty and a baby is even less capable of seeing the artist's point of

view." (Which is a funny line and far above par for this book.) Connolly's enemies of promise include these: babies and wives, wives and babies. The idea that the artist—whose promise is being thwarted so cruelly!—might be a woman is as absurd as the idea that the artist might be a baby. At least a baby can grow up to be an artist; that will never happen to a wife.

It's always baffled me a bit, Connolly's central image and the basic logistics of it—maybe because at bottom I'm a practical-minded mother, maybe because I have an enduring interest in between-the-wars London domestic arrangements. But really: Why is the pram in the hall? Is the baby in the pram? Is someone else minding the baby in the pram? Couldn't the pram be put in a closet? Etc. And are we really to believe that when the (male) writer emerges from the office, he's actually going to engage in any meaningful way with that hasslesome pram? I mean aside from banging his shin on it? Also, isn't there something odd about the fact that Connolly focuses on the pram, rather than the red-faced, noisome thing itself, the baby? And by *odd*, I mean *male*.

The image of the pram in the hall took hold of the popular mind, as a kind of synecdoche for all the troubles that family life can bring an artist. All writers struggle to find our way into that blessed place: a room with a door that locks from the inside, against the family.

To my mind there's no image that better captures the joy, the *luxury* of solitude for the working artist than a scene from *An Angel at My Table,* Jane Campion's 1990 biopic of the New Zealand writer Janet Frame. After enduring years in a mental hospital, Frame finally finds space and time to write—in her case, it's a daybed on a shabby sleeping porch. Frame sits upright on

the bed, her typewriter on her lap, typing furiously away, free and alone. Campion places her dead center in the shot. (One of Campion's great gifts to film is her non-sexualized and beautifully symmetrical centering of the female figure—I mean "centering" literally, not in some conceptual sense.) And then Janet Frame breaks the fourth wall; she turns and gazes straight into the camera with dazzling utmost happiness.

The writer alone, in a space with a door that closes against the world: that's the very picture of happiness. Some imaginary ideal mother-writer might not mind a knock at the door, but most of us don't have beautiful natures and we really *mind* being interrupted. Doris Lessing wrote in her memoir *Under My Skin:* "Very few people—perhaps one in fifty?—respect women's privacy. If you say, 'I spend my mornings writing' that will not prevent the furtive knock on the door, and then a moment later, the guilty, embarrassed, smiling face appearing around the edge of the door. 'I've just dropped in for a *second.*'"

Philip Larkin gets at this ideal state of pure selfishness in his poem "The Life with a Hole in It."

> . . . the shit in the shuttered chateau
> Who does his five hundred words
> Then parts out the rest of the day
> Between bathing and booze and birds

Larkin shows us the ideal writer's life: the (male) author whose needs are tended to, whose emotional connections are secondary to his work, whose selfishness is unquestioned, whose

freedom is total. I mean, it sounds *heavenly,* right? From the point of view of a regular well-adjusted member of society, you would think that loneliness would be a serious problem. If you retreat from the world, and serve only your own needs, you're bound to get lonely, right? The thing is, writers don't really get lonely. Liking being alone—even *liking loneliness itself*—is part of what makes a writer a writer. After I had children, I was an almost full-time mom, working about a quarter time at freelance writing. I thought to myself, how lucky that I am a writer, so that when I am working I get all this lovely restorative alone time. It was years before I realized: Oh. I became a writer so I could be alone all the time. It wasn't a by-product, it was a motivator.

The kinds of lives that are typically thought of as nice by non-writers, lives that involve things like unending vacations; things like never having to work again—these kinds of lives don't sound nice to writers. Not really. Writers want be left alone to write, and be waited on.

It is presumably easier for men to pull this off—or easier for the fact that they are *pulling something off* to remain invisible. But at least a few men are onto themselves. The novelist John Banville told the *Irish Times* that he was, not to put too fine a point on it, a shitty dad, and what's more, probably most writers are. "[Writing] was very hard . . . on the people around me, on my children. I have not been a good father. I don't think any writer is. You take so much and suck up so much of the oxygen that it's very hard on one's loved ones." No palaver about compromise. More generally he says of writers: "Well, we are ruthless. We're not nice people. We might be interesting, we might be diverting . . . but mostly [living with us is] just slog."

And then he goes on to say of his youngest daughter: "She

is so furious, indignant, about all this, in a good way—which is the best state for women to be in. If I were a woman I'd be so furious all the time."

Is it pathetic that I'm grateful for his empathy?

The female artists and writers I know yearn to be more monstrous. They say it in offhand ha-ha-ha ways: "I wish I had a wife." What does that mean, really? It means you wish to abandon the tasks of nurturing in order to perform the selfish sacraments of being an artist.

What if I'm not monster enough?

In a way, I'd been asking this question privately, for years, of a couple male writer friends I believe to be actually great—including the *Manhattan*-admiring man of letters I mentioned earlier. I write them both charming emails, but really I am always trying to find out: *How selfish are you?* Or to put it another way: *How selfish do I need to be, to become as great as you?*

I made friends with these men, flirted with them . . . for what? For thrills of course. I'm not a *nun*. But also I wanted details of how they got their work done. How did they arrange their lives?

When one described working through Thanksgiving and Christmas, I made a note of it. When another described leaving his wife with their child so he could work while they vacationed in Nova Scotia, I said to myself, *hmm*. It turned out, of course, that they in fact didn't arrange their lives. That was the essential point. They had someone else, a wife, to do it for them. In the main.

· · ·

Of course, to have someone arrange your life, you must believe in yourself, in the value of the thing you are making. Many years ago, at a smoky drunken party, I was chatting with a pal who recently published a novel.

"You should buy it," he drawled. "It's a *very important book.*"

(Unwittingly, the novelist was echoing Gauguin and his near-lunatic self-confidence: "I am a great artist and I know it.")

For years thereafter my artist friend Victoria and I tried in vain to copy the novelist when we talked about our own work: "It's a very important book," I attempted. "It's a very important painting," she tried. We couldn't make ourselves do it, with a straight face, in public. We collapsed in laughter.

But, really, what's so funny about saying your life's work is important?

And if you can't say your work is important, how can you, well, *do it?*

Ambition and self-confidence are all bound up together. Ambition is the thing that men have. In my usage here, "ambition" is an entirely positive word. Ambition is the key that turns the lock of art. Ambition simply means this: I'm not just trying to make something . . . I'm trying to *make something great.*

It turns out this is not such an easy word, for women. When the word is used about a woman, it is a pejorative. An ambitious woman is to be castigated or mistrusted. An ambitious woman is severed, perhaps tragically, from some essential feminine softness. (In my inmost child-of-the-eighties heart, the idea of

an ambitious woman always makes me think of Leona Helms-
ley, hair high, lipstick dark, screaming at her underlings.)

When the word is used *by* a woman, it's seen as hubristic at
best, and possibly a sign of total madness.

A few years ago I told my (former) male shrink I was trying
to write an ambitious book. I said it falteringly. I was, in fact,
afraid to say it. This is just the kind of thing you're supposed
to bring to your shrink, right? Not just your ambition but your
shame and embarrassment about your ambition?

Me: I want . . . to write . . . a very . . . *ambitious?* book.

Gerald, my ancient Jungian shrink, from underneath his
shrinky nimbus of white hair, his antennae almost visibly prick-
ing: Talk more about that.

Me: I just want to write something that attempts greatness.
I want to be more ambitious in my work.

Gerald: I think we should talk about that. Where does this
ambition come from?

Me: I guess from being a, um, writer?

Gerald: I wonder how we can address this issue of ambition.

Me, confused: By trying to write a great book?

Gerald: Do you think it has something to do with your father?

The idea that my ambition might be a virtue and not a
symptom—that didn't occur to Gerald. To be fair, not every man
pathologizes every woman's ambition. One day, while out for a
walk with a male writer, in the midst of a very serious heart-
felt conversation about my memoir, I screwed up my courage
and blurted: "I want to write a great book." Without breaking
his stride, he said expressionlessly, "Welcome to the Thunder-
dome," and we continued our walk, with me feeling secretly
buoyant, as if I'd swallowed a balloon.

Even the idea of *trying* to be great was thrilling to me.

If only I had the bravado of Gertrude Stein, who wrote, in the voice of Alice B. Toklas: "I may say that only three times in my life have I met a genius and each time a bell within me rang and I was not mistaken, and I may say in each case it was before there was any general recognition of the quality of genius in them. The three geniuses of whom I wish to speak are Gertrude Stein, Pablo Picasso and Alfred Whitehead. I have met many important people, I have met several great people but I have only known three first class geniuses and in each case on sight within me something rang. In no one of the three cases have I been mistaken." (This quote makes me laugh every time I read it—makes me think of Kanye West and his "the same people that tried to blackball me / Forgot about two things, my black balls.") Why was Stein able to induct herself into the Thunderdome with such insouciance? And how could a woman (say, me) learn to emulate her?

Another scene: One evening not too long ago I sat in the chaotic, book-strewn living room of a younger writer and her husband, also a writer. Their kids were tucked into bed upstairs; the occasional yawp floated down from above.

My friend was in the thick of it. Her three kids were in grade school and her husband had a full-time job while she tried to carve out her career freelancing and writing books. A cloud of intense literary ambition hung over the house like a stormy little microclimate. It was a work night; we all should've been in bed. Instead, we were drinking wine and talking about writing. The husband was being very charming to me, by which I mean he

AM I A MONSTER?

laughed at all my jokes. He was also tightly wound and overly alert, perhaps because he was not having success with his writing. He reminded me of an avid dog. The wife on the other hand was having success—a lot of success—with her writing. She was also completely exhausted—if he was a dog, she was a pile of laundry with a woman residing somewhere inside of it.

She mentioned a short story she'd just written and published.

"Oh, you mean the most recent occasion for your abandoning me and the kids?" asked the very smart, very charming husband.

The wife had been a monster, monster enough to be ambitious, monster enough to finish the work. The husband had not.

This is what female monstrousness looks like: abandoning the kids. Always. The female monster is Doris Lessing leaving two children behind to go live the writer's life in London. The female monster is Sylvia Plath, whose self-crime was bad enough, but worse still: the children whose nursery she taped off beforehand. Never mind the bread and milk she set out for them, a kind of terrible poem unto itself. She dreamed of eating men like air, but what was truly monstrous was simply leaving her children motherless.

I wish I had a wife.

Sometimes I think that I used my island as a wife. An artist requires healthy boundaries. Artists famously use their wives to set boundaries. My island had boundaries; they were made out of water. And so I used the island as a kind of stand-in wife. Its remove from the city took care of certain things for me. The island canceled plans for me. The island prevented my

extended family from popping by. The island made sure I could duck out early when I went to parties in the city—sorry, have to catch the ferry. I used the island to protect me from the world, because I didn't have a wife to do it for me. I had never written a book before I moved to the island; once there, I wrote three in a decade. The island was my Vera.

Maybe, as a female writer, you don't kill yourself, or abandon your children. But you abandon *something,* some giving part of yourself. When you finish a book, what lies littered on the ground are small broken things: broken dates, broken promises, broken engagements. Also other, more important forgettings and failures: children's homework left unchecked, parents left un-telephoned, spousal sex un-had. Those things have to get broken for the book to get written.

Sure, I possess the ordinary monstrousness of any real-life person, the unknowable depths, the suppressed Hyde. But I also have a more visible, quantifiable kind of monstrousness—that of the artist who completes her work. Finishers are always monsters. Woody Allen didn't just try to make a film a year; he tried to *put out* a film a year.

For me the particular monstrousness of completing my work has always closely resembled loneliness: leaving behind the family, posting up in a borrowed cabin or a cheaply bought motel room. If I can't detach myself entirely, then I'm hiding in my chilly office, wrapped in scarves and fingerless gloves, a fur hat plopped upon my head, going hell for leather, just *trying to finish.*

The ambition and the finishing: These are what make the

artist. The artist must be monster enough not just to start the work, but to complete it. And to commit all the little savageries that lie in between.

My friend and I had done nothing more monstrous than expecting someone to mind our children while we finished our work. That's not as bad as rape or even, say, forcing someone to watch while you jerk off into a potted plant.

It might sound as though I'm conflating two things—male predators and female finishers—in a troubling way. And I am. Because when women do what needs to be done in order to write or make art, we sometimes feel monstrous. And others are quick to describe us that way.

As a memoir writer, it's my job to answer the question: What is it that I am feeling, exactly? Not what am I *meant* to feel, or what is it politic to feel, or what is it convenient to feel. As Hemingway says in *Death in the Afternoon,* the greatest difficulty in writing is "knowing truly what you really felt, rather than what you were supposed to feel, and had been taught to feel." And when I am honest, when I really examine what's actually going on, I have to admit that I have felt like I'm a terrible person when I shut the necessary door on my children in order to work. I'm not accusing women artists of *being* terrible people, only of *feeling* like terrible people. This is important because it affects how and when and if we make work.

When women do what needs to be done in order to write or make art, we sometimes feel like terrible mothers. Oops, slipped into "we." When I do the writing that needs to be done, I sometimes feel like a terrible mother. And because motherhood is so close to the core of me, I feel like a terrible person. Like a monster.

. . .

In *A Pillow Book,* her strange and wonderful tribute to Sei Shonagon, the poet Suzanne Buffam defines another kind of silence—the hush of motherhood: "A Great Book can be read again and again, inexhaustibly, with great benefit to great minds, wrote Mortimer Adler, co-founder of the Great Books Foundation. . . . Among the five hundred and eleven Great Books on Adler's list, updated in 1990 to appease his quibbling critics, moreover, only four, I can't help counting, were written by women—Virginia, Willa, Jane, and George—none of whom, as far as I can discover, were anyone's mother."

Motherhood creates its own conditions for silence.

Hemingway's wife, the writer Martha Gellhorn, didn't think the artist needed to be a monster; she thought the monster needed to make himself into an artist. "A man must be a very great genius to make up for being such a loathsome human being." (I guess she would know.) She's saying if you're a really awful person, you are driven to greatness in order to compensate the world for all the awful shit you are going to do to it. In a way, this is a feminist revision of all of art history; a history she turns with a single acid, brilliant line into a morality tale of compensation.

But the question has to be asked: Are all ambitious artists monsters? Are all finishers monsters? Tiny voice: [Am I a monster?]

ABANDONING MOTHERS

DORIS LESSING, JONI MITCHELL

My initial list of female monsters was short and the sins had to do, but entirely, with motherhood. To be precise: negligent motherhood. If the male crime is rape, the female crime is the failure to nurture. The abandonment of children is the worst thing a woman can do.

I contemplated these things as I sat in a sun-flooded little house in Marfa, Texas. The house belonged to the Lannan Foundation. They brought me to Marfa for five weeks to write. That was all I had to do. I was here by myself—that is, minus my family. Many years had gone by since my children were little and every work hour felt like a stolen hour. But I was still a mother. My daughter was at college, but my son was at home. And I left him. To come to Marfa.

The first week I was in Marfa, I kept lists of numbers in my journal. I wrote 6,700 words, made two pots of soup, walked thirty miles, talked for four hours on the phone to my best friend. I was quantifying my days, tracking my words and miles

and minutes, because the usual container for my time—my family—was not there.

My house was down the street from the high school. I sat there and read and wrote and listened to the schoolchildren pass by and thought of my own children.

This idea of mothers abandoning their children has always held a lurid fascination for me.

Many years ago, at a party of journalists, I met a man whose wife had left him and their two young children. I leaned against the kitchen counter, drinking Shiraz and gobbling Humboldt Fog on crackers, while he unfurled his story, which I found extraordinary, fabulous, terrifying.

A decade previously, when their kids were five and eight years old, the man's wife had simply packed up and moved from their Colorado home to Portland, Oregon. Poof, she was gone, leaving behind the nice bearded journalist to mind the children. No, that's not quite right. He was left behind to *raise* the children. It's not like he was babysitting. He became a thing that does not trip off the tongue, a single dad (with its subtle notes of "widower"). He volunteered that when the kids were little he'd been away on assignment a lot and she got fed up.

When I met him and heard his tale, I was a thirty-something mother who could barely stand to be away from my little ones for longer than a night or two. My imagination was horrified/aroused by the tale of this woman who fled all that mighty distance: across the Rockies, down the Western Slope, over the

plains of eastern Oregon, and finally to rainy Portland, where she sought a new freedom, with all that extremely bumpy geography between her and her kids. I pictured her house, with no children, her kitchen, with no children, her bed, filled with lover after lover but, again, no children. How could she stand it? Why had she run away? What had driven her? How could she do it? I didn't ask him any of these questions. It seemed rude to ask, so I just sipped my wine and wondered. Perhaps a bit of glamour clung to her as well. She conjured up an image of the Bolter from Nancy Mitford's novels *The Pursuit of Love* and *Love in a Cold Climate,* the mousy narrator's wild, glittering mother who has famously abandoned her daughter—who has, in fact, bolted.

As a mother, I was horrified by her story. But, as a writer, I was fascinated. Because at the same time I was taking care of my children, I was also wondering, at the back of my mind, all the time: How was I going to make a living as a writer, with these two children to raise? More than that, how was I ever going to have a hope of writing something great? I loved the children with all my heart. I took good care of the children. The children were, frankly, the greatest thing that had ever happened to me. But also: the children made it hard to go to work, was what I was noticing. All of that was bound up in my response to the story of the journalist's wife—I wanted to rubberneck her whole life.

Even women who've done this terrible thing, who've abandoned their children, seem to agree that it's the blackest of crimes. Paula Fox writes in her memoir *Borrowed Finery:*

When I was two weeks away from my twenty-first birthday, I gave birth to a daughter.

I had put my daughter up for adoption. Ten days later, I went to see one of the doctors who had been an intermediary in the adoption and asked for her back. The doctor told me it was legally too late. I didn't know any better, so I accepted his lie as truth. I had asked a second doctor who was involved in the adoption to find a Jewish family to take her. I guess to comfort me, he said jovially, "He travels fastest who travels alone."

You can feel how difficult it was for Fox to set those words down. (A wild stinging tail to this scorpion of a story: Fox's daughter, who was put up for adoption, eventually became the mother of Courtney Love.)

Says the writer Jenny Diski (of whom much more in a bit): "Men do this all the time—desert the family, shall we say, in one form or another—but we assume, partly because of sloppy, ill-considered thinking and partly with some element of truth, that the wrench is too great for any but the hardest-hearted woman."

The hardest-hearted woman isn't a murderer or rapist—she's a leaver of children.

In 1949, Doris Lessing left behind two children from her first marriage when she moved to London from then-Rhodesia. Lessing brought along her third child, Peter, as well as a suitcase containing the manuscript for *The Grass Is Singing*. Once she got to London, the novel was published (or re-published—it had

previously been published in Rhodesia) to great acclaim, and Lessing went on to become one of the few female literary lions this planet has ever hosted, however grudgingly. Eventually of course she won the Nobel.

As for Peter, he lived with her until they both died, within a few weeks of each other, in 2013. Even abandoning mothers somehow end up lumbered with children.

A little more than a decade after she arrived in London, Lessing published her most famous novel, *The Golden Notebook*, which deals with the problem of how to live as a free person. Among other questions, the book examines and illuminates the question of how a female artist is supposed to live in a society that doesn't really want her to exist and make work.

While *The Golden Notebook* is shot through with the desire for human liberty—one of its subjects is the failure of communism to solve human relationships—the problems of motherhood haunt its pages, a kind of boggy murk that sucks and burbles at the ankles of its freedom-seeking females.

The novel is radically experimental in shape, even read from today's vantage—it comprises several different books, or rather notebooks, as they are called here, identified by color. Woven throughout all this is a more conventional novel-within-a-novel titled "Free Women," about an alter-ego-like novelist named Anna Wulf. I hesitate to call "Free Women" autobiographical, but only because it seems like Doris Lessing wouldn't approve of calling things autobiographical, and Doris Lessing scares the bejeezus out of me, even from the grave.

Nonetheless, it is irresistible to imagine the novel about Anna Wulf as the story of Doris Lessing's own experience of seeking freedom—from her children, from her old life in Africa,

from forces that would stop her from making art. The selection of just one child makes her flight even more unthinkable—if all the children were abandoned, the two left behind might have justified it to themselves. But not-abandoning just one child seems to send such a strong message to the others; you were not good enough.

When I first read *The Golden Notebook,* I was in fact a free woman. I was twenty-one years old, a college dropout living in a little house on the wild coast of New South Wales. I had ended up in the faraway antipodes for reasons I didn't really understand. Okay, I followed a boy there—a relationship that didn't work out. Now I had a tiny room to myself and I worked in a warehouse and aside from that I spent my time drinking beer, going to punk rock shows, hopping trains, and reading. Reading was my vocation, if a vocation is what you do when you are left entirely to your own devices.

I liked massive books then—like many free people, I found myself confronted with a string of empty days, and the longer a book kept me occupied, the better. *The Golden Notebook* was picked at least in part for its size, after a long bout with *Anna Karenina.* The problems faced by Anna Wulf were unknown to me; these were problems that had to do with commitments—to a child, to a politics, to a future. I was committed only to the pleasure of the day. But I chimed to the idea of freedom, and I could feel I was doing it wrong. Freedom, I intuited, ought to have higher stakes, and much much greater rewards than all the time in the world to read fat novels and steal a ride on a train to a rock show in the sticks somewhere.

Even if its concerns were not yet my own, I loved the book. It ate my hours. And I found Anna Wulf, Lessing's alter ego, irresistible. I loved the honesty of one passage in particular, when Anna Wulf wakes at the crack of London dawn with a lover in her bed and a small daughter in the room next door. She is trying to be a free woman and it's not easy and the stakes are perhaps altogether *too* high.

> It must be about six o'clock. My knees are tense. I realise that what I used to refer to, to Mother Sugar [her nickname for her analyst], as 'the housewife's disease' has taken hold of me. The tension in me, so that peace has already gone away from me, is because the current has been switched on: I must-dress-Janet-get-her-breakfast-send-her-off-to-school-get-Michael's-breakfast-don't-forget-I'm-out-of-tea-etc.-etc. With this useless but apparently unavoidable tension resentment is also switched on. Resentment against what? An unfairness. That I should have to spend so much of my time worrying over details . . .

It's not just the doing of the chores that eats at Anna Wulf, it's the worrying and the thinking and the remembering—what we might now call the emotional labor. She is tense with the fact that she is alone in being the woman/mother self. She goes on, thinking about her analysis:

> Long ago, in the course of the sessions with Mother Sugar, I learned that the resentment, the anger, is impersonal. It is the disease of women in our time. I can see it in women's faces, their voices, every day, or in the letters

that come to the office. The woman's emotion: resent-
ment against injustice, an impersonal poison. The
unlucky ones, who do not know it is impersonal, turn
it against their men. The lucky ones like me—fight it.

All that was still ahead of me when I first read this passage. I
was in some ways closer to Anna Wulf's tiny daughter Janet than
to Wulf herself. I devoured *The Golden Notebook* on the train, in
my monk-like little room, down at the pub while I waited for a
lover to arrive, with his accent that was just normal life to him
and a kind of wild excitement to me. In those days I gobbled the
parts of *The Golden Notebook* that were about communism and
love and found myself a little frightened of the motherhood pas-
sages. Surely that would never be me.

Two decades passed.

When I next came to the book, I was a mother of two. A
homeowner, a cook, a wife, a gardener, a teacher, a driver, a
cleaning lady. I found myself yearning for enough freedom, just
enough freedom, to get my writing done. This time around, I
found the passage, to use the parlance of our own day, intensely
relatable: "The resentment, the anger, is impersonal. It is the
disease of women in our time. . . . The unlucky ones, who do not
know it is impersonal, turn it against their men."

These latter days I feared I might be one of Lessing's unlucky
ones, taking it personally over and over, finding in my husband's
inability to overcome the privileges of millennia and do the fuck-
ing dishes evidence of his lack of love and respect for me.

This is what Lessing calls luck—the ability to fight the house-
wife's disease of resentment, to know it's an impersonal poison.
This poison is well known to any woman who's ever regarded

the landscape between the making of dinner and the singing-to-sleep as a vast wasteland, on a par with the bleaker landscapes from *Planet of the Apes*. And I don't know any mother who hasn't at least once felt that way, though they meet the moment with varying levels of anguish or sangfroid, depending on their situation, their income, their level of desperation. Depending on how much their husband does the dishes, how accepting their natures are, how radical their politics are. How afraid they are.

But why couldn't I accept that the situation might be impersonal? Might, in other words, not be my own fault, not be my own individual problem? Why couldn't I be one of Lessing's lucky ones?

It's a strange loop. Lessing is giving voice, through Anna Wulf, to the pressures that make a woman feel it is difficult to get her work done. (Her real work? At any rate, her art.) The pressures that might lead a woman to, oh, say, leave two children behind on a whole other continent.

Anna/Doris's ambivalence about motherhood is given full throat in what would become one of the most famous passages from *The Golden Notebook*, a passage that is a perfect tiny bijou portrait of maternal apathy and dissociation:

> Janet looked up from the floor and said, "Come and play, mummy." I couldn't move. I forced myself up out of the chair after a while and sat on the floor beside the little girl. I looked at her and thought: That's my child, my flesh and blood. But I couldn't feel it. She said again: "Play, mummy." I moved wooden bricks for a house,

but like a machine. Making myself perform every movement. I could see myself sitting on the floor, the picture of a "young mother playing with her little girl." Like a film shot, or a photograph.

This is the job of any good novel, or maybe even piece of writing: to reveal felt and lived experience, rather than what you think you *ought* to feel. The consciousness-raising sessions of second-wave feminism were built on exactly this idea. What if you said how you really felt? Would that be a revolutionary action? I suppose it depends in part on who does the saying. Lessing is doing important work in this passage. For women, laboring in domesticity, otherwise known as anonymity, it's all the more important to get at this truth of felt experience.

This sense of being an imposter, this quiet chafing against the role of mother—I lived it. For years and years, I lived this fear that I was not, am not, a good enough mother because I cannot inhabit the role with my entire being, cannot cast out the artist self, or maybe the true self, a self that is not entirely good. This is why, when my daughter was three years old, I used to pay myself to play with her. I chivvied myself into behaving like a good mother, but inside, sometimes, I felt like Anna Wulf: a machine, a film shot, a photograph, a simulacrum, a bifurcation, an other, a divided self.

The divided self is a common story for female artists. Lessing's story is echoed in the lives of other great women writers, from Jean Rhys to Alice Walker. In fact, Lessing's experience was closely paralleled by another great woman writer of her era,

though their artistic styles and projects could not have been more different. Muriel Spark also left Rhodesia for London in the 1940s, after undergoing a very difficult divorce. "I escaped for dear life," she wrote. "If I had not insisted on a divorce, God knows what would have happened." Her possibly violent husband wound up in a mental hospital. (But I feel I'm making excuses for her, or mounting a defense, or something.)

Spark furthered the cause of her freedom by having her son, Robin, live with her parents. "It was a great good thing, and an immense relief to me that he finally had a settled home with my mother and father in Edinburgh. My father was really a second father to my son."

Her biographer Martin Stannard had this to say about Spark's relinquishment of her child:

> Muriel was never to be the victim of the "pram-in-the-hall" syndrome [I *told* you—there's no escaping it] described in Cyril Connolly's *Enemies of Promise* (1938). Her "pram," her domestic responsibilities, were to remain in someone else's hall. Fetters were to be relinquished if they impeded the progress of art, and if that meant divorcing oneself from "that eternal chemistry of family/and family affairs" then so be it. . . . Driven by her vocation, she would not be driven by anyone or anything else, and had no intention of spending the rest of her life sighing for what might have been.

Stannard seems to lay blame at Spark's feet. Maybe it's just me, but is there a bit of a lip curl to his "fetters" sentence? And as for "driven by her vocation"—well, yes, exactly. Gauguin set

sail for Tahiti, his vocation the wind at his back, his wife and children waving from the shore.

A nd yet. Even if one stays home, even if one has luck, has money, has help, children and writing often seem stubbornly orthogonal, two forces constantly pitted against one another.

When I began to think of female monsters, Anne Sexton was one of the first names to come up. She was the harpy-mother, the screeching taloned swooping poetess, the housewife artiste who cherished her neuroses more than her children; the mother whose offspring were sacrificed on the altar of her terrible creativity. Sexton is nowadays arguably as famous for her daughter Linda Gray Sexton's incendiary memoir *Searching for Mercy Street* as she is for her poems, although she was once one of the most famous poets in America. Though is there even really such a thing as poet fame? It's like trying to measure the speed of a butterfly's fastball.

After Sexton's death, Linda Gray Sexton found tapes of her mother's therapy sessions. The transcripts reveal Sexton as a kind of nuclear version of Anna Wulf: her ambivalence has superheated. She is the dissatisfied mother/artist, turned up to 11. For instance, this passage:

> I drink and drink as a way of hitting myself.
> I started to spank Linda and Joan hit me in the face.
> Three weeks ago I took matches and went into Linda's room.
> Writing is as important as my children.
> I hate Linda and slap her in the face.

This writing is so alarmingly good that it's easy to forget it's not writing at all, it's actually tormented *talking*. The passage is shot through with a kind of brittle, compulsive truth-telling. It will be hard to forget the image of drinking as a way of hitting myself. And obviously "Three weeks ago I took matches and went into Linda's room" is a great opening line to a poem or story or an opera or pretty much anything.

But where you really feel the transgression is in the line "Writing is as important as my children," buried in the list of terrible utterances. Is it a truth? Or is Sexton playing at saying the unsayable, as one sometimes does in therapy?

I read the line and immediately it felt like a gauntlet thrown down. Did I believe my writing was as important as my children? I didn't think so, but I thought perhaps it was important to try thinking it, try saying it, to roll the words like olives in my mouth:

Writing is as important as my children. Just thinking it made me want to throw up.

Only two classes of people are asked to be purely good: mothers and children. We talk of good boys, good girls, good mothers. It's hard to imagine applying this word so easily, so naturally, to any other group. I felt myself in the grip of that idea of goodness; it was a powerful wanting, the desire to be a good mother. There was something pure in the middle of it, a plain fine human interaction: simply giving this sweet daughter—with her buttery curls and her protruding tummy and her costume made of slightly grubby chiffon scarves—a little attention, a little fun. But there was also a terrifying gap between the idea of what I was supposed to be, and the fugitive emotions I expe-

rienced in the moment: a boredom that at its best was a hon-
eyed lassitude, thoughts about work, a desire to run free with my
friends. My inner life didn't at all fit my picture of what a good
mother's brain might look like.

And how did I think a mother's brain really looked? Did I
see it as a lump of sugar? A lobotomized homogenous inoffen-
sive mass?

(And if my children have so far *turned out*—to be nice, to
be funny, to be thoughtful, to be smart, to be functional—was it
because of this abnegation of my desires? Or maybe despite my
attentions? There's no way to know.)

Above all, the good mother does not leave.

I did not entertain thoughts of flight. A phrase got lodged
in my head for years or decades, like a song I couldn't shake,
an earworm. The phrase went like this: "Being a mother means
always going back." A darker way to put it is that I was stuck. But
I was stuck being a mother, which I loved more than anything
I will do in this life. The problem was the orthogonal thing—
being a mother and being an artist. How to make them work in
tandem? (Imagine me, a giant toddler, picking up two toys and
trying to smash them together.)

Anna/Doris—please forgive me, dear dead Doris, for this
conflation—writes eloquently of feeling stuck with her child.
But didn't Doris Lessing abandon her children? What does she
know of the fatigue of the mother-writer? It's not so simple, after
all. As I said, she brought her boy Peter with her to England.
She also tried her hand at another nurturing relationship. In
1963, she took in a troubled young woman who would grow up

to become the writer Jenny Diski. Diski wrote about her time as Lessing's foster daughter in a series of sensational (in both meanings of the word) essays for the *London Review of Books,* which were eventually gathered with material about her fatal cancer in a volume ominously titled *In Gratitude.* (If you're missing the darkness in the title, try running the two words together in your mind.)

Lessing's relationship with Diski tells us a lot about her parental ambivalence, her powerful ability to compartmentalize, and most of all the utter horror with which she regarded motherhood.

Diski writes: "I don't remember the exact date when I went to live in Doris Lessing's house. I think of it as being just a few weeks after Sylvia Plath killed herself in early February 1963. The suicide was still very raw and much discussed by Doris's friends." This was the year following the publication of *The Golden Notebook.*

It's a bit muddy throughout just how Lessing came to take in Diski—it seems that the girl and Peter were classmates, but certainly not close in any way. Diski's parents were not fit to care for her, so she went to live with Doris Lessing. Diski says Lessing asked only that she do the same for someone in the future: "Her suggestion felt like a proper distribution of good fortune that took need and capacity rather than time as its fulcrum." From each, to each—Lessing's leftist principles were more than skin deep.

Lessing clearly saw herself as Diski's savior: "[Lessing] was adamant that I would have been dead"—without her own intervention—"before I was out of my teens. Being pregnant, married, and/or a junkie represented no life to Doris. In fact,

in relation to me and other young women, she considered that 'pregnant' and 'married' were alternative terms for 'death.'"

The author of *The Golden Notebook*, the woman who had laid bare the soul-annihilation of the nursery—here she was in real life, conflating motherhood and death. To hear Diski tell it, Lessing feared pregnancy above all else.

Diski continued to be a sort of run-of-the-mill bad kid, and Lessing eventually kicked her out, cut off communications with her, and in the end "crossed me off her Christmas list." Diski says that in Lessing's eyes, her crime was to do with her status as a kind of *pre-mother*, someone forever threatening to become pregnant: "Wild, dangerous, a woman with an active uterus that might do anything, and drugs as well. Hopeless. A terrible letdown. An experiment gone wrong."

Basically, Lessing accused Diski of potential motherhood. Was motherhood that, to Lessing? The worst thing that could befall a person? Is it really so awful to care for someone else?

And if so, why did Lessing keep doing it?

Diski in turn has sharp things to say about Lessing's own shortcomings as a mother. "To me," she writes, "the most interesting aspect of Doris arriving in London with her third child and a novel, while her other two children remained with their father, was that it required a move across the world. It was, as I see it, an instance of Doris putting as much space between herself and an unwelcome truth as she could." She means the truth that Doris lived, that children had to be left in order for her writing to get done.

Diski goes on: "I am a feminist and a mother. I applaud the escape to freedom of a woman living her own life at such a time and in such a place, and her determination to fulfill her pas-

sion, to experience the power of her need to write." She wonders, though, about Lessing's motivations for leaving, signally ignoring the political spin that Anna Wulf—that *Lessing*—put on it all in those famous passages from *The Golden Notebook*. Diski sees Lessing's abandonment of her children as more personal than political, asking, with a guileless intelligence that is typical of her brave and odd and immediate writing style:

> Willfulness? The necessity of art? The pain that others have to tolerate so that art could be made? I don't know. I know about feeling trapped and that sometimes you have to be somewhere else in order to do what you need to do, but I couldn't imagine leaving my daughter Chloe permanently in order to fulfill my promise. Perhaps that's just cowardice and Doris would say, I think, that I was lucky I didn't have to. I was in the privileged position of having enough money to live on from teaching.

Again, this political idea of *luck*. Who has enough money to live on? Who can afford the time it takes to write?

Art is often seen as voluntary, an item in a list of choices you're making, a task that can be prioritized or dispensed with, depending on available resources and time. An item to be balanced against the exigencies of family. But. If you are an artist and you always, always put your children's needs first, eventually your own need will make itself heard and you will wonder, What would I have made in those lost years? You will wonder, Am I too late?

And you might be. Too late. You might have needed those years, when your kids were small. Just the way other workers— lawyers, professors—also need those years if they are to have a career. And the way still other workers need those years if they are to make a living.

We mustn't punish mothers for going to work, even in our minds.

Marfa was a kind of Lourdes, and the water was art. The town took art and the production of art very seriously. This could of course make it a silly place, but also an exciting place, and kind of a relief. I told my mom on the phone: "It's like a resort town, except the sport is being smart."

It was the sculptor Donald Judd who came to Marfa and transformed it in the first place. Weary of crowded New York, he found this tiny West Texas town and bought the decommissioned army base on a rise at its edge. Now his town had become a kind of contradiction. Marfa was a place that lived its own businesslike life, full of PTA meetings and drugstore errands and Friday night lights and people in trucks getting shit done—but it was also an art pilgrimage site. Judd died in 1994, and his army buildings were now beautiful raw spaces devoted to his work and the work of his friends—a whole row of bunkers housing Dan Flavin pieces; two lofty hangars for Judd's own *100 untitled works in mill aluminum*. People came from all over the world to look at this stuff: took however many flights to get to El Paso; drove along the Rio Grande for two hours and

then hung a left and drove an hour more. Unless they came by private jet.

In any case, Marfa had become a place that was filled with like-minded souls. The art buyers came and went; the town itself was partially inhabited by cordial eccentric artists and writers who just wanted to make whatever it was that they made.

And here in Marfa, away from my family, I was one of them, a person defined not by my care for others, but by my work. Not by my giving, but by my taking—taking time, taking a house, taking financial support. It was a little bit lonely and scary to be that person. If I wasn't giving, wasn't useful, would I still be loved? Well, that old question.

In other words, my luck, in Marfa, was very good. I had everything I could possibly want: a beautiful house, a stipend for food, all the time and sunshine I could ask for. Even so, I never quite relaxed. The self I was asked to be there was janky and uncomfortable.

Marfa was confusing. I didn't know what I *was*, exactly. I became a non-wife, a non-mother.

I had become a taker; something other than a mother; a person with self-ness. In Marfa, I was taken care of so I could be a pure writer, full of torments and crazes, up till four a.m. if need be, drooping over my enchiladas the next day at lunch, wrung out by the sheer exhaustion of being my writer self. I discovered I liked my empty life, my empty hours. For the first time since I was a kid, I watched a square of sunshine make its way across the floor.

Was this as important as being with my children? How could I possibly measure that?

And the underlying question: How many days or weeks or

months would have to pass in such a manner before it would be called abandonment? And what if I just . . . didn't go home? What if I stayed and was driven mad by the distance between what I am—a mother—and what I am trying to be—an artist?

I missed my son and felt off-kilter. I missed my son and felt happy. My arms yearned to hold him. At the same time, I dreamed idle dreams about buying a truck and driving off into Mexico.

Horizons were shifting.

What exactly constitutes leaving? The question arises as soon as you make the assertion that a mother who leaves her children is a monster. Does it mean doing as the journalist's wife did: packing up, hauling ass across the Intermountain West, and seeing the kids only on occasional holidays, or never? How long does one have to be gone to qualify as an abandoner? If I shut my door against my children, am I an abandoner? No, you say, of course not, that's outrageous. But what if I do it all day long, every day, up to and through and beyond the dinner hour, as a male writer I know does for months or years on end when he's deep into a project? What if I go to a writer's retreat for a week? A month? A year?

What if I simply go to work?

The idea of what constitutes abandonment exists on a continuum. I mentioned to a dear friend—who happens to be a very accomplished and hardworking civil rights lawyer—that I was writing a chapter about abandoning mothers.

"I hate them!" she said. She was inarticulate with emotion. A moral feeling, rather than an ethical thought.

Then she paused. "But I guess I'm perceived as an abandoning mother by the stay-at-home island moms." My friend took the ferry from our island into the city every day to run a major government agency.

She thought about it some more. "A real abandoning mother is a mother who moves away from her children," she said. "I'm not an abandoning mother." But you could see that there was some little part of her that was nettled. That heard the chorus of those moms, judging her, as if their voices were audible sounds drifting over the stony beaches and closely furred forests of our island.

My friend was intimating something about the continuum of abandonment. There's a spectrum.

Here are some ways to be judged an abandoner of children:

Shut the home office or studio door against the child
Depend on the other parent to do the lion's share of the
 childcare
Let a grandparent or a nanny or a babysitter watch the
 child
Put the child in day care
Go away for work for days or weeks or months at a time
Get a divorce and let the other parent have majority
 custody
Give the child to your parents to raise
Flee the family home
And perhaps: give the child up for adoption at birth

Add your own! The thing is, each of us can draw a line across the page at any point on this list, and say: Here. Here is where

abandonment begins. Where is that line for you? Day care? Surrendering custody? Flight? Why is that the line, for you? Is it an ethical thought, or a moral feeling?

Please note that none of these behaviors count as abandonment if practiced by men. This is extra-true if the men in question are artists. As Jenny Diski so rightly points out: men do this all the time.

Men leave their children to pursue their art, or their *whatever*, so often that it hardly bears noticing. And it's certainly not perceived as monstrous enough to disrupt our experience of their work. But I look at Lessing with a gimlet eye, my experience of her altered, stained by this perception of monstrousness, wondering if her fierce intellect is somehow causally tied to her cold abandoning heart. I'm not saying it's fair. I'm saying it happens. Again: that's how stains work.

So what is a woman to do if she, like Sexton, begins to apprehend that her art is important, even perhaps as important as her children? Go insane? Get a babysitter?

You start to see how abandonment could become an option for a mother-artist, even one who passionately loves her children. Perhaps—radical thought—*especially* one who passionately loves her children.

In fact, the thought can be taken a step further: A young artist, a young female artist, might be forgiven for thinking that maybe it would be better not to have children in the first place. If you are going to be accused of child abandonment when you

go to work—and, more important, if you are inevitably going to internalize those accusations—perhaps better to skip the children and go straight to the art.

Artistic freedom (freedom, period) has often been tied, for women, to the problem of pregnancy. As a reader, I intuited this even when I was a young girl. I was a great consumer of old novels, and a thing that happens a lot in old novels is pregnancy: *Tess of the D' Urbervilles, Adam Bede,* etc. Whenever a protagonist got pregnant, I experienced a sinking feeling—in fact, I felt a vast boredom utterly unique to this reading circumstance. Now the protagonist would lose her options; now her world would be constrained to the four walls of a house, and what kind of plot would that be? I wasn't one to abandon a book midway through—once momentum caught me, it held me—but a full-body yawn would overcome me if I encountered this plot point, and the book's velocity would simply die. Who cared about a pregnant lady? Not me.

When I was young, I saw it, or rather felt it, like this: pregnancy was the very definition of the death of options. I was emotionally absolute on this score, as Doris Lessing had been with Jenny Diski.

Even to this day, I feel my interest in a story waning if a pregnancy occurs. And I speak as someone who has loved being a mother—in fact, I even liked being pregnant. But as a reader, a pregnancy makes my heart sink. Pregnancy is the end of narrative. All the doors shut at once. Don't cut yourself off from options! I want to yell at the pregnant characters in these books.

If motherhood is the greatest thing that has ever happened

to me, in large part that's because of—not despite—its optional nature. I got to choose.

The story of female rock 'n' roll is the story of women choosing to leave babies behind.

In 1965, Joni Mitchell, twenty-one years old and unmarried, fell pregnant. Mitchell was an art student and aspiring folk singer, just starting to find an audience. She decided to have the child but give it up for adoption—both abortion and keeping the child were unthinkable. Mitchell was terrified of what her rural Canadian family would make of her unwed pregnancy. The child was placed in foster care. And so baby Kelly (as in green) was left with her new family, who renamed her Kilauren.

Mitchell's song "Little Green" from her masterwork *Blue* is a veiled account of the giving up of the baby:

> *Child with a child pretending*
> *Weary of lies you're sending home*

The song pretends to a serenity Mitchell didn't really feel. She sings to her younger self, "You're sad and you're sorry but you're not ashamed." The singer claims she's not ashamed, but of course the song's indirectness—its reliance on metaphor and disguise—gives the lie to that assertion. In *Girls Like Us*—her collective biography of Mitchell, Carole King, and Carly Simon—Sheila Weller writes, "Joni now worried that her reputation and her prospects would be hurt by revelation of the baby. Even in rebel-loving 1960s rock . . . a young woman had to fear retribution for having a more tortured and romantic past than the public knew about."

Giving up the baby allowed Mitchell to become as weird and wonderful—and sometimes un-wonderful—as she needed to be. Without the baby, she was free to do the difficult work of becoming not just a great star, but a great artist.

And that is what came to pass. Like the men of rock, Mitchell was able to fuse artistic ambition with album sales. Unlike most female artists, she was able to be more than one thing at once. Remember Kanye West's description of the rock star? The artist who is a full human, not limited to one facet of his fame? Joni became that kind of rock star: artist and commodity, at the same time. Iconoclasm was central to her identity. And because she was unfettered, she was able to be difficult and problematic— code words for being creative while female.

The desire to live an artist's life drove her to upend households and leave behind seemingly good and loving men. Mitchell was the one who finally broke up the famous Laurel Canyon idyll she built and shared with Graham Nash—the two lived together in a stunningly pretty and much-photographed home, which inspired the classic Crosby, Stills, Nash & Young pastorale "Our House." In an interview quoted by her biographer David Yaffe, "I had sworn my heart to Graham in a way I didn't think was possible for myself and he wanted me to marry him. I'd agreed to it and then just started thinking, 'My grandmother was a frustrated poet and musician. She kicked the kitchen door off the hinges.' And I thought maybe I'm the one who got the gene who has to make it happen. . . . As much as I cared for Graham, I thought, 'I'll end up like my grandmother, kicking the door off its hinges.' It's like, 'I better not.' And it broke my heart."

"I'm the one who got the gene who has to make it happen." In other words, she owed something to her ancestresses on the

Canadian prairies, the ones who stayed with the children and didn't write poems and didn't play music—the grandmother who *minded,* the frustrated grandmother who kicked the door down.

And maybe the responsibility or onus was even deeper than that—maybe she owed it to the child she left behind to make her career as great as possible.

In *Girls Like Us,* Sheila Weller also gives voice to this point of view, imagining Mitchell's thought process: "If I give up this unsought baby, then I'm not going to do so for nothing. If I make this serious relinquishment, I will use my reclaimed life to 'give birth,' as it were, to something else." Weller goes on: "Joni herself seems to have believed that the loss of the baby equaled the beginning of the songs."

Mitchell cut off her motherhood to make her career. She separated the self from the art, as many women have had to do—privileging one over the other. Mitchell's life story puts me in mind of a wonderful adult student I had named Faith, who returned to writing after supporting her husband and taking care of her kids. She tabled her own work for those decades it took to raise her sons, sons who grew up to be good—even great—artists. In a way, Faith's story barbells Mitchell's. Faith, an artist herself, passed up the artistic life to be a mother; for Mitchell, it was the other way around. They are opposite poles of the uneasy continuum that all artist-mothers walk. On one end you have the woman who gives up a child in order to form herself into an artist; on the other end you have a woman who gives up the artist self for the sake of the children. Artist-mothers dwell on all points between these two poles, and maybe for some lucky (that word again) ones there are fleeting moments, flashing fugitive

points when they are able to make work in a way that's supported by the people around them. Faith needed to live her two identities—mother, artist—in succession. She couldn't do both things at the same time, as is the case for many women. Mitchell went the other direction, schismed herself, cut the mother self from the artist self altogether.

Instability, capriciousness, and outright fury fueled Mitchell's fame at its height. She was trying to make something great and at the same time trying to navigate the decidedly non-great waters of the music industry, which kept wanting her to be a woman in a very particular way. She released *Blue* on Warner Bros., and the in-house ad man, Stan Cornyn, wrote painfully sexist ads for her. To make a point about how little-heard her work was, his ad (from 1968 or so) read JONI IS 90 PERCENT VIRGIN. She was even angrier when he wrote an ad to explain the delays in getting *Blue* into the market: JONI TAKES FOREVER. She threw a fit in the office of the head of Warner Bros. and jumped labels not long after.

Mitchell—embattled, difficult, demanding—gave us this explosive quote, so germane to our purposes here: "Most of my heroes are monsters, unfortunately, and they are men. If you separate their personalities from their art, Miles Davis and Picasso have always been my major heroes." For Mitchell, separating the life from the art was not an aesthetic question, but a *point of view* necessary to her survival. In other words, she wasn't confronting the problem as an audience member, but as an artist. In that way, I am like her. Just trying to figure out *how to do it.* Perhaps the monstrousness of Picasso and Miles Davis provided an unlikely, even a topsy-turvy, model for building a life where the most personal thing—motherhood—is set aside in

the name of art. Maybe Joni was, like me, looking for models, looking at artists, trying to figure out how to behave.

And maybe it's not an accident that she chose as heroes two famously difficult men—maybe she chose them not in spite of their difficulty but *because of it*. I want to stress again the fact that Mitchell is not in any usual sense a likable figure. When I read *Girls Like Us*, I was busted up and inspired by how much of a pain in the ass Mitchell seemed compared to Carly Simon and Carole King. The very fact that Mitchell refused to be interviewed for the book made me like her more. She seemed—to me, a writer desperately in need of uncompromising female role models—committed to the role of artist. Unafraid of being perceived as pretentious. Utterly without a need to be liked—loved yes, liked no. In a telling tiny detail from *Girls Like Us*, Weller observes that Joni, meeting Graham Nash, wooed him "as she had Roy Blumenfeld, Leonard Cohen, and David Crosby—with her songs. Despite her femininity, like a man, she displayed her work to her would-be lovers." Any woman artist knows that this kind of arrogance does not make you *liked*.

Is it an accident that Mitchell was also the only, only, only real female titan of the great rock era?

She did what a great artist does: vigorously, aggressively protected her ability to make something vulnerable and tender. Men often have a woman in their lives who does this work for them; the wife who takes the calls, etc., so the man can be the shit in the shuttered chateau. Joni Mitchell was an asshole on behalf of her own vulnerability.

Women like Joni Mitchell are the essence of difficult: both the asshole-ness and the vulnerability disrupt the order of things. She talks in David Yaffe's biography about how radical

her openness was at the time, and how the (male) world did not want anything to do with it. "*Blue* was very open and vulnerable, unprecedented in pop music." (And there it is, the asshole in her, tooting her own horn.) She recalls: "All the men around me were really nervous. They were cringing. They were embarrassed for me. Then people started calling me confessional, and then it was like a blood sport. I felt like people were coming to watch me fall off a tightrope or something."

Interestingly, the men wanted to help her by stopping her. That was the only way they could think of to protect her. She goes on: "When *Blue* came out it was not popular and it was shocking to the men around me. Stunningly shocking. And upsetting. Kris Kristofferson said to me, 'Oh, Joni. Save something for yourself.' The vulnerability freaked them out."

At the beautiful "Joni 75" tribute to Mitchell at the Dorothy Chandler Pavilion in 2018, the singer Brandi Carlile performed a duet of "A Case of You" with Kris Kristofferson. As I watched, I was thinking all the while of his "Save something for yourself" line. And then—this still gives me goose bumps—when the two finished singing, Carlile recounted that exact story, the story of Kristofferson telling Mitchell "to save something for yourself." Carlile looked up into the audience where Joni Mitchell sat shining like a queen and said, "If I could be so bold as to speak for Kris and all of us here, thank you, Joni, for not saving anything for yourself."

My mother, not a huge Joni fan, also read *Girls Like Us*. She absolutely hated the way Joni came across in the book. Hated her for not finding a way to be an artist and a mother. Thought

she was selfish. Wondered why she couldn't be more like Carole King, another subject of that book, a mother and a partner and an artist. Why she couldn't *compromise*. That word again.

My mom asserted that Carole King's music was better anyway. Mom found Joni's pretensions distasteful. Lots of people do. They make fun of her upper register and her "I wanna knit you a sweater / I wanna write you a love letter" couplets and her *dulcimer*. I suppose it's a question you can ask: Whose music is best—Joni's, Carole's? There are arguments to be made for both their contributions.

Well. "Arguments to be made for both their contributions." That's a bit squirrelly, by which I mean it sounds like critic-speak. More useful is the perspective that subjective responses can and will occur. If Carole and Joni were both "stained"—that is, marked—by our knowledge of their biography, then part of what was happening here was a response to that stain based on our own biographies. My mother, born in 1940, a full-time mom, perhaps had a sense of identification with Carole, who brought together the personae of wife, mother, and artist in a beautiful and beautifully nonthreatening way. Don't get me wrong, I love Carole King, and what's more I loved her passionately as a small child when I used to—get this—*pretend she was my mom*.

But I'm looking for something different. For a struggling female artist (I mean me) trying to make herself into something uncompromising, trying to learn to trust herself, important questions loom: How should I act? How should I behave? How should I be? Maybe if Joni looked at Miles and Pablo, I can look at Joni.

By the time I had the courage to think of myself as an

artist—had the courage even to ask these questions—I already was in possession of two very adorable and needy children, and abandoning them was a non-option as far as I was concerned. So I wasn't taking notes on Joni putting her baby up for adoption—but I was noting the savagery with which she proceeded, the difficulty, the non-caring. I needed the model of her, the blazing comet trail of her life as an artist, the heat of which maybe came at least in part from the fact that she'd already given up the thing that women are never supposed to give up. I read her story, and I was galvanized. To do what, I did not know. But I was learning, once again, that a savage drive to vindication was one and the same as making art. For me.

When I think of Joni Mitchell, I think of her lost daughter. When I think of Doris Lessing, I think of her abandoned children. Does that mean the stain has disrupted their work for me? Or—scary thought—enhanced it?

I sat in my house in Marfa and I closed my eyes and I pictured Doris Lessing abandoning her children. I saw it as a kind of abstracted visual, almost cartoonish: Lessing on an airplane, clutching suitcase, novel, and youngest kid. Below her are the two *abandoned children*, standing alone in the middle of a map of Africa.

I noticed that my mind rejected the specifics.

Lessing's did too. In her memoir *Under My Skin*, she talks about this mental rejection of the truth: "I knew I was going to leave. Yet I did not know it, could not say, I am going to commit the unforgivable and leave two small children."

She later goes on to describe her rationalization for the

abandonment: "I felt—and still wonder if this wasn't right—that it would be better to make a clean break with the two children until—the formula used for these situations—they were old enough to understand. I pictured myself in a home of my own, but this formula did not mean merely a flat or a house, rather a feeling of myself solidly based somewhere, it didn't matter where, nor was this base money, or respectability, but *that I should have earned an identity that would justify my having left them* [italics mine]."

The new identity—the identity called "artist"—is what would justify the abandonment. We have come full circle to Martha Gellhorn: "A man must be a very great genius to make up for being such a loathsome human being." The artist becomes great in order to cover his ass for what a shitty person he really is—apparently this is just as true for women.

(Just as for Mitchell, the greatness of the songs was in some kind of balance—I'm not necessarily saying a successful balance—with giving up the baby.)

Doris Lessing, flying away from Africa, is like a character from a fable: The Woman Who Gave Up Her Child to Be an Artist. We need fables, parables, myths, because they illustrate, in simple, broad, stark brushstrokes, the moral complexities that rule our lives.

In reality, of course, these things are not done with clear intentions. Did Lessing turn herself into a difficult genius to make up for what she'd lost? Did Joni Mitchell? I doubt it. I think their genius was given; a gift from the gods, a force they channeled from somewhere mysterious.

I am never going to be one of those—a genius—but I study their lives in order to learn how to put that steely bit inside

myself, so I can get my writing done. So I can perform the small, human abandonments that will let me do my work.

On the seventh morning I was in Marfa, I walked up to the Chinati Foundation for the first time. I felt I had written enough words to earn myself a visit. This punitive relationship to word count is typical of me. But also, I was strangely hesitant to go up to Chinati, the sprawling museum complex left behind by the artist Donald Judd. I felt like an interloper among the pilgrims, the real audience. I checked in at the front desk, and went to look at Judd's *15 untitled works in concrete*, a massive series of concrete boxes—both dense and airy—that lay in a valley at the foundation's edge.

I walked along a dirt path marked by a sign that read WATCH OUT FOR SNAKES. However, I did not. Instead, I gazed at the row of enormous cement sculptures, a line of very serious gray elephants marching across the grass. I was trying to have an art experience. Sometimes minimalism involves a suspension of disbelief, a kind of trying, that takes my total concentration. I imagine it's different for people who happen to actually understand it.

A burr got caught in my boot. I balanced on one foot and dug around for a while trying to get it out. The sun was starting up with its serious midday business. I prepared myself for transcendence.

I walked slowly along the monuments that the art saint Donald Judd put here in the early 1980s. Was he lonely, I wondered. I was kind of lonely.

It was very silent; I heard only the mild hum of cars from the

extremely minor highway on the other side of a row of trees. I was walking in the shadow of these monuments, glancing upward at a vulture silhouetting its way across the blue sky, when some atavistic part of my brain shrieked *look down* and I did look down and there in front of me was a huge fat coiled snake.

I was immediately covered in sweat. It was snake sweat, a special sweat reserved for snake sightings, a sweat as old as the history of people on the earth, a sweat that had been residing in my body my entire life, waiting until this moment to be released in all its very specific snake-inspired clamminess.

Maybe it's dead, I thought hopefully. It wriggled as if in answer to my hope.

And then it uncoiled and slithered away from me, its length astonishing, and the whole thing was over as quickly as it had begun. The snake headed for the shade of a nearby Judd sculpture, and smoothed its way underneath the monolith's edge. I looked down the row of gray behemoths. Did all those structures sit on top of snakes or even—oh, terrible phrase!—*nests of snakes?*

It seemed like the most perfect metaphor in the world—so perfect that it was almost embarrassing. This work, huge and heavy, was an immaculate expression of artistic ambition and achievement. It was work that required resources, and time, and the help of others. It required Judd's belief in himself. And underneath: snakes. Like a ridiculously literal interpretation of Benjamin's apocryphal line: "At the base of every major work of art is a pile of barbarism." That barbarism doesn't need to be something as explicit as a rape or an assault—it can be, simply, the taking of resources. Selfishness. Entitlement. Luck. Whatever you want to call it.

I hotfooted it back to the parking lot and when I got there I looked back down on 15 *untitled works in concrete*. The scene was clean and plain: blue sky, reddish-brown dirt, gray structures. Like a kid's drawing. It looked as though Donald Judd had erased himself and what remained was only his will, inscrutable, monumental, written all over the landscape.

LADY LAZARUS

VALERIE SOLANAS, SYLVIA PLATH

I left Marfa and I went home. I hugged my teenage kid and felt right at last. I felt, when I hugged that funny, clever, kind child, that I was placed as correctly in the world as a freshly baked loaf of bread, as Laurie Colwin would put it. The abandoner returneth!

B y this time it was 2018, and I was used to being the specific kind of audience you become when the news is very, very bad: the sense that you must watch in order to keep an eye on things. This sense of responsibility is inevitably matched by the dispiriting outcome: the realization that watching is achieving absolutely nothing at all. Rinse, repeat for each appalling news cycle.

My armchair was placed beside the window to take in the view. When the Brett Kavanaugh hearings started, I turned my chair to face the television to take in the display of contempt. My main memory is that rain was beating on the windows and I couldn't believe my eyes.

Furious—yet smiling as if he'd just been coached in the

art—Kavanaugh hulked in his chair, his paws flipping through a binder of notes, glowering so hard that an upside-down capital T appeared in the furrow of his brow. He breathed as laboriously as a yogi, intaking sharply and out-blowing like a bull. Around him the faces of women were an all-white sea; emotions rippled across them, as if he were a storm.

He was ready to fight anyone about anything. Menacingly, belligerently, *meanly*, he said: "I am an optimistic guy. I always try to be on the sunrise side of the mountain." This was so psychotic and ill-stated that I knew it had to be some kind of Republican secret handshake—and indeed it's a phrase George W. Bush often used, a phrase that signaled he, like Christ (perhaps you've heard of him), would be resurrected. Kavanaugh spat it out.

He was clearly a total head case. And yet as the days passed, it became just as clear that he would be confirmed. No hallway intervention, no bonnet-wearing protest, no outrage, no math, would make it come right. Certainly no television viewing. And yet I couldn't stop watching. As I watched, I was overwhelmed with a sense of powerlessness. Someone had to do something!

R age is the emotion of the powerless," said my therapist to me sometime in the mid-1990s.

F emale rage was mounting, was searching for expression.

The violence of male artists has a story. The story is this: He is subject to forces greater than himself, forces that are beyond his control. Sometimes these forces get out of hand, and

he slips up and commits a crime. That's unfortunate, but we understand that these forces are the same forces that make his art great.

When female artists do violence, what story do we tell? Do we tell any story at all? Or is it a biographical black hole around which we must nervously edge, in order to somehow apprehend the work?

Female violence is no different from any other violence—because femaleness isn't an inherent quality, but something we've agreed upon, and one of the things we've agreed is that it's not violent. "One is not born but becomes a woman," wrote de Beauvoir. And woman, as she is made, is a creature of compliance, of compromise, of nonviolence.

In the context of our agreed-upon *made woman,* female violence is unthinkable. It is the void. It's the thing that ends the conversation. The spectacle from which the mind retracts, turns away instinctively, the way an ill-treated dog startles at a loud sound. The way a child shrinks from a raised hand. Yes, exactly like that.

In 1966, Valerie Solanas moved to New York, the city that would become the stage for the enactment of her depravity. She was already thirty years old, a woman with a difficult past. Growing up in New Jersey, she was molested by her father. She attended college at the University of Maryland, then did a year of grad school in the psychology department of the University of Minnesota. She worked as a prostitute either during or after college, according to different accounts.

Once ensconced in Greenwich Village, Solanas wrote a play titled *Up Your Ass*—which, delightfully, she dedicated to herself.

Then, sometime in early 1967, she wrote the book that would change her life: the *SCUM Manifesto.*

"SCUM" stood for Society for Cutting Up Men. The manifesto is a call to rid the planet of men. It opens with this sentence: "Life in this society being, at best, an utter bore and no aspect of society being at all relevant to women, there remains to civic-minded, responsible, thrill-seeking females only to overthrow the government, eliminate the money system, institute complete automation and destroy the male sex."

Get rid of money, work, and men, and you'd have a society fit to live in. As the kids would say, where's the lie? Solanas, though she maybe didn't know it, was echoed by other thinkers of the time, at least when it came to the money and work. There's no evidence that Solanas was a scholar of the Marxist situationist movement, but if she had been, she would've known that just a few years before she published her manifesto, the Marxist theorist Guy Debord famously graffitied a wall in Paris: *NE TRA-VAILLEZ JAMAIS.* Never work. A chalk-scrawled rejection of the very basis of Western society. Solanas's manifesto sprang from the same radical impulse, and then careened off wildly . . . away from Marxism, away from the dream of a practicable revolution.

Her critique was rooted in a psychological reading of the male condition—perhaps this is down to her year of grad school. According to Solanas, deep down each man "knows he's a worthless piece of shit." In an attempt to compensate for his inadequacy, Solanas's man dominates the family, the workplace, and, through his war-making, the world. "No genuine social revolution can be accomplished by the male," she writes, "as the male on top wants the status quo, and all the male on the bottom wants is to be the male on top. . . . The male changes only when forced to do so by technology, when he has no choice, when

'society' reaches the stage where he must change or die. We're at that stage now; if women don't get their asses in gear fast, we may very well all die." Again, this sentiment feels more true than ever—this intense knowing that the people in charge have screwed up irrevocably and the rest of us had better get our asses in gear. As you can see, once you start quoting Solanas, it's hard to stop, largely because she's so often right.

For Solanas, getting our asses in gear means getting rid of the men. Not all women can be trusted with this charge; only SCUM—"hateful, violent bitches given to slamming those who unduly irritate them in the teeth"—are up to the task. The manifesto whipsaws you. One moment you're nodding along with her rage, the next you're wondering "How did we end up here?" as she talks about ramming ice picks up assholes.

Solanas mimeographed her manifesto and sold it on the streets. (In Mary Harron's 1996 film *I Shot Andy Warhol,* we see her charging women a quarter and men fifty cents, like a good materialist, even if she didn't self-identify as Marxist.) Around the same time, Solanas stormed the gates of the Factory to present a copy of *Up Your Ass* to Andy Warhol, who declined to produce it. He did, however, let her hang around the Factory for a time, and cast her in his film *I, a Man.* Solanas, a budding paranoid, hounded Warhol about *Up Your Ass* and grew anxious about his possession of the manuscript. Was he stealing her work?

Solanas continued to hit the streets, peddling her manifesto, her body, or even an hour of lively conversation, for which she charged just six dollars. By chance, she saw an ad placed by Olympia Press chief Maurice Girodias, the legendary maverick who published Nabokov, Burroughs, and Miller. He was looking for new authors and signed her up to write a book. Solanas

was thrilled by her status as a soon-to-be-published writer, but it wasn't long before she began obsessing about the seemingly restrictive legal language of Girodias's contract. (Which was, in fact, boilerplate.)

One imagines her roiling in hot sheets, frustrated by these men in league against her, isolated by her refusal to participate in the myth of femaleness.

Powerless, enraged.

On June 3, 1968, Solanas roamed the city, carrying a carpet bag that contained within it a paper bag and inside that there were not one but two guns.

I find this detail wildly evocative. Why did she not carry the gun in her pocket or waistband? The paper bag is like a stand-in for a pocketbook, a blunt, ugly parody of that most female accessory, the *purse*—with all its connotations. She's put the phallus inside the vagina, not as a penetration, but as a confused kind of power.

The bag is also a way to keep the gun away from her body. The potential violent act is something she is just carrying around, something that might happen. It is not *of* her.

Solanas made a few stops throughout her day. Possibly she went by Girodias's office, though some believe this was a rumor (or myth) started by Girodias himself in the aftermath of the shooting. Again, this sense that the act was not so much an act of stiletto courage as a bumbling annexing of a power that I can't help but think of as male. This phallic object she held apart from herself, in a brown paper purse, as she roamed Manhattan looking for someone to shoot.

At the Factory she shot Warhol in the chest. And the art critic Mario Amaya as well—no one ever seems to remember the poor guy. She aimed the gun next at Warhol's manager, Fred Hughes, who uttered a line so deadpan that it could have been lifted from one of Warhol's films: "Oh, there's the elevator. Why don't you get on, Valerie?" She did. That evening, she turned herself in.

The pointlessness of her act is underscored by the wrongness of her choice of victim. Warhol—a gay icon, an anti-genius, a subverter of norms, perhaps even a spiritual descendent of Wilde—was hardly the prime candidate for ridding the world of masculinity.

In any case, Warhol survived, and Solanas was sentenced to three years. In the 1970s, she was in and out of psychiatric wards. In the 1980s, she continued to live a marginal life, nursing a drug problem and supporting herself with sex work. She died of emphysema and pneumonia in 1988, in a hotel in San Francisco's Tenderloin district.

The *SCUM Manifesto*, on the other hand, went on to bigger and better things. In 1968, Girodias published it with a commentary by the *Realist* publisher Paul Krassner. Feminist movement leaders like Florynce Kennedy, Ti-Grace Atkinson, and Robin Morgan hailed Solanas as an important new voice. In 1970, Morgan included the manifesto in her influential anthology *Sisterhood Is Powerful*. Girodias published it twice more, in 1970 and 1971. In 1977, Solanas, freaked out by minor edits made by Girodias, self-published "the CORRECT Valerie Solanas edition." In 1983, the Matriarchy Study Group in London brought it out, and it has been published repeatedly ever since. (San Francisco–based AK Press put out an edition in 1996 with a terrific afterword by the artist Freddie Baer.)

Riding the coattails of her manifesto, Solanas's rehabilita-

tion has been ongoing. SCUM is no longer so scummy. SCUM is transgressive, radical, queer, other-identified. SCUM has its own learned journals, its own university departments, its own bands and movies. Way back in 1993, the cultural critic B. Ruby Rich noted Solanas's burgeoning relevance in her essay "Manifesto Destiny," which ran in the *Voice Literary Supplement*. "The 90s is the decade of the Riot Grrrls, the Lesbian Avengers, Thelma and Louise, the Aileen Wuornos case, and Lorena Bobbitt," she wrote. "There's something intensely contemporary about Solanas, not just in her act but in her text as well."

Rich makes it sound so balanced: act and text, of equal import, in a kind of equilibrium with each other. That's not how the world has seen it—Harron's film title *I Shot Andy Warhol* says it all—it is the shooting for which she is remembered.

But Solanas believed her text to be as important as her act.

Her words eerily conjure a new way of looking at the problem of separating the art from the artist: Does the manifesto justify the shooting? Or does the shooting vindicate the manuscript? Is *she* the manifesto? Or is she the shooting? Text or action? Word or woman?

Of course, we'll never be able to answer these questions, because we can never encounter the manifesto without the shooting. Solanas is her act. (In this way, she makes a kind of strange cousin to the groupie-fucking men of rock, whose offstage and extracurricular behaviors were at least as important as their music.)

"Read my manifesto. It will tell you who I am."

Why did she believe her manifesto would tell you who she was? Because her act didn't do what she wanted it to do:

express her rage. Instead, it was a misfire, a botched message, a joke. The manifesto, on the other hand, transmuted her rage into language.

That feeling of wanting to *do something* was frustrated when, in fact, she did something. Instead, that yearning found a better home in the teleology of the manifesto, which promised revolution.

A question nagged at me as I read the *SCUM Manifesto:* What if Sylvia Plath had shot Ted Hughes instead of gassing herself? How would we read her work?

Sylvia Plath, like Solanas, is a staggeringly pure example of an artist who can't be shaken free from her biography. Despite our best intentions of separating art from artist, *Ariel* flies to us on papery wings made of the famous stories of Plath's famous death. Plath, as an author, is imprisoned by her own biography. And we are imprisoned there with her. We don't get to choose that imprisonment. It just happens.

We hear "Plath" and we think, in a tumble: oven, children, beauty, Ted Hughes, and at the same time we think of those poems—if we are poetry readers. If not, we just think the rest of it. But either way, the knowledge of the violence with which she ended her life crowds our brains, whether we like it or not.

This imprisonment makes Sylvia Plath a test case for the whole idea of the stain—the work is ineluctably changed. Our experience of Plath's biography is essentially involuntary, and yet there's a whole area of Plath scholarship that seems largely to consist of smart people telling other smart people to forget about her suicide, and then the other smart people basically saying, "I tried to forget about it and I can't!"

Writing in *The Independent*, the poet Ruth Padel admonished: "Some ways of reading [Plath's] poems are more illuminating than others. In one corner stands Reading-from-Life, or Biographical Reading; in the other is Reading-for-the-Poetry, which is the one that poets delight in and learn from."

The idea that two ways of reading—"from life" and "for poetry"—can be separated is absurd. Are they dueling boxers, as Padel intimates, these two forms of taking in the work? Any sensible person can see they're not even really in opposition to each other—it's a false division. Yes, the mythology of the real-life Plath is disruptive to our reading of her work, and yes, we ought to look closely at the work itself, and yes, sometimes her mythology troubles or complicates a serious, close reading. Nonetheless, the very notion that there exists a *more correct* way of reading is silly.

Plath seems to attract this kind of reproachful critic—self-appointed arbiters who are eager to tell the rest of us how we ought to read. In response to Padel and her ilk, let us imagine a reader of Plath. Say, a teenage girl who is attracted to this female poet who made a fatal (a violent) occasion of her own sadness. The girl is attracted entirely *because* of the suicide, because it is an acting-out of something unnameable yet familiar. From Plath's biography our imaginary girl travels to *The Bell Jar*, and from there to *Ariel*, where she becomes awed by the easier and more furious lines of the book, eating men like air, and all the direct address to Daddy. In other words, she makes her way from biography to work, in her own time. (Reader, you will be entirely unsurprised to learn I was that girl. Maybe you were too.) Does that make her way of reading "less illuminating" (which, by the way, is classic vague critic-speak, the kind of language designed to fence off mingy little pastures)?

Like Solanas, Plath can't be approached separately from her violent act. Both acts have meaning, or at least they have meaning to me: Plath's suicide and Solanas's attempted murder of Warhol might be considered two major acts of feminist violence of the 1960s. Plath and Solanas can be seen as representing two aspects of the movement. One aspect deals with interiority and self-reflection; the other with political action.

Plath falls into the former category. Women were trying to articulate their unhappiness and their madness in a male-dominated society. They talked, soul-searched, bore witness. They wrote memoirs and met in consciousness-raising groups. Plath's writing predates this discourse, but belongs firmly in it.

Just as "journaling" is a term that makes literary memoirists shudder (trust me on this one), I have zero doubt that Plath would have pooh-poohed the idea of her work as consciousness-raising. And yet the impulse runs through her work—confession; intimacy; the personal.

As for Solanas—it wasn't just that she came along too early for consciousness-raising. You feel pretty sure she would have detested it, had she ever met it. She believed in action. "SCUM is too impatient to wait for the de-brainwashing of millions of assholes." The *SCUM Manifesto* is a kind of anti-memoir.

Instead of focusing inward on her own feelings and experiences, Solanas looked outward at the world and demanded action. She had a theory and a plan.

Solanas imagined her SCUM sisters as a fierce tribe of vibrant *ur*-women: "dominant, secure, self-confident, nasty, violent, selfish, independent, proud, thrill-seeking, free-wheeling, arrogant females, who consider themselves fit to rule the universe, who have free-wheeled to the limits of this 'society' and are ready to

wheel on to something far beyond what it has to offer." To me
this is the most painful and beautiful moment of the manifesto.
You picture beer halls and fistfights, wet kisses and joyrides. But
Solanas, as far as we know, wasn't a member of some utopian
girl gang. She was evasive even on the topic of her lesbianism.
She had no SCUM sisters. She was alone. In her introduction
to the Verso edition, the scholar Avital Ronell (herself eventually
the subject of a Title IX sexual harassment case) rightly situates
Solanas alongside the cult leader David Koresh, a pair of revolu-
tionaries "unmoored and alone with their inscriptions."

A manifesto needs a goal, a green pasture where you'll pre-
sumably go when all your revolutionary acts are discharged.
Solanas's goal was global slaughter, but it was also an intimate
fantasy of female comradeship. Her green pasture was filled
with freewheeling women. In the meantime, her happiness
was made safely impossible by the unmanageable scope of her
revolution. Solanas is saying she'll be happy personally after her
political needs are met. Since this can never happen, she's per-
fectly justified in her misery and loneliness.

In a sense, Solanas's manifesto is, like her act, an expression
of powerlessness. Her revolution is so huge that it can never
begin. True, she did shoot a man, but even that seemingly mili-
tant act was marbled with vulnerability and unsureness. In the
manifesto, Solanas was the decisive woman who attacked silently,
ruthlessly, in the dark. Her real-life shooting lacked a basic uni-
fying intention. It was a flailing.

The *SCUM Manifesto* is a document of profound vulnerabil-
ity, written in a voice of profound empowerment. It's a brutal call
to arms, written by a woman in a world of hurt.

Solanas, the polemicist, ultimately becomes a memoirist.

Does Plath make a similar turn? Can we read her tender confessional poems as small manifestos? How else do we read "I eat men like air"?

Listen, I get that it's annoying to pair Plath with Solanas. I understand that Plath is a great artist and a revered figure and Solanas is a not-great artist; in fact, it could be argued she hardly counts as an artist at all. Moreover, I understand that Solanas is truly a monster; Plath is not.

But both are stained by their acts of violence. Both zippered the little metal teeth of rage and powerlessness. And both found themselves in a double bind in their work.

Their texts are places free of men and yet defined by men. Places of unfree freedom. They are dreaming worlds free of the violence of men, and their dreams are still proscribed by men, like a perversion of the line from the theorist Mark Fisher: "It is easier to imagine the end of the world than the end of capitalism." It is easier to imagine the end of the world than the end of patriarchy.

Biographically, of course, they were struggling and heartbroken people, not Amazons battling patriarchy. But they were also that, also battlers against patriarchy: because what is feminism (or any liberation movement) if not a daily struggle against forces that are so large, so consuming, that those forces are invisible to—forgotten by, taken for granted by—the very people wielding them?

As Solanas said, read her text and you will know her. But also read her act. Each woman tried to escape male hegemony in her work, and then in her violent act. Each of them—*in her*

work—laid bare the violence at the center of the male-controlled world. That is to say, the real world.

At the end of the Kavanaugh confirmation hearings, Democrats made a deal calling for a weeklong FBI investigation of the charges against him. It was clear that this investigation would be meaningless. (Which was perhaps a good reminder to liberals who had started to believe that the FBI was going to in some way prove to be the arm of government that would finally quash Trump. The FBI is not the friend of the powerless.) I was left slack and dismayed. I didn't know what to do about any of it. I turned off the TV until the next crisis came. I sent money to some abortion rights groups.

The violence of male artists is tied to their greatness. It's an impulse. It's freedom. The violence or self-harm of female artists can be a sign of sensitivity, a sign of lunacy, but it is rarely turned inside out to become a sign of creative and moral strength.

We've turned each of these two women into a fairy tale. Plath is the victim (oven), Solanas is the perpetrator (gun). I wrote about Joni Mitchell and Doris Lessing as instructive parables of female selfishness—figures in a kind of *Pilgrim's Progress* of the story of the female artist as she makes her way through the valley not of death, but of obstacles to her creative work. If Mitchell and Lessing become parables of female empowerment, Plath and Solanas become parables of powerlessness and rage.

. . .

Plath, of course, wields the powerful and subtle hammer of her art. Solanas on the other hand is like a rat in a trap by the end. She understands, on some level, that material circumstances shape our lives, and must be altered if we are to improve the world. But she's held back by the limits of her critique— she can't see past gender. In this way, she exposes the limits of radical feminism. Seeing the world through a binary lens—men versus women—has its uses, but she can't build a revolution out of that schism. The divide between male and female becomes a kind of spectacle she loses herself in.

There are glimmers in her work of an understanding of the actual material circumstances that shape our lives: "There is no human reason for money for anyone to work more than two or three hours a week at the very most" is a Marxist (a Marx-ish?) thought, and one that echoes Debord's NE TRAVAILLEZ JAMAIS. She's reaching, just for a moment here and a moment there, for a revolution that would free everyone. But then she hoists her ice pick over her shoulder and continues on her way, looking for more assholes.

Even so, she's left us with something unexpected: by taking us to the farthest extreme of a certain kind of radical feminism, she's given us a glimpse of its limits. She sacrifices a true vision of liberation on the altar of gender essentialism. She makes me wonder: How much is my preoccupation with the crimes of men blinkering me? What am I not seeing when I monster the monstrous men?

CHAPTER 12

DRUNKS

※

RAYMOND CARVER

The question arises stubbornly, again and again: What about empathy for the stained among us? What about empathy for wrongdoers?

Monster, the stained, the accused—these are names for people whose identities have been boiled down to something terrible they did. But of course no one is purely a monster. Even the worst of the people discussed in these pages is a human, with a life that means more than whatever terrible thing he or she did.

The idea of having empathy for the monster—this was uncomfortable for me. I consumed the art of monsters, but it was with a bit of steel in my heart. How could I have empathy for Polanski or Woody Allen? Their misdeeds—their biographies— were something to be ignored. To lock the door against. My feminism—which was elastic enough to allow me to consume the work—was not elastic enough to countenance empathy for these men. They had behaved terribly; they had abused positions of power; they had brought shame upon themselves. They had me as an audience; they did not also deserve my sympathy.

The misdeed was a biography-ender. A full stop. Redemption was not something that entered my imagination; you messed up and you were *out.* You were finished. The internet agreed with me. It was waiting for you, with its deathly arms spread wide; once it embraced you, you were dead. So much for second acts in American lives.

I grew up with a redemption story right in my backyard.

To set the scene a little: When I was a child in the 1970s, Seattle was a non-place in literature. There were few nationally published authors from our part of the world. Whenever I encountered any writing at all about the Northwest, I fell upon it gratefully. I was happy to read anything that had blackberries and Puget Sound and Douglas firs and the names of the streets downtown. I read Richard Brautigan stories; Ken Kesey's *Sometimes a Great Notion,* though I didn't even pretend to enjoy it; collections of columns by crabby old *Seattle Post-Intelligencer* newspapermen of the 1950s. We had Betty MacDonald and Tom Robbins and Mary McCarthy—but MacDonald was easy to dismiss as a housewife, Robbins was cosmically silly, and McCarthy had determinedly burned the bridges connecting her to the provincialism of the Northwest.

And then came Raymond Carver, whose alpha and omega were the Pacific Northwest. He was born in Clatskanie, Oregon, and raised in Yakima, down in the golden southeast corner of Washington State. Married at age nineteen, Carver lived a life of odd jobs and poverty with his first wife, Maryann Burk. Carver was a hard drinker, a bad earner, and an abuser of his wife. Eventually, the family moved to California and Carver enrolled

in Chico State College, where he ended up in a class with John Gardner, a famously inspiring—and famously intimidating—writing teacher, and the future author of *The Art of Fiction*.

After that, writing pulled at Carver relentlessly. So did drinking. His stories began to appear in magazines. His first major collection of stories, *Will You Please Be Quiet, Please?*, was published in 1976. The same year, he was hospitalized four times for acute alcoholism.

The following year he quit alcohol with a new and serious resolve and made Tess Gallagher's acquaintance at a series of festivals and conferences. In 1978, Carver and his wife split up, and in 1979 he and Gallagher began a life together. And then: grace. He quit drinking for good and he came back to Washington, moving in with Gallagher in her house in Port Angeles, a working-class town on the big wild water at the blunt northern head of the Olympic Peninsula. There he stayed until the end of his life in 1988, sober, writing, fishing, entertaining friends—a luminous final act.

In the mid-to-late 1980s, the idea that Carver was physically nearby was important to me, a very young person with only two serious interests in life: reading and writing. In Seattle, a town still obscure in the popular imagination, I wasn't the only one. Carver belonged to the world; but for those of us in the Northwest, he was of special significance, and dear. Beloved.

On an August morning in 1988, I sat at a seminar table in a sunny, dusty-windowed classroom in Loew Hall at the University of Washington. I was taking a fiction-writing workshop from the poet David Wagoner, and he was a little late. Finally, he

arrived. He walked slowly into the room and set his books and papers down on the table. "Bad news," he said. "Ray Carver has died." Hardly a breath, hardly a beat had passed when one of my fellow students—the one who had a Bettie Page haircut and always wore flamboyant red lipstick—dropped her head into her hands and cried, "Poor Tess!"

My fellow student didn't know Carver or Gallagher personally, and truth be told I found her outcry melodramatic and presumptuous. Embarrassed, I sat silently at my desk. Even so, I felt a kind of silent eruption passing through the room. There was no internet then; there was only the poet telling us the story writer had died—our story writer. And some part of me understood my red-lipsticked, melodramatic classmate and wanted to cry out "Not Ray!" with the familiarity of the truly bereaved. Which I was.

His biography—okay, his geography—was important to me. But you could say Carver's biography, with its dramatic reversal from abject alcoholism to sober contentment, hung over his stories and poems for all his readers.

His salvation was told in the development of his style and voice. It was all laid out there for us to see: his transformation from miserable drunkard to saved man.

Carver's stories from the 1970s were terse to the point of refusal. His reputation as literature's preeminent minimalist was cemented with the breakout 1981 story collection *What We Talk About When We Talk About Love*. Seventeen stories of working-class despair were rendered in the barest prose imaginable. Every word seemed fought for. Redemption was not on the menu. In the (very wonderful) "Why Don't You Dance?," a middle-aged man has arranged all his furniture in the driveway

for a yard sale. It opens with the man contemplating the bed-
room set:

> In the kitchen, he poured another drink and looked at
> the bedroom suite in his front yard. The mattress was
> stripped and the candy-striped sheets lay beside two
> pillows on the chiffonier. Except for that, things looked
> much the way they had in the bedroom—nightstand
> and reading lamp on his side of the bed, nightstand and
> reading lamp on her side.
> His side, her side.
> He considered this as he sipped the whiskey.

It's a perfect opener; a whole failed marriage is contained in those
three short paragraphs. A young couple (creating a specter of the
lost marriage) comes along and looks over his things. Eventually
the man pours them all drinks, starts up the record player, and
they dance. This is told in flat-footed prose that somehow man-
ages to be simultaneously terse and disorienting. In the story's
coda, the girl from the couple is recounting to some friends the
story of their strange encounter with the man. The final lines
read: "She kept talking. She told everyone. There was more to
it, and she was trying to get it talked out. After a time, she quit
trying." The story is defined by the failure of connection, from
beginning to end.

 What We Talk About When We Talk About Love influenced a
generation of writers who studied Carver's work and slavishly
attempted to imitate his deceptively simple rhythms. As the nov-
elist Jay McInerney wrote in *The New York Times,* "We all shame-
lessly cribbed from him, we students at Syracuse, and Iowa and

Stanford and all the other writing workshops in the country where almost everyone seemed to be writing and publishing stories with Raymond Carver titles like 'Do You Mind if I Smoke?' or 'How About This, Honey?' " *What We Talk About When We Talk About Love* is, in other words, a special book—a book that changed the way people wrote. Writers wanted to *sound like that.*

However: Carver, in the grip of happiness, no longer sounded quite like that. Compare the sheer dizzying sad-sackery of "Why Don't You Dance?" to the sense of communion that can be found in Carver's next story collection, *Cathedral.* The book is still terse, still concerned with working-class people, but there is a new generosity. The title story tells of a couple hosting the wife's old friend, who is blind, for a visit. The narrator—the husband—is skeptical of his wife's friend before the two meet, as husbands sometimes are, but the evening goes more pleasantly than promised. The two men share a love of scotch, and the blind man accepts the narrator's offer of weed. Relaxing on the couch, they watch a TV documentary about cathedrals, and the narrator realizes the blind man has no idea what a cathedral looks like. The narrator unfolds a grocery bag that previously held onions (like the narrator, earthy and sharp), and together they draw a cathedral: "His fingers rode my fingers as my hand went over the paper. It was like nothing else in my life up to now."

The narrator has escaped himself, and the story closes with this simple (simplistic, even) line: " 'It's really something,' I said."

It's almost like a joke on the idea of the epiphanic short story—all that Joycean whatness, all those Cheeveresque intimations, boiled down into the flat vernacular. And it allows for human connection; in fact the possibility of connection is what the story is *about.*

It seems clear: between the two books, he got better.

Carver shows us what it means to be more than your worst self; he outlived his own monstrousness. He was redeemed. In this way, his story is not so uncommon. In the second half of the twentieth century, the idea of the reformed drunk became a reality for untold millions. Maybe F. Scott Fitzgerald would've believed in second acts in American lives if he'd hit a few AA meetings.

In any case, the tale of Carver's redemption is one of the great late-twentieth-century literary stories. He burnished the redemption story himself. On his gravestone, in a cemetery above the Strait of Juan de Fuca, is inscribed his poem "Gravy": ". . . He quit drinking! And the rest? / After that it was *all* gravy . . ."

This story, this gravestone even, became important to many writers and many drinkers. Not one but two writers—Olivia Laing and Leslie Jamison—have made Carver's grave a centerpiece of their books about writers and drinking and writers who drink and drinkers who write. I suppose I could do the same: locate myself on a windy hill above Port Angeles. But I don't need to go there; I live in Carver's landscape.

It so happens that Carver's biography disrupts his stories, but not in the way you might expect.

What really happened between the two books? The reporter and biographer D. T. Max wanted to know. The accepted story was that Carver's work was affected by his biography. Max wrote: "Many critics over the years have noticed this difference and explained it in terms of biography. The Carver of the early stories, it has been said, was in despair. As he grew success-

ful, however, the writer learned about hopefulness and love, and it soaked into his fiction. This redemptive story was burnished through countless retellings by Tess Gallagher. Most critics seemed satisfied by this literal-minded explanation: happy writers write happy stories."

The distinctive voice that slashes its way through *What We Talk About* is at the heart of the question. That voice was associated with Carver, but Gordon Lish, Carver's editor at Knopf, reportedly claimed to have edited the stories so heavily that they were as much his as they were Carver's.

Had Carver really gotten better, healthier, happier when he wrote *Cathedral?* Or had he simply gotten a different editor?

In 1998, Max, then a writer for *The New York Times Magazine,* visited Indiana University, which had acquired Lish's papers in 1991. Max found that the stories indeed bore the signs of Lish's rumored aggressive edits. Many lines of prose had been cut, whole paragraphs added, endings changed. Correspondence that Max unearthed from the period reveals a terrified Carver, afraid that his reputation wouldn't survive the revelation of the extensiveness of Lish's editorial pen. (This fear of exposure, which chameleon-like takes many forms, is well known to every alcoholic.)

How does this affect our reading of Carver's work? Does it matter that the redemption story we were told about his work was not quite true? Does knowing Lish's involvement change the work itself? I, a devotee of Carver's writing, find that I *needed* his golden redemption story, his tale of life getting better high above the Strait of Juan de Fuca, where, as he wrote, "water comes together with other water." I guess I needed the hope that story offered me.

. . .

One sunny hungover fall morning, deep in the Trump years, I quit drinking.

What entity was it that visited me that morning, as I lay grainy-eyed in bed, just as I had done hundreds of times before? For suddenly—and it truly was sudden—knowledge inhabited me: the knowledge that my drinking and my despair were one and the same. For the first time, I admitted to myself that I hadn't missed a day of drinking in over ten years; ten years when my personal misery index skyrocketed. For the first time, I admitted to myself that I had binged and blacked out and driven drunk and lied. I hadn't abandoned my children, but I'd absented myself in a profound way from my own life. In short, I'd done all the things drunks do. Suddenly it was as obvious as a dumb joke.

What was it, I ask you, that made me fix myself a cup of coffee, sit down in my armchair, open my laptop, and google the words "alcoholism test"?

I groggily, warily clicked my way through something called the Alcohol Use Disorders Identification Test. I didn't answer all the questions honestly, but I revealed a little of how it had been for me. The test spat out my answer: I was exhibiting "harmful drinking behavior."

I thought to myself, *hmm, I wonder what would happen if I told the truth*. I could at the very least experiment with the truth. I took a deep breath and restarted the test. When the results came back this time, it was news I already knew, somewhere inside me.

I stretched out on the living room floor with the sunlight

streaming all over me and the decision to stop drinking happened to me. It was the saddest decision in the world.

I could make my quitting sound good, heroic. I could make it sound like it was an outcropping of my despair over the state of the world. And that was part of it. As my sober friend Kristi wrote me the day I quit: "I'd rather be the gimlet-eyed tip of the spear than one of those women drinking wine and quoting *The Handmaid's Tale* like she's just *rolled over.*"

But it wasn't really that; I wasn't quitting to be anything spear-related. I quit drinking because it was making me an awful, miserable person.

There are two kinds of people who stop drinking: those who simply don't care for the stuff, and those who care for it too much. I was the latter kind. And when a person like me quits drinking, they are confessing, on some level, that they have become an unmanageable monster.

Am I a monster? The answer, it turned out, was a resounding yes.

All those years I had chimed to Raymond Carver as a Pacific Northwest writer, as *my* Pacific Northwest writer, there was something else I recognized as well: the lost man, the drunk man. I was him. I loved him most when I was in my twenties, my party-drinking era—when once every year or so, or maybe every financial quarter, I would wake up and wonder if I should be going to AA. Carver was my avatar, though I refused to see it at the time; refused to see it until that strange sunlit morning when suddenly a new kind of knowledge was available to me; who knows why.

. . .

The recovery movement tells us we are more than the worst thing we've ever done. If we believed otherwise, wouldn't the alcoholic just stay in the gutter, an XXX bottle tipped to her lips like a cartoon drunkard? What would be the point of even trying, if we're only going to be defined by our shittiest moment?

The idea of redemption is crucial to the survival of the drunk, the addict, who must believe in a future that is at least a little free of what she was.

I noticed a certain . . . asperity about so-called cancel culture when it came up in online recovery circles, especially the edgier, crankier online recovery circles inhabited by young former drug users, rather than middle-aged, middle-class former drinkers like myself. There was a note of impatience with the banishing of bad people. Because, after all, we were the bad people. Or had been bad people and were trying not to be.

Recovery, as a way of living, makes you see things from the monster's point of view. You see things from his point of view because you are him. You sit in the rooms and listen and you hear terrible, terrible things, but they are also ordinary things. Because everyone in that room has been through them. Leslie Jamison has written about this gift of the ordinary—your own story is not paramount after all. It's a new experience of empathy for me—the empathy of saying what is worst about me, what is most monstrous, and having it accepted not because I am special, but because I'm not. (An uncomfortable echo here of Humbert's not-specialness.)

When that happens to you, when you receive that very specific kind of empathy: You learn to give it to others as well. Not as a kind of painstaking reciprocity, or out of fairness, or because you are good, but because hearing that you are ordinary in your badness, and extending that understanding of ordinariness to others—doing that helps you continue to not-drink. And therefore continue to live.

Of course the complicating factor is that many addicts and alcoholics are survivors of abuse (even of abuse within the recovery world, which has had its own #MeToo reckonings). It's been shown time and again that trauma and abuse lead to substance abuse. The fact is, alcohol is a really useful way of managing trauma—until it is not. This understanding has profoundly changed the model for thinking about alcoholism. AA framed alcoholism as a disease, but drinking can also be thought of as a solution. Drinking and drugging are a shit solution in the long run, but in the short run they are *extremely* effective strategies for managing Bad Feelings.

In a nutshell, addicts are often people who have been badly hurt—sometimes by other people, sometimes by more structural abuses like poverty and racism. When we sit in a room and accept our fellow monsters, this knowledge—of our own experiences with pain—informs that acceptance as well. We're monsters and we're victims.

We want the story to be one of redemption. But it's always going to be more complicated than that. It's going to be

about fucking up and having been fucked up. It's going to be about Carver's fear of exposure; his addict's knack for hiding the secret self.

Gallagher put Carver's poem "Gravy" on his tombstone, but the poem "Luck" (luck, again) tells what it was really like, before the halcyon days. In the poem, the narrator is nine years old and roaming the house the morning after a party. The boy drinks from the leftover bottles and glasses. "What luck, I thought." This, he writes, was his dream for the rest of his life: to be alone in "a house where no one / was home, no one coming back" and all he could drink.

We drunks have all been that boy, who thinks he's free as he's hurting himself terribly, as he goes on to hurt the people around him. Because we've all been that boy, we found that it was in our best interest to remind the world that people were better than the worst thing they'd ever done.

I guess all of this is a long way of saying: monsters are just people. I don't think I would've been able to accept the humanity of monsters if I hadn't been a drunk and if I hadn't quit. If I hadn't been forced, in this way, to acknowledge my own monstrosity.

Quitting drinking undermined my belief in my own rightness. My own belief that I was better. If I was part monster, surely people who'd done crimes were part human?

It so happened that even as I was being confronted with my own faults, the world was hurtling toward a reckoning with sins that had long gone unacknowledged—or not acknowledged enough, not by people like me. In the months and years after I

quit drinking, history tapped me on the shoulder and reminded me of its swift existence. The pandemic hit; my children, and then I, took to the streets to protest systemic racism; the university where I teach undertook a reckoning, uncomfortable for many of us, with its own whiteness; our entire coast caught fire; we breathed the atmosphere of the end of the world. The cold light of sobriety left me blinking, awake, and wondering why I hadn't seen how bad things were before; hadn't seen how very stacked the decks were and are. Hadn't understood my own luck, and what it meant.

Like many people I knew, I had a growing (correct) sense of my own complicity, my own reliance on the luck of my skin color and my family. I yearned to do the right thing, though I wasn't always clear on what the right thing was.

In light of all this, I came to see the question "what do we do with the art of monstrous men?" in a new way. The initial thought of how to take responsibility is to boycott the art—the liberal solution of simply removing one's money and one's attention. But does that really make a difference?

To say someone else is consuming improperly implies that there's a proper way to consume. And that's not necessarily true.

When we ask "what do we do with the art of monstrous men?" we are putting ourselves into a static role—the role of consumer.

Passing the problem on to the consumer is how capitalism works. A series of decisions is made—decisions that are not primarily concerned with ethics—and then the consumer is left to figure out how to respond, how to parse the correct and ethical way to behave. Michael Jackson is exploited, packaged, served, catered to, even as his behavior becomes more and

more erratic. The music industry does not concern itself with the ethics involved; that's left to us, caught up in a cavalcade of emotions and responses as "I Want You Back" plays over the café speakers.

In his 2009 book *Capitalist Realism: Is There No Alternative?*, Mark Fisher tries to wake us up to the atmosphere of capital in which we all move—an atmosphere so pervasive that we can barely see it, let alone critique or resist it. We are corralled into the role of atomized, individual consumer, even when we're not actively buying something.

Given the role we inhabit, it's natural for us to try to solve injustice and inequity through our individual choices. This feels like a great idea, but unfortunately it doesn't really *work*. "The problem is that the model of individual responsibility assumed by most versions of ethics" can have "little purchase on the behavior of Capital or corporations."

Fisher uses the idea of recycling to explain how the consumer is required to be the enforcer and practitioner of ethics. "*Everyone* is supposed to recycle; *no-one*, whatever their political persuasion, ought to resist this injunction. . . . In making recycling the responsibility of 'everyone', structure contracts out its responsibility to consumers, by itself receding into invisibility. . . . Instead of saying that *everyone*—i.e. every *one*—is responsible for climate change, we all have to do our bit, it would be better to say that no-one is, and that's the very problem."

The scale of what needs to happen in order for climate change and environmental degradation to be slowed is so massive that no single entity can handle it. The emphasis devolves to the individual's responsibility: to recycle, to reuse water bottles, to forgo plastic straws. Because we are atomized individuals

with no collective power, we are left with a grandiose yet ulti-
mately meaningless sense of the importance of our purchases,
our gestures, our decisions.

Fisher's book asks us to understand ourselves as isolated
consumers, and from there it asks us to accept the amorality
of our own consumption. In other words, we keep looking to
consumption as the site of our ethical choices, but the answer
doesn't lie there. Our judgment doesn't make us better consum-
ers—it actually makes us more trapped in the spectacle; more
complicit in what Fisher calls the atmosphere of late capitalism.

Art does have a special status—the experience of walking
through a museum is different from, say, buying a screwdriver—
but when we seek to solve its ethical dilemmas, we approach the
problem in our role as consumers. An inherently corrupt role—
because under capitalism, monstrousness applies to everyone.
Am I a monster? I asked. And yes, we all are. Yes, I am.

Becoming overly focused on what we do about monstrous
men turns attention away from the real work of #MeToo. By
immediately responding, "Well, are you going to throw out the
work of X?" critics become handmaidens of capital, moving the
focus from the perpetrator and the systems that support the per-
petrator to the individual consumer.

This is the liberal, enlightened ideal of individual solutions—
people will make good choices because people are inherently
good. Liberalism wants you to turn your gaze away from the
system and focus instead on the importance of your choices. In
late-stage capitalism, this individual choice becomes irreparably
soldered to consumer choice. What you consume is what you
are. You are, after all, your fandom.

Biography, in this moment of what Guy Debord calls "appearances," reigns supreme. We created a media that thrived on biography, that watered and fed our parasocial relationships, that told us our fandom was ourselves. This, combined with the internet's undreamed-of ability to disperse information, created a condition where we knew everything about everyone, for good or ill. Biography defined our relationships to our faves.

Then came #MeToo. When it was time to criticize the system—to hold power accountable—we remade ourselves in the image of the broken system. We canceled individuals—canceled individual biographies, that is. We were shocked over and over by what these men had done, and reinstated them in the role of charismatic megafauna—this time the glorious animals transformed into terrible monsters. Their downfall was ultimately a reaffirmation of the powers in place—these guys and their biographies remained central. Meanwhile, I pretend that it matters whether or not I stream *Knife in the Water*.

We attempt to enact morality through using our judgment when we buy stuff, but our judgment doesn't make us better consumers—it actually makes us more trapped in the spectacle, because we believe we have control over it. What if instead we accepted the falsity of the spectacle altogether?

Condemnation of the canceled celebrity affirms the idea that there is some positive celebrity who does not have the stain of the canceled celebrity. The bad celebrity, once again, reinforces the idea of the good celebrity, a thing that doesn't exist, because celebrities are not agents of morality, they're reproducible images.

The fact is that our consumption, or lack thereof, of the work is essentially meaningless as an ethical gesture.

We are left with feelings. We are left with love. Our love for

the art, a love that illuminates and magnifies our world. We love whether we want to or not—just as the stain happens, whether we want it to or not.

My reading and compulsive rereading of Carver is shaped by my own experience; my own history, my own geography, my own drunkenness, my own literary aspirations. It is also shaped, for me, by his biography. What follows from all the complication is a plain and uncomplicated thing: love.

I n other words: There is not some correct answer. You are not responsible for finding it. Your feeling of responsibility is a shibboleth, a reinforcement of your tragically limited role as a consumer. There is no authority and there should be no authority. You are off the hook. You are inconsistent. You do not need to have a grand unified theory about what to do about Michael Jackson. You are a hypocrite, over and over. You love *Annie Hall* but you can barely stand to look at a painting by Picasso. You are not responsible for solving this unreconciled contradiction. In fact, you will solve nothing by means of your consumption; the idea that you can is a dead end.

The way you consume art doesn't make you a bad person, or a good one. You'll have to find some other way to accomplish that.

THE BELOVEDS

MILES DAVIS

And so we come back around to what to do about these monstrous people. Emotion, subjectivity, forgiveness, empathy, institutional change, making room for silenced voices, acknowledgment that the work is altered—all of these things matter. So does one more thing: beauty.

It was a cold winter night in a remote cabin. Some friends and I were arguing about which is the best kind of tree. That's the kind of argument we have in the Pacific Northwest. My friend said cedar, because it's so highly functional: Northwest Coast native people used it for shelter, for clothing, for medicine. I said madrona. Why? Because it is beautiful. Its twisting boughs are covered with papery reddish bark, which peels away to reveal another layer of pistachio-colored bark below. It's just an extremely chic-looking tree. It makes its elegant way up the West Coast, changing its name as it goes; madrone in California, madrona in Cascadia, arbutus in British Columbia. The beauty of the madrona was, to me, reason enough to love it. (I did *not* quote "Ode on a Grecian Urn.")

My friend and I didn't realize it at the time, but we were having an argument about utility versus aesthetics. In an argument, utility is almost always going to win. And so it was on this night: beauty lost—except, you know, *in my heart*.

B eauty is a fragile principle. It looks silly when it's brought up against utility—or morality. When we mull over what to do about the art of monstrous men, beauty seems like a dandelion puff—the merest nothing—next to the loud *j'accuse* of saying how awful these men were in their personal lives.

Beauty would come to seem less important than ever over the next few years, as hundreds of thousands died, our fellow citizens were routinely killed by the police, and late capitalism exacted its cruelest tithing.

And yet. Beauty matters too. We don't make decisions about beauty. Beauty happens to us. In a 1995 interview, the critic Dave Hickey distinguished between the beautiful and beauty. "The beautiful is a social construction. It's a set of ambient community standards as to what constitutes an appropriate visual configuration. It's what we're supposed to like. *Beauty is what we like, whether we should or not, what we respond to involuntarily.*" (Italics mine. Also, note how the involuntary nature of our response to beauty echoes the involuntary nature of the stain.)

Hickey goes on: "So beauty is not the product of communities. It creates communities. Communities of desire, if you wish." This is another way to say fandoms. Beauty—our experience of it, rather than our idea of it—is a powerful force, an emotional force.

. . .

watched a video from 1959 of Miles Davis playing "So What" with his stratospheric combo: Coltrane and Cannonball Adderley and Bill Evans. The camera pans the room, landing on Davis's unmistakable stance, his good squared-away athlete's shoulders, his whole body poised to connect.

Davis, an erstwhile heroin addict and pimp, was also known by that time as a musical genius. His history was full of such contradictions. A father by the age of seventeen, he sat in with Billy Eckstine in St. Louis and thereafter left his middle-class family home in Alton, Illinois, for New York to train at Juilliard. He ditched school for the Village, where he hunted Charlie Parker, replacing Dizzy Gillespie in Parker's band. An addiction to heroin dogged him from New York to Europe, but even when he was destitute he put together little combos and small orchestras. The fifties were a decade of turbulence, and throughout it all Miles's playing continued to develop. George Avakian, who signed Davis to Columbia Records, said with great simplicity of his playing: "It was a vulnerable sound."

In 1959, with the full backing of Columbia and the classroom management of the bandleader and arranger Gil Evans, Miles was in control and at the helm of something akin to a miracle.

So, *Kind of Blue:* A few seconds of piano, drums, and bass and then those two opening plangent notes, kicking off the most influential jazz album ever made—those two notes Davis's own, yet belonging to all of us; belonging, right from the start, to the history of music; belonging, all too clearly, to forever.

I came to Miles through the back door. Of course I knew his music, had lived with it my whole life, but it only became the focus of my attention in the year following the initial #MeToo accusations. Not because I automatically became interested in Miles, but because when I looked around for writing on the

separating-the-art-from-the-artist question, a series of false starts and missteps led me to Pearl Cleage's essay "Mad at Miles."

This was the writing, thinking, feeling I'd been looking for. "Mad at Miles" is a hot beast, a headlong piece of writing threaded through with passion and regret. With emotion. With subjectivity. Cleage, a Black playwright, fiction writer, and essayist, writes about the evolution of her relationship with Miles Davis's music in general, and with *Kind of Blue* in particular. "Relationship" is the right word, because Cleage is writing about feelings.

I mentioned in a previous chapter that I had read too many critics whose subjectivity, whose personal perspective, was the ghost in the critical machine. Pearl Cleage makes that ghost howl. She doesn't let us forget the ghost of subjectivity, not even for a minute.

Pearl Cleage comes from her own experience as a Black woman and an abuse survivor. Her unique experience complicated her consumption of Miles Davis—and, in her essay, she doesn't hide that experience or claim she was speaking from objectivity.

Cleage's first experience of Davis's music was euphoric. Those opening notes of "So What" affected her as they had affected so many others. Her language describing her initial encounter with *Kind of Blue* is immediate and intimate—in fact, emotional: "I loved it, listened to it, couldn't get enough."

The album became a personal totem, woven through the eras of her life. Miles saw her through it all: "The Bohemian Woman Phase. The single again after a decade of married phase. The last time I had a date I was eighteen and oh, god, now I'm thirty phase. . . . The cool me out quick cause I'm hanging by a thread phase. For this frantic phase, Miles was perfect."

This is just what happens when we fall in love with a piece of art—especially when it comes to music, which tends to become, just as Cleage shows here, epoch-defining in our lives. Jurassic, Cretaceous, Tertiary; Beatles, Dinosaur Jr., Belle and Sebastian.

The importance of *Kind of Blue* can't be overstated; it's a masterpiece that also happens to be the bestselling jazz record of all time. By every critical and commercial yardstick, *Kind of Blue* matters. But that's not what concerned Pearl Cleage. What concerned her was how she felt.

Transported. In love.

Art-love, love of the work—*Liebe zur Kunst*—can be a life-changing thing. I've already described the living room where I write this, a room in which I have consumed books and films and albums that have brought me joy (or agony, or just amusement); a room packed to the cornices with *Liebe zur Kunst*. Art-love has shaped my life, our lives. Like Pearl Cleage and her phases marked by Miles, art-love has marked the lives of my people:

My mom lay on the couch reading, smoking, drinking Fresca, unwilling or perhaps unable to move, pinioned by her book. This seemed to go on for a decade or two.

My friend Peter, a teenager in the 1980s and closeted (even to himself), methodically made his way through the old films in the Leonard Maltin movie guide, and found—in those Katharine Hepburn and Bette Davis and Elizabeth Taylor movies—something that told him it was okay to be gay.

Visiting New York, my friend Victoria rushed from gallery to gallery, until her feet were blistered and bleeding.

My brother, stuck at his corporate desk, streamed old concert footage of Waylon and Willie while he worked.

My father, freshly retired, sat in his houseboat on Seattle's Lake Union and methodically, purposefully made his way through Thomas Mann, finding in those fat novels a new structure for his days.

I flew with my children to Chicago to see Belle and Sebastian play their best album in its entirety. My daughter and I sang along to every song; my son smiled an indelible smile.

My friend Scott listened to old big band tunes, his mother's favorite songs, over his iPhone as he built a box for her ashes.

I sat for weeks and weeks by my dying father's bedside, reading. I chose books that were light, so I could easily hold them in one hand, my other hand gripping my father's gnarled claw, the ventilator whooshing rhythmically in the background.

I read a thousand thousand thousand books.

I read books when I woke and books when I slept, and I carried a book with me all day every day.

My books kept me from loneliness, all my life.

As I mentioned earlier, for a dozen years I lived on an island. My island was not a metaphorical island. It was an actual island you got to by ferryboat. And there I was cloistered away. Most of my friends lived across the water, in the city. That happened on purpose. I wanted more aloneness, and I certainly got it. I'll put it this way: I got to know a lot of really great trees. But my island solitude was crowded, of course, with books. This is what has saved me from myself since I was a little kid. Reading is an unambiguously good thing in a life that's been filled with mixed blessings.

Love of the work—it's not the most celebrated love. Cleage's essay matters, and it matters not just because she's mad at Miles,

but because she's in love with Miles; because Miles makes her feel less alone; because Miles speaks to her specific experience. Cleage is getting at the feeling that an artist *belongs* to you; it's the honorable, nutritious, essential feeling underlying the way we semi-jokingly get pissed off when a favorite obscure band becomes popular.

Cleage's evocation of the specificity of her experience—all those phases she lists—reflects the deeply personal nature of art-love. As with any kind of love, art-love is an intimate experience, and specific to one's own nature.

In *Howard's End*, E. M. Forster gets at the way art's effect is felt differently by each of us—but the thing is, we feel something. Here he describes several characters attending a concert:

It will be generally admitted that Beethoven's Fifth Symphony is the most sublime noise that has ever penetrated into the ear of man. All sorts and conditions are satisfied by it. Whether you are like Mrs. Munt, and tap surreptitiously when the tunes come—of course, not so as to disturb the others; or like Helen, who can see heroes and shipwrecks in the music's flood; or like Margaret, who can only see the music; or like Tibby, who is profoundly versed in counterpoint, and holds the full score open on his knee; or like their cousin, Fräulein Mosebach, who remembers all the time that Beethoven is "echt Deutsch"; or like Fräulein Mosebach's young man, who can remember nothing but Fräulein Mosebach: in any case, the passion of your life becomes more vivid, and you are bound to admit that such a noise is cheap at two shillings.

He opens with an authoritative pronouncement, but moves quickly and comically into more human and specific responses. In his wry way, Forster is pinning down the validity and meaning of each individual response to the music; the passage is a kind of "Varieties of Aesthetic Experience." None of the responses is rational (though Tibby might think his is). Each is personal; each is emotional; each is love.

So it is when Cleage says: "I will confess I spent many memorable evenings sending messages of great personal passion through the intricate improvisations of *Kind of Blue*" or "Chill the wine. Light the candles. Put on a little early Miles." She's talking about her idiosyncratic response to the music, like Mrs. Munt tapping a toe. To use her own word, she's *confessing* her response.

Fair enough—why, though, is it a confession? Because she feels guilty about her feelings. Because her knowledge of Miles's abuse of women is complicating her love of him. "Complicating" is too dull a word; her knowledge is ruining her love, ruining the music. And meanwhile, she doesn't *want* to voice these feelings about a Black man. She wants to venerate Black men. As she wrote in a later collection, *Deals with the Devil*, people who read "Mad at Miles" wanted to make sure that "I understood the danger of and divisiveness of perpetrating such 'negative images' of black men." But she is adamant: Miles himself has forced her into this crisis. It's not something she chose, and she is, in a word, mad about it.

She describes the first time her friend A.B. played *Kind of Blue* for her: "I was an innocent. He could have given me anybody. But he gave me Miles Davis. *Kind of Blue*. And he didn't even warn me that *Miles was guilty of self-confessed violent crimes*

against women such that we ought to break his records, burn his tapes and scratch up his CDs until he acknowledges and apologizes and agrees to rethink his position on The Woman Question."

Davis wrote frankly in his autobiography of his abuse, talking about how he "slapped the shit" out of Cecily Tyson. He described violent fights with his wife Frances, who told *The New York Times* in a 2006 interview, "I actually left running for my life—more than once." Miles was a more run-of-the-mill asshole as well, demanding that Frances give up her career. He writes: "She was a star and on her way to being a superstar, probably the premier black female dancer when she went with me. She was getting all these offers to dance when she won Best Dancer for what she did in *West Side Story* on Broadway. But I made her get out of that because I wanted her at home with me."

There's no hiding the monstrousness, and Cleage takes it all personally. She asks at the end of her essay: "Can we make love to the rhythms of 'a little early Miles' when he may have spent the morning of the day he recorded the music slapping one of our sisters in the mouth? Can we continue to celebrate the genius in the face of the monster?"

Cleage is affronted; her love is personal, and her hate is too. Her hate stems from her own experience, and from the fact that Davis is slapping her sisters. Cleage is railing against Davis's assault on Black womanhood; in other words, an assault on herself, or rather her self.

As I said earlier, consuming a piece of art is two biographies meeting: the biography of the artist, which might disrupt the consuming of the art; and the biography of the audience member, which might shape the viewing of the art. I repeat: this occurs in every case.

. . .

This kind of subjective response to the work would seem to make Cleage's essay weaker, in terms of mounting a convincing argument. She shows her hand—shows that her own experience is shaping her response to the work—so that we know she's not speaking from authority. She's speaking from what seems to be authority's opposite: personal experience. Her whole argument is built on what seems an assailable position: a feeling.

What she's given us, though, is a sound as strong and clear as a coin rapped on a counter.

Emotions are of course changeable; Cleage and her feelings wound up in a different place from where she started. In a 2012 interview in *Atlanta* magazine, she was asked: "There are countless jazz fans who haven't been able to listen to Miles Davis the same way since reading your 1990 book, *Mad at Miles: A Blackwoman's Guide to Truth,* where you detail Davis's abusive relationships with women. Should I continue to feel guilty about wanting to listen to his work?"

Cleage responded: "No, you should not feel guilty. Miles is dead. . . . And I will confess that I was never able to give up listening to *Kind of Blue* myself either!"

I love this because it speaks of the open-endedness of the relationship to the work: we change, and our relationship to it changes. Another strike against authority. Cleage loves Miles, and then hates him, and then loves him in a more knowing way. So our relationships shift as we grow up. But pretending the love doesn't exist, or saying it oughtn't to, doesn't help anything.

Stephen Fry loves Wagner; the college students quizzing me about David Bowie love David Bowie; I love Polanski.

Those facts might not be ideal, might even be depressing, but they are true.

A few months after the madrona/cedar debate, at the same remote cabin with family and friends. Everyone else was inside the cabin making dinner while my friend Sam and I tended the fire in the gathering dusk. It was a cold July evening in the north. The kind of night when all my life's decisions seemed, in retrospect, to have been good ones. They must have been good, to have ended up here, among friends and children. The adults were cooking or drinking, the teenagers were drifting around in a loose clump, a little phone-tranced but basically okay. Or maybe it had nothing to do with my decisions, maybe it was just dumb luck, the luck I was born into.

Somehow my friends and our kids and I had made it through the crushing world and ended up here: on a high bluff over a darkening sea, Mt. Baker and Mt. Rainier like two squat ghosts, linked by a long horizon.

The weak northern light shone on Sam's face as he poked the fire with a stick. Sam had a way of doing things with a jolly efficiency. Sam was solid. It was easy to forget he'd made his way here with more difficulty than the rest of us had.

He poked the fire and asked idly, "So, are you still working on that book about monsters?"

"I am."

"I've been thinking about it. I was actually thinking about my stepdad Fred, who was"—he laughed—"kind of a monster."

I'd heard a bit about Sam's troubled mom and her years with the criminal Fred, but it was easy to forget, here in the orange-gray dusk, with the lovely teenagers avoiding helping in the kitchen and the fire really starting to catch.

"How was Fred a monster?" I asked uncertainly. I didn't want to pry, or to predate on his bad-luck childhood in a prurient kind of way.

Sam unspooled his story. I don't want to disrespect him by going into every last detail here, but suffice it to say he was dragged back and forth across the West by his drug-addicted mother; Fred disappeared and reappeared, committing abuses and crimes all along the way until he ended up in prison.

"Did Fred ever straight-up kill someone," I wondered aloud. Sam couldn't actually say, just gave a very Sam-esque shrug— the kind of shrug that comes with a "people are nuts" kind of laugh.

We sat in silence for a moment. People started trickling out of the cabin, carrying platters of food toward the picnic table. The fire burned in the waning sunshine with a profligate light. I took a turn prodding at it.

"But the thing is," Sam went on thoughtfully, "I still love Fred. That's what makes me think of your book. Even after everything he did." (That phrase again, *even after everything*.) "When he was dying, we reconnected and became close again. He was a bad man, but he loved me and I loved him. I still love him."

I froze, held in place by Sam's thought. Of course. This was what I was trying to say, what I had been trying to say all along.

What do we do with the art of monstrous men? This question is the merest gnat, buzzing around the monolith that is the bigger question: what do we do about the monstrous people we love?

We've all loved terrible people. How do I know this? Because I know people, and people are terrible. Sam went to the real problem at the heart of everything: the problem of human love. The aesthetic and ethical issues presented by men from Caravaggio to Michael Jackson are a kind of parable for this larger problem.

What do we do about the terrible people we love? Do we excise them from our lives? Do we enact a justice, swift and sure? Do we *cancel* them? Sometimes. But to do so is an excruciating process, and ultimately goes back to the calculator I introduced in the beginning. We ask, or maybe don't ask, but actually feel our way through the problem: How terrible is their terribleness? How much do we love them? And how important is that love to us?

Mary Karr spoke many years ago about the problem of love in the memoir. In an interview, she described the typical bad memoir like this: "You find out what the problem is in the beginning and it's the same problem kind of reiterated. My mother hit me on the head with a brick on Monday and then I was a sophomore in high school and my mother hit me on the head with a brick and then I was a junior and she hit me on the head with a brick. Then I got some car keys and I left and I'm better now."

But that is not how life really works. Karr goes on: "The problem isn't that your mother hit you on the head with a brick. The problem is that you still love her, that you depend on her."

The problem is that you still love her. Yes, exactly. When we talk about the problem of the art of monstrous men, we are really talking about a larger problem—the problem of human love. The question "what do we do with the art?" is a kind of laboratory or a kind of practice for the real deal, the real question: what

is it to love someone awful? *The problem is that you still love her.*
How often this describes our relationships with our families,
our spouses, sometimes even our children. It's the problem and
it's the solution, this durable nature of love, the way it withstands
all the shit we throw at it, the bad behavior, the disappointments,
the tantrums, the betrayals.

What do we do about the terrible people in our lives? Mostly
we keep loving them.

Families are hard because they are the monsters (and angels,
and everything in between) that are foisted upon us. They're
unchosen monsters. How random it all seems, when you really
consider it. And yet somehow we mostly end up loving our fami-
lies anyway.

When I was young, I believed in the perfectibility of humans.
I believed that the people I loved should be perfect and I should
be perfect too. That's not quite how love works.

Another thought: I rushed to sympathize with Sam, but per-
haps Fred wasn't the only monster under discussion. Maybe
Sam had been a monster to Fred sometimes. And maybe I had
been a monster too. I thought of this feeling I had, the feeling
that I had abandoned my children simply by drinking. My chil-
dren who still loved me, who loved me no matter what. I was,
in a way, more like Fred than like Sam: loved despite my flaws.
Unfairly loved. Undeservedly loved.

What do we do about the terrible people we love? That ques-
tion comes with another question nestled inside it: how awful
can we be, before people stop loving us?

. . .

n her haunting little book *Love's Work*, the British philosopher Gillian Rose writes: "In personal life, regardless of any covenant, one party may initiate a fundamental change in the terms of relating without renegotiating them, and further, refusing even to acknowledge the change. . . . There is no democracy in any love relation: only mercy."

That is: Love is not reliant on judgment, but on a decision to set judgment aside. Love is anarchy. Love is chaos. We don't love the deserving; we love flawed and imperfect human beings, in an emotional logic that belongs to an entirely different weather system than the chilly climate of reason.

Pearl Cleage—in her older, mellower days—softened toward Miles. She spoke of him with tenderness, with sadness, with feeling: "We can just hope the next time he comes around his spirit and his personality will be as lovely as his music." We can just hope.

ACKNOWLEDGMENTS

Deepest gratitude to my dear and recently departed father. When I told him I was planning to write a book about monstrous artists, he immediately replied, "Be careful not to meet any!"

I'm more indebted to the brilliant Jordan Pavlin than it is possible to say.

For assistance and support in making this book: the great Anna Stein, Hedgebrook, the Lannan Foundation, Nadja Spiegelman and *The Paris Review,* and everyone at Knopf, including Reagan Arthur, Isabel Yao Meyers, Rita Madrigal, Amy Hagedorn, Morgan Fenton, Holly Webber, and Kelly Blair for the perfect cover. In the UK, many thanks to Sophie Lambert at C&W and Charlotte Humphery at Sceptre, an indefatigable champion of this book. Special thanks to Cathy Lomax for the painting on the cover of the UK edition.

For important conversations and/or pointing me in the right direction: Jason Zinoman, John Toews, Kate Rossmanith, Andy Miller, Sara Dickerman, Emily Hall, Margot Page, Erika Schickel, Courtney Hodell, Matthew Klam, Ijeoma Oluo, Nell Freudenberger, Abe Carlin, Sonora Jha, Noah Chasin, Alex Blumberg, Danai Gurira, Faith Childs-Davis, Simon Reynolds, Ama Codjoe, Suzanne Morrison, Victoria Haven, Jeanne Garland, Joanna Rakoff, Johnny Stutsman, Rachel Monroe, Rinku Sen, Kim Brooks, Shobha Rao, Sanjiv Bhattacharya, all the members of

the prison abolition reading group, and the community of the Pacific University MFA program.

This is just a selected list of the many, many writers and thinkers whose work informed this book: Simon Callow, Kelly Oxford, Maya Cantu, E. L. Doctorow, Gillian Flynn, Claire Vaye Watkins, John Durham Peters, Shoshana Zuboff, Randall Kenan, Hanif Abdurraqib, Donna Haraway, Sasha Geffen, John Berger, Miles J. Unger, Paul Hendrickson, Sydney Brownstone, Stephen Fry, Hans-Jürgen Syberberg, Martin Amis, Deborah Levy, Judd Tully, Marisa Crawford, Sarah Manguso, Suzanne Buffam, Elaine Showalter, Paula Fox, the late great Jenny Diski, Alexandra Fuller, Martin Stannard, Linda Sexton, Stephen Trask, David Yaffe, bell hooks, Sheila Weller, B. Ruby Rich, Breanne Fahs, Carol Sklenicka, Jay McInerney, D. T. Max, Mark Fisher, Dave Hickey, Gillian Rose. All mistakes are mine, of course. Special thanks to Jenny Offill, whose novel *Dept. of Speculation* has been a source of inspiration and a spur to thought for so many writers, including myself.

Thanks to Pearl Cleage for getting it right.

For boundless generosity and smarts and love: Miranda Beverly-Whittemore, Kristi Coulter, and Tova Mirvis.

For the kind of durable friendship that keeps a person afloat: Victoria Haven, Dave Lipe, Steve Fradkin, Linda Mangel, Scott Loveless, Teresa Howard, Jeanne Garland, Jeff Garland, Trilby Cohen, Margot Page, Suzanne Morrison, and Bruce Barcott.

For being my irreplaceable and beloved family: Donna Dederer, Larry Jay, Dave Dederer.

For providing endless joy: my sun and also my moon, Lou Barcott and Will Barcott.

For love: Peter Ames Carlin.

NOTES

PROLOGUE THE CHILD RAPIST

3 On March 10, 1977: Transcript of Samantha Gailey testimony, in Luchina Fisher, "Roman Polanski: What Did He Do?," *ABC News*, September 29, 2009.

6 life involves maintaining oneself between contradictions: William Empson, in notes on the poem "Bacchus," *The Complete Poems of William Empson* (London: Allen Lane, 2000), 290.

9 "The heart wants what it wants": quoted in Walter Isaacson, "The Heart Wants What It Wants," in *TIME*, Monday, August 31, 1992.

I ROLL CALL

16 *"Grab 'em by the pussy"*: "Transcript: Donald Trump's Taped Comments About Women," in *The New York Times*, October 8, 2016.

16 "Women: tweet me your first assaults": Kelly Oxford (@kellyoxford), Twitter, October 7, 2016.

21 "I never said 'La-di-da' in my life until he wrote it": Diane Keaton to Katie Couric, "The Real Annie Hall," *NBC News*, November 12, 2010.

25 "depressed enough to wonder": E. L. Doctorow, "Braver Than We Thought," *The New York Times Book Review*, May 18, 1986.

25 "Men always say that as the defining compliment": Gillian Flynn, *Gone Girl* (New York: Ballantine, 2012), 222.

26 "I have built a working miniature replica": Claire Vaye Watkins, "On Pandering," *Tin House*, Winter, 2015.

28 "She's seventeen. I'm forty-two": *Manhattan* (United Artists, 1979), directed by Woody Allen.

29 "Groucho Marx, to name one thing": *Manhattan*, Allen.

29 "Your concerns are my concerns": *Manhattan*, Allen.

29 "Isaac: The steel cube was brilliant?": *Manhattan*, Allen.

30 "I finally had an orgasm": *Manhattan*, Allen.

31 "There's no logic to those things": Isaacson, "The Heart Wants What It Wants."

31 *I moved on her like a bitch:* "Transcript: Donald Trump's Taped Comments About Women."

35 "the closest possible examination of what the poem says as a poem": Cleanth Brooks, *The Well-Wrought Urn* (New York: Harvest, 1947), xi.

2 THE STAIN

40 "My plan was to never get married": Jenny Offill, *Dept. of Speculation* (New York: Granta, 2014), 8.

43 *"i am currently trying to do the aesthetico-moral calculus thing":* Simon Reynolds, personal correspondence with the author.

3 THE FAN

54 "How we take broadcast personae is a measure of mental health": John Durham Peters, "Broadcasting and Schizophrenia," in *Media, Culture & Society* 32, no. 1 (2010): 123–40.

55 "behavioral futures markets": Shoshana Zuboff, "Surveillance Capitalism," *Project Syndicate*, January 3, 2020.

59 " 'inclusive' language that calls female people": J. K. Rowling, "J. K. Rowling Writes About Her Reasons for Speaking Out on Sex and Gender Issues," jkrowling.com, June 10, 2020.

4 THE CRITIC

62 "My voice, forever edged in judgment": Vivian Gornick, *The Odd Woman and the City* (New York: Farrar, Straus and Giroux, 2015), 6.

66 "Every work of art provides its reader with all the necessary elements": Alessandro Manzoni, *The Count of Carmagnola and Adelchis* (Baltimore: Johns Hopkins University Press, 2004), 103.

70 "If you're going to assemble a team now": Quoted in Rebecca Nichol-

son, "That's quite enough silly walks from BBC comedy. New voices please," *The Guardian*, June 23, 2018.

70 "I no longer want to be a white male": Quoted in Deborah Frances-White, "Pink Protest," in *Feminists Don't Wear Pink and Other Lies: Amazing Women on What the F-Word Means to Them* (New York: Ballantine, 2018), ed. Scarlett Curtis, 171.

70 "social engineering": Quoted in Sopan Deb, "For Eric Idle, Life's a Laugh and Death's a Joke, It's True," *The New York Times*, September 26, 2018.

72 "can sympathize with, say, feminism": Richard Schickel, *Woody Allen: A Life in Film* (Chicago: Ivan R. Dee, 2003), 176.

72 "What feeling do you have that is not tied up with history?": Randall Kenan, "Understanding Randall Kenan," University of Mississippi Department of English Lecture Series, April 11, 2019.

74 "a conquering gaze from nowhere": Quoted in Kate Rossmanith, *Small Wrongs: How We Really Say Sorry in Love, Life and Law* (Melbourne: Hardie Grant, 2018), 20.

75 "I think the political responsibility of the fan": Quoted in Nawal Arjini, "How to Be Critical of the Things You Love," *The Nation*, February 12, 2019.

76 "Five Years": David Bowie, genius.com/David-bowie-five-years-lyrics.

76 "I was an innocent girl, but the way it happened was so beautiful": Quoted in Michael Kaplan, "I Lost My Virginity to David Bowie," *Thrillist*, November 2, 2015.

78 initiating unwanted sexual contact: Sasha Geffen, "Queer Kids Deserve Better Than PWR BTTM," *Pitchfork*, May 16, 2017.

78 "It's Hard Not to Feel Cynical About PWR BTTM": Jordan Sargent, *SPIN*, May 16, 2017.

5 THE GENIUS

82 "dehumanization to the point of death": Quoted in Maureen Dowd, "This Is Why Uma Thurman Is Angry," *The New York Times*, February 3, 2018.

86 "To the prodigy himself": John Berger, *The Success and Failure of Picasso* (New York: Vintage, 1989), 28.

87 "Picasso, at the age of eighty-two": Berger, *The Success and Failure of Picasso*, 29.

87 "unleashed universal anger": Quoted in Miles J. Unger, *Picasso and the Painting That Shocked the World* (New York: Simon & Schuster, 2018), 344.

90 "The public is wonderfully tolerant": Oscar Wilde, *The Critic as Artist* (Los Angeles: Green Integer Books, 1997), 10.

91 "The associations around Picasso's name": Berger, *The Success and Failure of Picasso*, 6–7.

92 *"And girls could not resist his stare"*: Jonathan Richman, "Pablo Picasso," 1976, https://genius.com/The-modern-lovers-pablo-picasso-lyrics.

92 "Woman is a machine for suffering": Françoise Gilot, *Life with Picasso* (New York: McGraw-Hill, 1964), 84.

93 "He submitted them to his animal sexuality": Quoted in Shannon Lee, "The Picasso Problem: Why We Shouldn't Separate the Art from the Artist's Misogyny," *Artspace*, November 22, 2017.

94 "Concealed among the stones": Paul Gauguin, *Noa Noa: The Tahitian Journal* (New York, Dover, 1985), 12.

94 *his diaries were plagiarized*: Stephen F. Eisenman, *Gauguin's Skirt* (London: Thames and Hudson, 1997), 18.

94 "Gauguin 'created' a style of painting": Wayne V. Anderson in Eisenman, *Gauguin's Skirt*, 16.

95 "I am a great artist and I know it": Quoted in Michael Fraenkel, "A New Gauguin," *VQR*, Winter, 1928.

95 "Everything, the whole of creation, was an enemy": Arianna Huffington, *Picasso: Creator and Destroyer* (New York: Avon Books, 1988), 91.

96 Marlene Dietrich wrote a piece: Paul Hendrickson, *Hemingway's Boat: Everything He Loved and Lost* (New York: Vintage, 2012), 31.

96 "Years of the Dog": Archibald MacLeish, *The Collected Poems of Archibald MacLeish* (Boston: Houghton Mifflin, 1962), 145.

97 "It is more than a year since he actually hit me": Hendrickson, *Hemingway's Boat*, 439.

97 "Walking home I tried to think what he reminded me of": Ernest Hemingway, *A Moveable Feast* (New York: Scribner, 1996), 115.

98 "To a Tragic Poetess": Ernest Hemingway, *Complete Poems* (Lincoln, Neb.: Bison Books, 1983), 87.

98 "Bullfighting is the only art in which the artist is in danger of death": Ernest Hemingway, *Death in the Afternoon* (New York: Scribner, 1960), 77.

99 "Direct action. It beats legislation": Ernest Hemingway, *The Sun Also Rises* (New York: Scribner, 2006), 116.

100 "You did not kill the fish only to keep alive": Ernest Hemingway, *The Old Man and the Sea* (London: Grafton, 1989), 90–91.

100 "He was 'tough' because he was really sensitive and ashamed that he was": Quoted in Hendrickson, *Hemingway's Boat*, 277.

101 "devil things": Ernest Hemingway, *The Garden of Eden* (New York, Scribner, 1995), 29.

101 "anatomically vague but emotionally precise": Eric Pooley, "How Scribner's Crafted a Hemingway Novel," https://tomjenks.com.

102 "Recently I got sucked into a research project in northern Michigan": Quoted in Alec Hill, "John Jeremiah Sullivan: There's No Such Thing as Wasted Writing," *Literary Hub*, January 17, 2018.

103 "That sacred animal the artist justifies everything": Doris Lessing, *The Golden Notebook* (New York: Perennial Classics, 1999), 60.

104 "Married and the father of two small children": Quoted in Jim Windolf, "Songs in the Key of Lacerating," *Vanity Fair*, May 22, 2007.

106 "I am a rock star": Quoted in Austin Scaggs, "Kanye West: A Genius in Praise of Himself," *Rolling Stone*, September 20, 2007.

107 "What's a black Beatle anyway?": Kanye West, "Gorgeous," 2010, https://genius.com/Kanye-west-gorgeous-lyrics.

108 "specialists of apparent life": Guy Debord, *The Society of the Spectacle* (Bureau of Public Secrets, 2014), 24.

108 "spectacular representations of living human beings": Debord, *The Society of the Spectacle*, 24.

108 "I think all kinds of artists who live on that ragged edge": Quoted in Hendrickson, *Hemingway's Boat*, 83.

6 THE ANTI-SEMITE, THE RACIST, AND THE PROBLEM OF TIME

113 Dave Meinert: Sydney Brownstone, "Five Women Accuse Seattle's David Meinert of Sexual Misconduct, Including Rape," KUOW, July 19, 2018, https://www.kuow.org/stories/five-women-accuse-seattle-s-david-meinert-of-sexual-misconduct-including-rape.

116 "I have this fantasy": Stephen Fry, *Wagner & Me* (2010), directed by Patrick McGrady.

116 the festival at Bayreuth: Rachel Gessat, "Bayreuth's Historical Ties

to Nazism," *Deutsche Welle*, July 24, 2012, https://www.dw.com/en/bayreuths-historical-ties-to-nazism/a-16121380.

116 "Wagner's anti-Semitism . . . was more than a bizarre peccadillo": Simon Callow, *Being Wagner: The Story of the Most Provocative Composer Who Ever Lived* (New York: Vintage, 2017), 185.

117 "The Jew—who, as everyone knows, has a God all to himself": Richard Wagner, "Judaism in Music," in *Richard Wagner's Prose Works: Vol III, The Theatre* (London: Kegan Paul, Trench, Trubner & Co., 1907), 82–83.

118 "We have to explain to ourselves the involuntary repellence": Wagner, "Judaism in Music," 80.

118 "Even to-day we only purposely belie ourselves": Wagner, "Judaism in Music," 80–81.

119 "I'm Jewish and lost relatives in the Holocaust": Fry, *Wagner & Me*.

119 "Imagine a great beautiful silk tapestry": Fry, *Wagner & Me*.

120 "no cozy home of his own": Winifred Wagner in *The Confessions of Winifred Wagner (1975)* by Hans-Jürgen Syberberg.

120 "He was always free and easy with the children": Wagner in *The Confessions of Winifred Wagner*.

121 "the good uncle with the pistol in his pocket": Wagner in *The Confessions of Winifred Wagner*.

121 "We said *du* to each other": Wagner in *The Confessions of Winifred Wagner*.

121 "But I don't want to divulge these purely personal things to the public": Wagner in *The Confessions of Winifred Wagner*.

121 "He used to shout 'Look out! Woman driver!'": Wagner in *The Confessions of Winifred Wagner*.

122 The director here interjects an apt quotation: Hans-Jürgen Syberberg, *The Confessions of Winifred Wagner*. The translation of this Walter Benjamin quote I was able to source is: "Such is the aestheticizing of politics, as practiced by Fascism. Communism responds by politicizing art." Walter Benjamin, "The Work of Art in the Age of Its Technological Reproducibility," in Michael W. Jennings, Brigid Doherty, and Thomas Y. Levin, eds., *The Work of Art in the Age of Its Technological Reproducibility and Other Writings on Media* (Cambridge: Harvard University Press, 2008), 42.

124 "We all wish our idols and exemplars were perfect": Doris Lessing, foreword to Virginia Woolf, *Carlyle's House and Other Sketches* (London: Hesperus, 2003), 3.

125 "It was many years before I knew that those little brown shavings": Willa Cather, *My Antonia* (New York: Vintage Classics, 1994), 63.

125 "He had the Negro head, too": Cather, *My Antonia*, 139.

125 "There were no people; only Indians lived there": Laura Ingalls Wilder, *Little House on the Prairie* (New York: Harper & Brothers, 1935), 1. In later editions the word "people" is changed to "settlers."

126 "the only good Indian is a dead Indian": Laura Ingalls Wilder, *Little House on the Prairie* (New York: Harper Trophy, 1971), 211.

128 "Rather than a thousand shoots blossoming": Francis Fukuyama, *The End of History and the Last Man* (New York: The Free Press, 1992), 338–39.

7 THE ANTI-MONSTER

135 "The cradle rocks above an abyss.": Vladimir Nabokov, *Speak, Memory: An Autobiography Revisited* (New York: Vintage International, 1989), 19.

135 "She was Lo, plain Lo": Vladimir Nabokov, *Lolita* (New York: Vintage International, 1997), 9.

135 "I would have the reader see 'nine' and 'fourteen' ": Nabokov, *Lolita*, 16.

135 "ineffable signs—the slightly feline outline": Nabokov, *Lolita*, 17.

137 "The best part of a writer's biography": Vladimir Nabokov, "Vladimir Nabokov Talks About Nabokov," *Vogue*, December 1969.

139 "I realise, if I have *killed* somebody, it wouldn't have had so much appeal": Martin Amis, "Roman Polanski" in *Visiting Mrs. Nabokov: And Other Excursions* (New York: Vintage International, 1995), 246.

140 "an inherent singularity": Nabokov, *Lolita*, 13.

140 "You can always count on a murderer": Nabokov, *Lolita*, 9.

141 "I exchanged letters with these people": Nabokov, *Lolita*, 35.

141 "possibly, owing to the synchronous conflagration": Nabokov, *Lolita*, 35.

141 "the king crying for joy, the trumpets blaring": Nabokov, *Lolita*, 39.

142 "(Had I done to Dolly, perhaps": Nabokov, *Lolita*, 289.

142 "very like the one I had": Nabokov, *Lolita*, 294.

142 "He rolled over me. I rolled over him": Nabokov, *Lolita*, 299.

142 " 'You chump,' she said, sweetly smiling": Nabokov, *Lolita*, 141.

144 "And I catch myself thinking today that our long journey": Nabokov, *Lolita*, 175–76.

144 "It struck me, as my automaton knees went up and down": Nabokov, *Lolita*, 284.

145 "Rather abstractly, just for the heck of it": Nabokov, *Lolita*, 269.

146 "What I heard was but the melody": Nabokov, *Lolita*, 308.

150 "Farlow, with whom I had roamed those remote woods": Nabokov, *Lolita*, 216.

8 THE SILENCERS AND THE SILENCED

152 "In my late teens I had read the dusty literary journals": Deborah Levy, *Real Estate* (London: Bloomsbury, 2021), 177.

152 "earth-body works": *Ana Mendieta: Earth Body,* Hirshhorn Museum and Sculpture Garden, Smithsonian, Sept. 3, 2020, https://hirshhorn.si.edu/exhibitions/ana-mendieta-earth-body-sculpture-and-performance-1972-1985/.

152 her father had joined counterrevolutionary anti-Castro forces: "Ana Mendieta," The Guggenheim Museums and Foundation, https://www.guggenheim.org/artwork/artist/ana-mendieta.

152 *Silueta:* "Untitled: Silueta Series," The Guggenheim Museums and Foundation, https://www.guggenheim.org/artwork/5221.

153 "my wife is an artist and I am an artist and we had a quarrel": Quoted in Jan Hoffman, "Rear Window: The Mystery of the Carl Andre Case," *The Village Voice,* March 29, 1988.

154 "Carl got a Minimalist trial.": Hoffman, ""Rear Window."

154 "Central Park suspect's lawyer claims 'Jenny killed in wild sex'": Erin Jensen, " 'Preppy Murder' spotlights Jennifer Levin, victim-blaming; would the case be different today?," *USA Today,* November 13, 2019.

155 "What they did was try to degrade Ana": Judd Tully, April 26, 1988, https://juddtully.net/news/andre-acquitted/.

155 "developed an original and somewhat morbid style": Calvin Tomkins, "The Materialist," *The New Yorker,* December 5, 2011.

157 *TEARS:* From "Crying; A Protest," https://m.facebook.com/events/660897607355966/.

158 "I walked into the exhibit's main room": Marisa Crawford, "Crying for Ana Mendieta at the Carl Andre Retrospective," *Hyperallergic,* March 10, 2015, https://hyperallergic.com/189315/crying-for-ana-mendieta-at-the-carl-andre-retrospective/.

9 AM I A MONSTER?

161 "There has never been a document of culture, which is not simultaneously one of barbarism": Walter Benjamin, "Theses on the Philosophy of History," in *Illuminations* (New York: Schocken Books, 2007), 256.

163 "It can be worth forgoing marriage for sex": Sarah Manguso, *300 Arguments* (Minneapolis: Graywolf Press, 2017), 3.

163 "There is no more sombre enemy of good art": Cyril Connolly, *Enemies of Promise* (New York: Macmillan, 1948), 116.

163 "Writers choose wives": Connolly, *Enemies of Promise*, 115.

165 "Very few people—perhaps one in fifty?—respect women's privacy": Doris Lessing, *Under My Skin: My Autobiography to 1949* (New York: HarperCollins, 1994), 369.

165 *. . . the shit in the shuttered chateau*: Philip Larkin, *Collected Poems*, ed. Anthony Thwaite (London: Marvell Press and Faber & Faber, 1988), 202.

166 "[Writing] was very hard . . . on the people around me": Quoted in Kathy Sheridan, "John Banville: 'I have not been a good father. No writer is,'" *The Irish Times*, October 22, 2016.

170 "I may say that only three times in my life": Gertrude Stein, *The Autobiography of Alice B. Toklas* (New York: Harcourt, Brace, 1933), 5–6.

170 "the same people that tried to blackball me": Kanye West, "Gorgeous," 2010, https://genius.com/Kanye-west-gorgeous-lyrics.

173 "knowing truly what you really felt": Ernest Hemingway, *Death in the Afternoon* (New York: Scribner, 1960), 2.

174 "A Great Book can be read again and again": Suzanne Buffam, *A Pillow Book* (Marfa, Tex.: Canarium, 2016), 20.

174 "A man must be a very great genius to make up for being such a loathsome human being": Elaine Showalter, "A Hemingway Tell-All Bares His Tall Tales," *The New York Times*, May 25, 2017.

IO ABANDONING MOTHERS

178 "When I was two weeks away from my twenty-first birthday": Paula Fox, *Borrowed Finery* (New York: Henry Holt, 2001), 208.

178 "Men do this all the time": Jenny Diski, *In Gratitude* (London: Blooms-bury, 2016), 187.

178 In 1949, Doris Lessing left behind two children: Alexandra Fuller, "First Person: Admiring Doris Lessing's Decision to Forgo an Ordinary, Decent Life," *National Geographic*, November 21, 2013.

181 "It must be about six o'clock": Doris Lessing, *The Golden Notebook*, (New York: Perennial Classics, 1999), 318.

181 "Long ago, in the course of the sessions with Mother Sugar": Lessing, *The Golden Notebook*, 318–19.

183 "Janet looked up from the floor": Lessing, *The Golden Notebook*, 222.

185 "I escaped for dear life": Quoted in Martin Stannard, *Muriel Spark: The Biography* (New York: W. W. Norton, 2009), 77.

185 "It was a great good thing": Stannard, *Muriel Spark*, 137.

185 "Muriel was never to be the victim": Stannard, *Muriel Spark*, 77.

186 "I drink and drink as a way of hitting myself.": Quoted in Linda Sexton, *Searching for Mercy Street* (Berkeley: Counterpoint, 2011), 228–29.

189 "I don't remember the exact date": Diski, *In Gratitude*, 63.

189 "Her suggestion felt like a proper distribution": Diski, *In Gratitude*, 81.

189 "[Lessing] was adamant that I would have been dead": Diski, *In Gratitude*, 24.

190 "Wild, dangerous, a woman with an active uterus": Quoted in Diski, *In Gratitude*, 106.

190 "the most interesting aspect of Doris arriving in London": Diski, *In Gratitude*, 191.

191 "Willfulness? The necessity of art?": Diski, *In Gratitude*, 199.

198 "Little Green": Joni Mitchell, "Little Green," 1971, https://genius.com/ Joni-mitchell-little-green-lyric.

198 "Joni now worried that her reputation": Sheila Weller, *Girls Like Us: Carole King, Joni Mitchell, Carly Simon—and the Journey of a Generation* (New York: Atria, 2008), 145.

199 "I had sworn my heart to Graham": Quoted in David Yaffe, *Reckless Daughter: A Portrait of Joni Mitchell* (New York: Sarah Crichton Books, 2017), 122.

200 "If I give up this unsought baby": Weller, *Girls Like Us*, 145.

200 "Joni herself seems to have believed": Weller, *Girls Like Us*, 146.

201 "Most of my heroes are monsters": Quoted in Yaffe, *Reckless Daughter*, 344.

202 "as she had Roy Blumenfeld, Leonard Cohen, and David Crosby":
Weller, *Girls Like Us*, 278.

203 "*Blue* was very open and vulnerable": Quoted in Yaffe, *Reckless Daughter*, 141.

203 "If I could be so bold": Brandi Carlile in *Joni 75: A Birthday Celebration*,
Dorothy Chandler Pavilion, Los Angeles, 2018.

205 "I knew I was going to leave": Doris Lessing, *Under My Skin: My Autobiography to 1949* (New York: HarperCollins, 1994), 261.

206 "I felt—and still wonder if this wasn't right": Lessing, *Under My Skin*, 401.

II LADY LAZARUS

212 "One is not born but becomes a woman": Simone de Beauvoir, *The
Second Sex* (New York: Knopf Doubleday, 1953), 267.

213 "Life in this society being, at best, an utter bore": Valerie Solanas,
SCUM Manifesto (London: Verso, 2004), 35.

213 "knows he's a worthless piece of shit": Solanas, *SCUM Manifesto*, 39.

213 "No genuine social revolution can be accomplished by the male": Solanas, *SCUM Manifesto*, 54.

214 By chance, she saw an ad: Breanne Fahs, *Valerie Solanas* (New York:
The Feminist Press, 2014), 110.

215 On June 3, 1968: Fahs, *Valerie Solanas*, 132.

215 Solanas made a few stops: Fahs, *Valerie Solanas*, 132.

217 "The 90s is the decade of the Riot Grrrls": B. Ruby Rich, "Manifesto
Destiny: Drawing a Bead on Valerie Solanas," *Voice Literary Supplement*,
October 12, 1993, 16–17.

219 "Some ways of reading": Ruth Padel, "Sylvia Plath: The idol, the
victim—and the pioneer," *The Independent*, January 12, 2013.

220 "dominant, secure, self-confident": Solanas, *SCUM Manifesto*, 70.

221 "unmoored and alone with their inscriptions": Avital Ronell, "Deviant
Payback: The Aims of Valerie Solanas," in Solanas, *SCUM Manifesto*, 9.

222 "It is easier to imagine the end of the world": Mark Fisher, *Capitalist Realism: Is There No Alternative?* (Winchester, UK: Zero Books, 2009), 1.

224 "There is no human reason for money for anyone to work more than
two or three hours": Solanas, *SCUM Manifesto*, 39.

12 DRUNKS

226 He was born in Clatskanie, Oregon, and raised in Yakima: Carol Sklenicka, *Raymond Carver: A Writer's Life* (New York: Scribner, 2009), 3–10.

226 an abuser of his wife: Skenicka, *Raymond Carver*, 230, 279–81, 289.

227 Chico State College: Skenicka, *Raymond Carver*, 3.

227 a class with John Gardner: Skenicka, *Raymond Carver*, 65.

229 "In the kitchen, he poured another drink": Raymond Carver, "Why Don't You Dance?," *Where I'm Calling From* (New York: Vintage Contemporaries, 1989), 155.

229 "She kept talking. She told everyone": Carver, "Why Don't You Dance?," *Where I'm Calling From*, 161.

229 "We all shamelessly cribbed from him": Jay McInerney, "Raymond Carver: A Still, Small Voice," *The New York Times Book Review*, August 6, 1989.

230 "His fingers rode my fingers": Carver, "Cathedral," *Where I'm Calling From*, 374.

230 "'It's really something,' I said": Carver, "Cathedral," *Where I'm Calling From*, 374.

231 "Gravy": Raymond Carver, *The New Yorker*, August 21, 1988.

231 "Many critics over the years": D. T. Max, "The Carver Chronicles," *The New York Times Magazine*, August 9, 1998.

232 "water comes together with other water": Raymond Carver, "Where Water Comes Together With Other Water," in *Where Water Comes Together With Other Water: Poems* (New York: Vintage Books, 1985), 17.

237 "What luck, I thought": Raymond Carver, "Luck," *Fires* (New York: Vintage Books, 1984), 37.

239 "The problem is that the model of individual responsibility": Mark Fisher, *Capitalist Realism: Is There No Alternative?* (Winchester, UK: Zero Books, 2009), 667.

239 "*Everyone* is supposed to recycle": Fisher, *Capitalist Realism*, 66.

13 THE BELOVEDS

244 "*Beauty is what we like*": Quoted in Saul Ostrow, "Dave Hickey," *BOMB* magazine, April 1995.

245 erstwhile heroin addict and pimp: *SPIN* magazine interview, November 1985.

245 A father by the age of seventeen: Miles Davis and Quincy Troupe, *Miles: The Autobiography* (New York: Simon & Schuster Paperbacks, 2011), 46.

245 Billy Eckstine: Davis and Troupe, *Miles*, 49.

245 hunted Charlie Parker: Davis and Troupe, *Miles*, 57.

245 replacing Dizzy Gillespie: Davis and Troupe, *Miles*, 68.

245 "It was a vulnerable sound": George Avakian in the documentary *The Miles Davis Story* (2001), directed by Mike Dibb.

246 "I loved it, listened to it, couldn't get enough": Pearl Cleage, *Mad at Miles: A Blackwoman's Guide to Truth* (Cleage Group, 1990), 40.

246 "The Bohemian Woman Phase": Cleage, *Mad at Miles*, 40.

249 "It will be generally admitted": E. M. Forster, *Howard's End* (New York: Knopf, 1948), 38.

250 "I will confess I spent": Cleage, *Mad at Miles*, 40.

250 "Chill the wine": Cleage, *Mad at Miles*, 40.

250 "I understood the danger of and divisiveness of perpetrating such 'negative images' of black men": Pearl Cleage, *Deals with the Devil* (New York: Ballantine, 1993), 22.

250 "I was an innocent": Cleage, *Mad at Miles*, 42.

251 "slapped the shit": Davis and Troupe, *Miles*, 366.

251 "I actually left running for my life—more than once": "Wrestling with Miles Davis and His Demons," *The New York Times*, November 16, 2006.

251 "She was a star and on her way to being a superstar": Davis and Troupe, *Miles*, 228.

251 "Can we make love": Cleage, *Mad at Miles*, 41.

252 "There are countless jazz fans": Richard L. Eldredge, "Q&A with Pearl Cleage," *Atlanta* magazine, September 1, 2012.

252 "No, you should not feel guilty": Quoted in Eldredge, "Q&A with Pearl Cleage."

255 "You find out what the problem is in the beginning": Mary Karr, "Writers on Writing" podcast hosted by Barbara DeMarco-Barrett.

255 "The problem isn't that your mother hit you": Karr, "Writers on Writing" podcast.

257 "In personal life, regardless of any covenant": Gillian Rose, *Love's Work* (New York: Vintage, 1997), 54–55.

257 "We can just hope": Quoted in Eldredge, "Q&A with Pearl Cleage."

Claire Dederer is the author of two critically acclaimed memoirs: *Love and Trouble: A Midlife Reckoning* and *Poser: My Life in Twenty-Three Yoga Poses*, which was a *New York Times* best seller. *Poser* has been translated into eleven languages, optioned for television by Warner Bros., and adapted for the stage. Dederer is a longtime contributor to *The New York Times*. Her essays, criticism, and reviews have also appeared in *The Paris Review*, *The Atlantic*, *The Nation*, *Vogue*, *Marie Claire*, *Elle*, *Real Simple*, *Entertainment Weekly*, *New York* magazine, *Chicago Tribune*, *Newsday*, *Slate*, *Salon*, *High Country News*, and many other publications. Her essays have appeared in numerous anthologies, most recently *Labor Day*. Dederer began her career as the chief film critic for *Seattle Weekly*. She lives on her late father's houseboat in Seattle.

A NOTE ON THE TYPE

This book was set in Scala, a typeface designed by the Dutch designer
Martin Majoor (b. 1960) in 1988 and released by the FontFont foundry
in 1990. While designed as a fully modern family of fonts containing
both a serif and a sans serif alphabet, Scala retains many refinements
normally associated with traditional fonts.

Typeset by Scribe,
Philadelphia, Pennsylvania

Printed and bound by Berryville Graphics,
Berryville, Virginia

Designed by Soonyoung Kwon